MICHAEL FREEMAN
THE PHOTOGRAPHER'S
DSLR POCKETBOOK

MICHAEL FREEMAN
THE PHOTOGRAPHER'S DSLR POCKETBOOK

The **essential guide** to getting the most from your camera

ILEX

First published in the United Kingdom
in 2010 by:

I L E X

210 High Street
Lewes
East Sussex
BN7 2NS
www.ilex-press.com

Copyright © 2010 The Ilex Press Limited

Creative Director: Peter Bridgewater
Publisher: Alastair Campbell
Managing Editor: Natalia Price-Cabrera
Editor: Steve Luck
Designer: Jon Allan
Art Editor: James Hollywell
Index: Indexing Specialists (UK) Ltd.

British Library Cataloguing-in-Publication Data
A catalogue record for this book is available
from the British Library.

ISBN 978-1-907579-06-6

Printed and bound in China
Colour Origination by Ivy Press Reprographics

10 9 8 7 6

CONTENTS

Introduction

In their infancy, digital SLRs were the preserve of a select group of professional photographers, or exceptionally wealthy enthusiasts. While 35mm SLRs had reached a point in their development where there was something for everyone, regardless of their skill level or budget, the transition to sensor-based digital capture came with a price-tag that made it prohibitively expensive for the photo enthusiast. To enjoy the benefits of photography with an interchangeable lens digital camera meant investing heavily in a technology that was evolving at a phenomenal rate, with manufacturers turning out significantly superior cameras on an alarmingly regular and brief timescale; a doubling of camera resolution in as little as 12 months was common.

Today, however, the frenetic pace of DSLR development and the leaps in technological "breakthroughs" have slowed, although that isn't to say they have ceased altogether. Sensor resolutions continue to creep upward, albeit in smaller increments, and new technologies continue to be squeezed into the camera body to enhance the photographer's experience; built-in anti-shake systems to combat camera shake, in-camera dust-removal, live LCD screens, and video recording are all increasingly common, for example. But it is not the maturing technology that has expanded the DSLR market to the point that 35mm SLRs are now near-obsolete, it is a far more material aspect: price. While hefty prices excluded most non-professional photographers (and many pros) from "going digital" a decade ago, the low-cost of modern DSLRs is no longer a barrier.

Yet while buying a DSLR no longer requires the same financial sacrifice, it still demands an investment in time if you want to make the most of it. Fundamental photographic concepts such as aperture, shutter speed, and ISO may not have changed since the day photography was born as a medium, but their implementation in the digital age, to a certain extent, has. In addition, there are all of the necessary digital technologies that need to be mastered or, at the very least, understood. While some photographers may be happy setting their camera to "automatic" and allowing it to determine the many and varied picture-taking parameters, to use a DSLR to its fullest potential there is a great deal to learn. That is precisely why you have bought this book. What I aim to do here is to reveal how you can get the very best from your camera, and show how digital capture can, and should, change the way you think about shooting, regardless of whether this is your first DSLR or not.

THE DIGITAL ENVIRONMENT

There's no doubt that if you're already familiar with the basic controls of a conventional film SLR—by which we mean the aperture, shutter speed, shooting modes, and so on—then the switch to a DSLR should be relatively painless. If you're moving up from a digital point-and-shoot, you may have more to learn in terms of technique, but you'll be familiar with much of the "vocabulary" that is used in digital photography.

The world of digital SLRs (DSLRs) is a rapidly evolving environment. It seems almost inconceivable that it was only in 2000 that Canon launched its flagship DSLR, the D30, which featured a 3.1-megapixel sensor—a resolution now found on many cameraphones.

However, the speed of technological change can make life expensive for the photography enthusiast, as improvements tend to be much greater as new camera models are launched. On the face of it, this is simply a matter of buying a digital body to use with existing lenses and accessories, and in one sense it is no more complicated than that. Nevertheless, exploiting the enormous capabilities of digital cameras and software to their fullest means immersing yourself in a different world, and, after this initial chapter, starting to shoot intuitively. This means not following the manual—but it will still help to have read it first.

DSLRs

The DSLR offers an excellent compromise between image quality, affordability, flexibility, and convenience. While there are medium format cameras that offer greater dynamic range, less noise, and the ultimate in image quality, their high cost puts them firmly in the professional category.

As with film SLRs, the big draw of DSLRs is that you can see exactly what you are about to shoot, from framing to focus and depth of field, thanks to the use of a prism and flip-up mirror that deliver an exact view of the scene that is about to be captured. You may argue that digital point-and-shoot cameras with their electronic, non-mechanical shutters also offer this, but it's at the cost of loading more circuitry onto the sensor, with a corresponding reduction in their image-gathering ability.

SLRs also have interchangeable lenses, which vastly broadens their capabilities. Indeed, all the major camera manufacturers have invested their best efforts in image quality and operational perfection into SLR bodies—in other words, SLRs are where the good stuff resides.

Ergonomically, 35mm SLR designs became highly refined over the past 70 years, and while point-and-shoot cameras have produced a chaotic number of styles, DSLRs have followed their film predecessors. But, although the principle may be the same as a film camera, the inner workings of a digital

PENTAX
Despite enjoying only a relatively small share of the DSLR market, Pentax is producing high-specification cameras that have a loyal following.

How DSLRs gather light

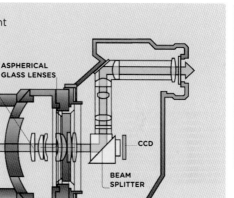

GAUSS TYPE LENS GROUPS

ASPHERICAL GLASS LENSES

CCD

BEAM SPLITTER

HIGH INDEX LOW DISPERSION LENS

ED (EXTRA DISPERSION) LENS

camera are quite different. For a start, the imaging is being performed by a silicon-based chip sensor—either a CCD (charge-coupled device) or CMOS (complementary metal-oxide semiconductor) containing millions of light-sensitive photodiodes. Each photodiode converts light from the scene being photographed into a voltage that is proportional to the brightness. The charge is amplified, then transferred to an ADC (analog-to-digital converter) that translates the pattern of charges recorded by the sensor into discrete binary code. This code is sent to a DSP (digital signal processor) that performs a variety of operations depending on the needs of the image and the settings chosen by the user: reducing noise and adjusting brightness, color, contrast, and sharpness, for example. Finally, all of the digital information that defines the image is saved

onto the storage medium—a memory card of one kind or another.

This technology has important structural implications. There are no chambers for a film cassette or take-up, and no mechanically complex film transport, but the space that is saved is needed for the processor, sensor, and their associated circuitry, as well as the removable memory card. This all fits, just, and by coincidence, the volume of a former 35mm SLR is approximately what is needed for a digital model. Many mechanical parts remain the same—mirror, lens connection, pentaprism, and shutter mechanism. The last, incidentally, takes the place of the all-electronic shutter found in some point-and-shoot models (which enables a video feed); only recently have the majority of DSLRs allowed a real-time preview of the scene on the LCD screen, enabling DSLR users to

compose using the LCD screen as well as shoot video. The screen itself is always a compromise on a handheld camera, and is necessarily inadequate in size for detailed viewing. Digital backs on "medium-format" cameras can have more sensible LCD screens, but on mainstream SLRs, the screen is for very basic checking; judging color and image quality by appearance alone is pointless.

Interestingly, on the subject of digital backs, the old divisions between formats (35mm, rollfilm, and so on) are now becoming thoroughly blurred. The only reasons why some differences survive are historical. Most backs are designed to fit the standard range of rollfilm cameras (645 and 6x6cm in particular) and these of course have their own styles of design and ergonomics.

Point-and-shoot

Although affordable, entry-level DSLRs are making in-roads, the vast majority of cameras bought today are point-and-shoot. The main feature that distinguishes high-end models, which sell to the "prosumer" (high-end consumer) sector, from professional SLRs is that they have a fixed zoom lens instead of interchangeable lenses. Sensor resolution is not necessarily different, and as most deliver at least the nine megapixels necessary for normal full-page print reproduction, they have their uses for professional photography. Being light and small they can be carried and used unobtrusively, and so are convenient to have around on the off-chance of a picture opportunity. Build quality, however, is usually not as high as for SLRs, and their smaller sensors mean point-and-shoot cameras can struggle with picture quality, particularly in high contrast or low-light conditions.

OLYMPUS PEN
Despite its point-and-shoot style design, the Olympus Pen is comparable to a DSLR in just about every other way; it features a large sensor, the lenses are interchangeable, and image quality is on a par with DSLRs of a similar price.

Micro Four Thirds

A relatively new format that looks set to become popular with the prosumer market is the new range of what are loosely described as "mirrorless interchangeable lens cameras" that utilize the Micro Four Thirds system.

The Four Thirds system was developed by a collective of camera manufacturers looking to produce a universal, cross-manufacturer range of DSLRs designed specifically for digital photography, as opposed to DSLRs that relied on existing film-based technologies. As the system was developed from the ground-up, the cameras and lenses could be optimized for one another, while the smaller sensor size allowed camera manufacturers to produce smaller DSLR camera bodies and lenses.

Micro Four Thirds is an extension of this, which dispenses with the reflex mirror and prism of a traditional SLR, resulting in a very small body—often without a viewfinder—where image composition takes place using the rear LCD screen. Such cameras sit between compacts and fully-fledged digital SLRs; they are comparable in size to large compacts, but share an SLR's ability to change lenses, from wide-angle to telephoto.

NIKON VS. CANON
Nikon and Canon remain the "big two" when it comes to DSLR cameras, sharing around 80 percent of the overall market.

DSLR Controls

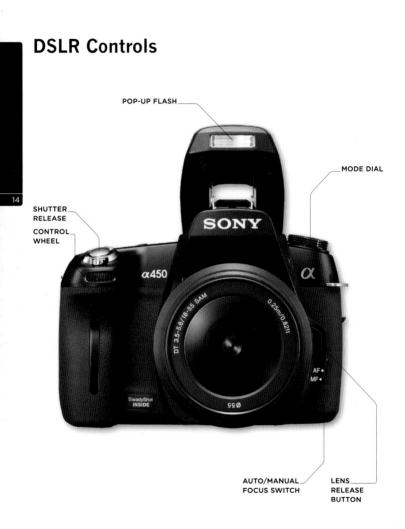

POP-UP FLASH

MODE DIAL

SHUTTER RELEASE

CONTROL WHEEL

SONY

α450

DT 3.5-5.6/18-55 SAM

0.25m/0.82ft

SteadyShot INSIDE

Ø55

AF •
MF •

AUTO/MANUAL FOCUS SWITCH

LENS RELEASE BUTTON

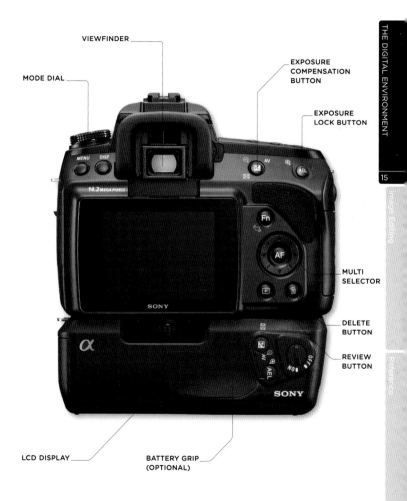

VIEWFINDER

EXPOSURE COMPENSATION BUTTON

EXPOSURE LOCK BUTTON

MODE DIAL

MULTI SELECTOR

DELETE BUTTON

REVIEW BUTTON

LCD DISPLAY

BATTERY GRIP (OPTIONAL)

The Digital Sensor

The sensor lies at the heart of all DSLRs. It is an integral part of the camera that feeds, or is served by, almost all of the camera functions. As the technology is still evolving, gradual improvements in dynamic range capture and noise reduction are ongoing, although increases in resolution are not as frequent or as dramatic as they once were.

This inevitably means new cameras, as there is no question at this point of simply upgrading a sensor. It also means that if the sensor is sometimes exposed to the environment, as in an SLR, it needs particular care and attention to avoid particles on the surface and damage.

A sensor is an array of photoreceptors embedded on a microchip, along with the circuitry and components necessary to record the light values. The circuits are etched into the wafer by repeating the photolithographic process of light exposure and chemical treatment, with extreme precision. The width of circuit lines is typically less than 4μm

Capturing color

Photosites are not able to distinguish between different wavelengths of light, and as such are unable to record variations in color; color is added by filtering the light. The entire sensor is covered with a Color Filter Array (CFA)—a mosaic of red, green, and blue filters, one for each photosite. The camera's processor then interpolates the missing two-thirds of the color information from the surrounding pixels—at least the neighboring block of eight. The CFA pattern, as illustrated here, is not an even distribution of the three wavelengths. In order to better correspond with human vision, which is most sensitive to green-yellow, there are usually twice as many green filters as red and blue.

Sensor development

All sensor manufacturers are seeking to improve the performance of their particular sensors—and attention is often focused on reducing the size of photosites or increasing the size of the sensors. There are special technical challenges for each, and resolution is not the only thing affected. A larger receptor (such as 8μm—8 microns, or 0.008mm) is slower to fill up, and this is claimed to give a better dynamic range, as is the case for deeper receptors.

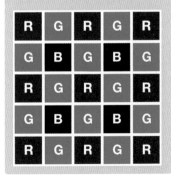

(4 microns). As an indication of the complexity, Canon's 11.1-megapixel CMOS sensor has approximately 700 feet (200 meters) of circuitry. The individual unit of a sensor is the photosite, a minuscule well that is occupied principally, though not exclusively, by a photodiode. The photodiode converts the photons of light striking it into a charge—the more photons, the higher the charge. The charge is then read out, converted to a digital record, and processed. Each signal from each photosite becomes the light and color value for one pixel—which is the basic unit of a digital image.

Photodiodes record light rather than color, so this has to be added by interpolation in the vast majority of sensor designs. The usual method is to overlay the sensor array with a transparent color mosaic of red, blue, and green. As in color film and color monitors, these three colors allow almost all others to be constructed. The difference here, however, is that the color resolution is one-third that of the luminance resolution. Oddly, perhaps, this doesn't matter as much as this figure suggests. Interpolation is used to predict the color for all the pixels, and perceptually it works well. As we'll see later in this book in the color management and optimization sections, color is a complex issue, psychologically as well as physically. The ultimate aim in photography is for the color to look right, and this is heavily judgmental.

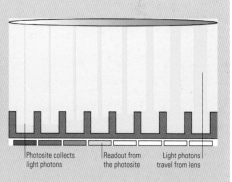

Photosites

Photosites create an electrical charge when struck by light. An absence of light means no electrical charge, resulting in black. On the other hand, if light continues to strike a photosite beyond its "holding capacity" the result is pure, featureless white. This accounts for the linear response of digital sensors to light rather than the subtle fall-off that allows film to capture a relatively wide dynamic range.

Photosite collects light photons

Readout from the photosite

Light photons travel from lens

Sensor types

Digital cameras utilize one of two main types of sensor—CCD (charge-coupled device) or CMOS (complementary metal oxide semiconductor). Chips of all kinds are made in wafer foundries, but as CCDs are a specialized variety, they are more costly to produce. CMOS foundries, however, can be used to manufacture computer processors and memory, and so CMOS sensors can take advantage of economies of scale. This makes them much cheaper than CCDs to produce, although some of this saving is offset by the need to overcome some performance problems, notably noise, which means additional onboard processing. In other words, CCDs are inherently better for high-quality imaging, but once data processing has been factored in there is little to choose in performance at the top end of DSLRs. In fact most high-end DSLRs now use CMOS chips.

A CCD CHIP

CMOS chips are produced as part of a silicon wafer, like other computer chips, and are cut into individual chips using a diamond-edged saw.

Once cut into separate pieces, the chips can be placed onto circuits like any other computer chip.

The problem of moiré

Light from certain subjects, such as fabrics or materials with a tight weave, can occasionally only activate certain rows of the sensor's pixels, leaving neighboring rows inactive, or "dark." This results in an effect known as moiré, which usually manifests itself as wavy patterns, and is an interference effect caused by the overlapping of tight, fine patterns.

In digital photography, this special kind of artifacting is particularly common because of the grid pattern of photosites on the sensor. If a second pattern with a similar spacing is shot, such as a textile weave, it can interact to create a moiré pattern, as shown here. The camera's low-pass filter helps to reduce the effect, although only to a certain degree as strong correction softens the image overall. The lenses, sensor, and software in a DSLR system are all designed for high sharpness and accuracy, and this makes moiré more likely.

To avoid or reduce moiré:
• Change the camera angle or position.
• Change the point of focus and/or aperture.
 (Moiré is a function of sharp focus and high detail.)
• Vary the lens focal length.
• Remove with image-editing software.

Warning: always inspect for moiré at 100% magnification. At smaller magnifications you can often see a false moiré, which is the interaction of the image with the pixels in a camera's LCD screen or a computer monitor.

Picture suffering from moiré

Combating moiré

To combat moiré, light is passed through a low-pass filter that effectively spreads light by the width of a pixel, both horizontally and vertically. This results in more accurate data separation. The filter illustrated here is Canon's three-layer filter, in which a phase plate—which converts linearly polarized light into circularly polarized light—is sandwiched between two layers that separate image data into horizontal and vertical directions. Another substrate cuts infrared wavelengths by a combination of reflection and absorption to further improve color accuracy.

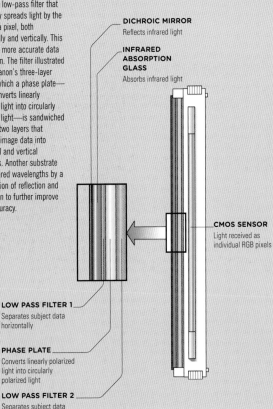

DICHROIC MIRROR
Reflects infrared light

INFRARED ABSORPTION GLASS
Absorbs infrared light

CMOS SENSOR
Light received as individual RGB pixels

LOW PASS FILTER 1
Separates subject data horizontally

PHASE PLATE
Converts linearly polarized light into circularly polarized light

LOW PASS FILTER 2
Separates subject data vertically

Data Transfer

Once the sensor has captured the light from the subject and generated a charge, the data has to be transferred in a readable form to the camera's processor as quickly and as accurately as possible, and there are different ways of achieving this.

The original method, which gave the CCD (charge-coupled device) its name, relies on reading out the charges row by row, linking the end of one row to the beginning of the next. In this way, the charges are "coupled."

Improving speed

One of the key issues is the speed at which the image data can be moved off the sensor so that it is ready for the next exposure. This decides the shooting speed—an important factor for sports and news photographers in particular—and the baseline that most professionals have become used to is the eight-frames per second common among high-end cameras.

At the moment, there are three methods used by sensors—interline transfer, full frame transfer, or X-Y addressing—of which interline transfer, reading one column at a time, is the traditional method. All have advantages and disadvantages, and different manufacturers favor one or the other according to how they choose to solve inherent problems. The lesson here for photographers is that there is no steady progression of sensor improvement, but a more chaotic world of innovation and secretive independent engineering—problems that once seemed intractable can suddenly have a solution.

Data readout

Improving the speed and efficiency of data transfer is a critical area of development. Currently there are three methods of transferring the data from an exposed sensor:

Interline transfer
In this basic, original method (which gave CCDs their name) the data from the photosites is shunted to one side of the sensor so that the rows can be read one at a time, with the end of one linked to the start of the next. The readout is therefore sequential. Originally developed for video, its disadvantages for still digital capture are the time it takes to shunt the data across the array, and the need for transfer channels adjacent to the photodiodes, which reduces the aperture ratio at the photosite.

X-Y addressing
Each photosite is read individually, which cuts down the transfer time and offers potential processing advantages. It requires individual switches for each site, which potentially reduces the area available for the photodiode, reducing the aperture ratio. This method is used in CMOS sensors and some others (such as the Nikon LBCAST, which uses buried channels).

Full-frame transfer
All of the data is moved at once down onto an area the same size as the sensor. This adds another layer of the same area as the sensor, but as the transfer channels can be underneath the photosites, the photodiodes can occupy a larger area. It also addresses the issue of transfer speed.

The creation and storage of an image

1 Light strikes the active area of the photodiode.

2 The photodiode converts the quantity of light into an accumulated charge.

3 The charge is moved off the sensor (with all the other charges from other photosites) through transfer channels to an amplifier.

4 The amplified charge is moved to the ADC (analog-to-digital converter).

5 The signal is processed by the ADC into digital data.

JPEG

File.jpg

6 The imaging engine processes the image in a number of ways, including applying user settings, compressing, and reducing noise.

7 The data is transferred to the memory card or direct to the computer's hard drive (if the camera is connected).

The Imaging Processor

A DSLR's imaging processor works behind the scenes, turning the data received from the sensor into a viewable digital image. As such, it is responsible for all the computation of the data from the sensor, from the signal received by the ADC (Analog-to-Digital Converter) to the transfer of a completed image to the memory card.

There is a great deal of hidden work going on here, not only because you have no direct access to it (other than through the menu settings), but because the proprietary algorithms that are at the heart of the processor are kept secret. As with software applications used on desktop computers,

algorithms are the mathematical procedures for performing actions, and those for imaging are complex. Not only that, but there are differences in the quality of the programming—which can only be judged in the appearance of the final image. There is more to do with image quality, in all its aspects, than the simple specifications of the sensor.

In high-end cameras, the design of the sensor and the imaging engine proceed in tandem. Major camera manufacturers develop their own sensors and processors, and this alone helps to improve imaging performance. For example, Canon, and more recently some

A processor engine

Your camera's onboard electronics can make decisions for you, should you choose, but it will only ever be able to see the scene from the point of view of "averages" or "most people."

Nikon cameras, currently use CMOS sensors for their advantages in speed, power consumption, and cost, and address the known higher noise level in two ways: through on-chip noise-reduction circuitry, and through noise-reducing algorithms in the processor. In another example, Nikon's high-end models use the processor to carry some of the burden of suppressing color aliasing (false coloration), which is normally the job of the optical low-pass filter immediately in front of the sensor. Increasing the birefringent index of this filter suppresses the color artifacts better, but it also lowers resolution. The Nikon filter has a lower birefringent index because the imaging engine takes on some of the task.

A great deal of sensor technology involves compromise, and the imaging engine can solve many of the problems. You can experience something of this (in a much more limited way) by shooting in Raw format and optimizing your images later. It's important not to try to make comparisons between DSLRs based on the specifications that are usually published. Properly designed, a sensor and processor combination with a modest megapixel size can ultimately produce images that have a higher resolution and better sharpness than a larger, more primitive sensor.

The processor is primarily responsible for the following tasks:

The memory buffer As frames are captured they are moved immediately to the buffer, from where they are transferred one at a time for processing. Buffer size has an impact on the shooting speed (capture rate).

Creating color Pixels are sampled in relation to their neighbors, taking into account the color array pattern, to fill in the missing color information. Color gradation across the image needs to be smoothed, and color artifacts (false colors and fringing) removed.

Resolution and sharpness A number of aspects affect sharpness and resolution, including noise, aliasing (jaggies), and color artifacts.

Reducing noise An extremely important operation, as the various kinds of noise are obstacles to capturing a clean image from a sensor.

User settings Applying the choices offered in the menu to the image.

Image creation Combining all of the sensor data and processing to produce a readable image in one of several formats.

Compression In the case of JPEG and some Raw images, applying compression algorithms.

Updating firmware

Firmware is the term used to describe various programs already encoded in the camera, and it will occasionally need updating as the manufacturer makes new versions available. There will be an option in the camera menu that lets you check the firmware version installed; make a note of this and every few months check the manufacturer's website to see if there are updates. If so, you may be able to perform the operation yourself, depending on the make of your camera (with some makes this must be done by an authorized service center). With user-installed updates, pay careful attention to the instructions as this is an operation that can damage the processor if it goes wrong. In principle, the sequence is:

1 Download the firmware update installer to your computer from the manufacturer's website.

2 Copy the installer to a blank memory card, using either a card reader or the camera.

3 Run the install operation from the memory card. This takes several minutes, and during this time the camera must under no circumstances be powered down.

4 Erase the installer from the memory card.

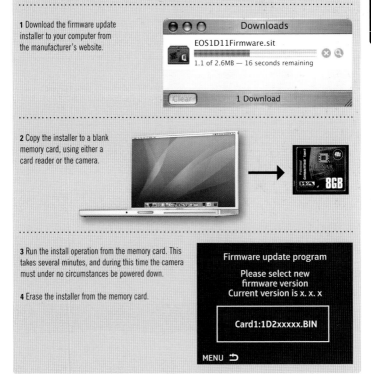

Image Editing

Reference

Camera Menus

Because a digital camera can be set up with an often bewildering number of user preferences, from significant shooting settings such as ISO sensitivity to convenience options such as how files are numbered, all cameras need a comprehensive menu.

The options are grouped more or less logically, and a typical division is into set up, shooting, and playback, with an extra sub-menu for custom settings in some instances.

Some of the settings can be accessed via dial and button controls on the camera body for ease and speed of operation—this may be instead of being on the menu or in addition. The menu structure varies from brand to brand, but is likely to cover the following:

Standard options

. .

Set up (may be subdivided)

LCD brightness, time on
Date and time
Language
Folder creation, assignment
Add information
Mirror lock-up
Format card
Video output
Cable connection protocol
File numbering
Noise reduction
Auto features on/off
EV steps
Bracket steps
Focus settings
Grid display
Flash mode
Assign dials and buttons
Shoot to computer

Shooting

File format
Image size
White balance
ISO
Contrast
Hue adjustment
Color mode
Sharpen
Print specification

Playback

Image size on screen
Data displayed
Zoom
Delete
Image protection
Hide image
Folder selection
Slide show

Quality	◢L
Red-eye On/Off	Off
Beep	Off
Shoot w/o card	On

Flash exp comp	.:-2..1..0..1.:2
WB SHIFT/BKT	Off
Custom WB	
Color space	sRGB
Picture Style	Standard
Dust Delete Data	

Protect
Rotate
Print order
Transfer order
Auto play
Review time
Histogram

Shooting settings | Shooting settings | Playback settings

Auto power off	8 min.
Auto rotate	On
LCD brightness	L
LCD auto off	Enable
Date/Time	31/08/06 15:36
File numbering	Continuous
Format	

Language	English
Video system	NTSC
Custom Functions	(C.Fn)
Clear settings	
Sensor cleaning: Auto	
Sensor cleaning: Manual	
Firmware Ver. 1.0.4	

Custom Function

SET button/Cross keys funct.

0:SET:Picture Style

01 02 03 04 05 06 07 08 09 10 11
0 0 0 0 0 0 0 0 1 0

Camera setup | | Custom functions

SHOOTING MENU	
Optimize image	N
Image quality	FINE
Image size	
White balance	☀
ISO sensitivity	200
Noise reduction	OFF

SHOOTING MENU	
Optimize image	N
Image quality	FINE
Image size	
White balance	AUTO
ISO sensitivity	200
Noise reduction	OFF

PLAYBACK MENU	
Delete	🗑
Playback folder	ND40X
Rotate tall	ON
Slide show	2s
Print set (DPOF)	

Shooting settings | Shooting settings | Playback settings

SET UP MENU	
CSM/Setup menu	
Format memory card	
Info display format	
Auto shooting info	
World time	
LCD brightness	0
Video mode	NTSC

CUSTOM SETTING MENU	
R Reset	
01 Beep	ON
02 Focus mode	AF-A
03 AF-area mode	
04 Shooting mode	
05 Metering	
06 No memory card?	LOCK

RETOUCH MENU	
D-lighting	
Red-eye correction	
Trim	
Monochrome	
Filter effects	
Small picture	
Image overlay	

Image Resolution

In the digital environment, an image's resolution is governed simply by the number of photosites or pixels sited on the sensor: the greater the number of pixels, the more detail the sensor is capable of capturing.

However, it's important not to think of resolution as the defining factor in image quality, as more pixels don't necessarily make for a better image. It's the quality of the pixels that count, and not the quantity.

Camera sensor technology has evolved to such a point that today, most DSLRs are capable of producing high-quality tabloid- or A3-sized prints; and for the vast majority of us this is quite sufficient. However, for some this is still not quite enough, and so we need to be aware of what the limits are—and which techniques are available to help push the envelope.

The way to deal with resolution is to work backward from the end use. What looks good on a 22-in monitor will not necessarily look good as a normal print, but if the screen view is all you need, that doesn't matter. Professionally, the main uses for images are prepress, display prints, and the Web. For both prepress and display prints, digital files should be at twice the resolution at which they will be printed. A high-quality web offset press, for example, has a line-screen resolution of 133 and 150, so the digital file should be 300 ppi. This is the standard, default resolution for printing.

What ultimately counts, of course, is the number of pixels that goes into making the image. Simply expressed, you need a 22MB file for an 8 × 10 in print, and about the same for a full page in most magazines. Each camera megapixel gives 3MB of image (that is ×3 for the three RGB channels), which means that 7 megapixels will do the job perfectly and a 6-megapixel camera will be adequate. In terms of use, a full page is one of the most basic professional units, while a double-page spread—twice the size—takes care of any possible use that an editorial client might want to make. Stock libraries are in the best

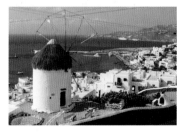

DIGITAL
This view of an old windmill on the beautiful Greek island of Mykonos was shot using a digital camera with a 6-megapixel resolution.

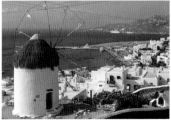

FILM
This shot was taken immediately after (in the same conditions) with a traditional film camera. Film is believed to be equivalent to about 20 megapixels of detail.

Resolution: digital vs. film

Although it's a question often asked, it's almost impossible to compare resolution
between digital and film because the measurement systems are different, and because
digital images are in principle "cleaner" than film images. Digital images can be
measured by the density of pixels, but other factors creep in, particularly
the quality of the lens. The usual measurement is pixels per inch or per centimeter
along a straight line. A full-frame 36 × 24mm sensor with 12 megapixels would have a
resolution of 4048 × 3040 pixels.

Digital 100%

Digital 200%

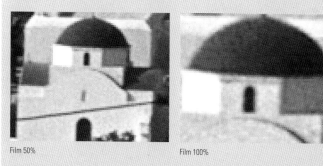

Film 50%

Film 100%

position to know the demands of the market, and Corbis, for instance, set the following specifications for their own images: 40MB for editorial sales, 50MB for commercial. These are, naturally, high professional specifications, but the principle is the same as for less demanding uses—calculate backward from the end-use.

All this is without attempting to improve resolution by upscaling. How successful this is depends on the algorithm used, and this is highly technical. It also depends on how much deterioration you are prepared to accept. No interpolation method, however sophisticated, can equal a higher resolution original, but on the other hand the differences can be surprisingly small. Resolution, together with sharpness and noise, are also matters of judgment. If you have a unique or important photograph by virtue of its content, image quality takes second place. This regularly happens in news journalism and in art, too, and always has. Compare, for example, an early Bill Brandt print (many are technically sub-standard) with an Edward Weston print from an 8 × 10 in negative (Weston was known for his technical perfection).

Digital resolutions vs film resolution

Prepress and display prints	Millimeters (w x h)	Inches (w x h)	MB @ 300 ppi
A5	148 x 210	5.83 x 8.27	12.7
Magazine full page (Time magazine size)	190 x 260	7.5 x 10.1	19.5
US Letter	216 x 279	8.5 x 11	21.2
A4	210 x 297	8.27 x 11.69	25.5
8 x 10in print	203 x 254	8 x 10	21.1
A3	297 x 420	11.69 x 16.54	51.0
A3 +	329 x 483	13 x 19	63.4
Magazine double spread (Time magazine size)	380 x 260	15 x 20.2	78

Monitor display (pixels)	Millimeters (w x h)	Inches (w x h)	MB @ ppi
15-in full screen (800 x 600)	305 x 229	12 x 9	1.4 @ 66 ppi
17-in full screen (1024 x 768)	345 x 259	13.6 x 10.2	2.3 @ 75 ppi
20-in full screen (1280 x 960)	406 x 305	16 x 12	3.5 @ 80 ppi
20-in cinema display (1680 x 1050)	432 x 269	17 x 10.6	5.1 @ 100 ppi
23-in cinema display (1920 x 1200)	495 x 310	19.5 x 12.2	6.6 @ 100 ppi

(Note: software commonly assumes monitors to be either 72 ppi or 96 ppi, though in reality it varies.)

File Formats

Digital photography can be seen as just one branch or one element of the larger subject of digital imaging. Images have been created digitally, without digital cameras, for many, many years, and for this reason a number of different ways of organizing and storing digital images, known as file formats, has evolved, each with a particular specialty.

Some formats are better suited to one kind of image than another—for example, graphic illustration with solid color and hard edges as opposed to photographs containing complex detail and shading. Some formats are aimed at delivery—such as for the Web. By now, a few standard formats are accepted as useful for photographic images, primarily TIFF (Tagged Image File Format) and JPEG (Joint Photographic Experts Group). These two are readable and interchangeable by all imaging software that deals with photographs. In addition, there is the native application format that each software program uses for its own internal workings, such as Photoshop's .psd files. These may or may not be readable by other applications.

Most SLRs offer two kinds of format: JPEG and Raw. JPEG, pronounced "jay-peg," is computing's longest-established system for writing images. It has two powerful advantages: it is optimized for transmitting images, and so is the universal format for the Web, and also compresses images so that they occupy less digital space. The amount of compression is chosen by the user—to more than 90%—and typical compression ratios are between 4:1 and 40:1. The compression method used is Discrete Cosine

Bits and colors

One bit (a contraction of binary digit) is the basic unit of computing, and has two states, on or off—black or white. A byte is a group of 8 bits, and as each of these has two states, one byte has a possible 256 combinations—that is, 256 values from black to white. An RGB image has three channels, so at 8 bits per channel has a color accuracy of 256 x 256 x 256—that is, 16.7 million possible colors. This is well beyond the ability of the human eye to discriminate, and is standard. Why then, do higher-end scanners and cameras make much of higher bit-depths, such as 12-, 14-, and 16-bit? This is because, first, it makes smoother and better graduated tones in a gradient (such as a clear, blue sky), and second, it improves the accuracy of interpolation when images are altered or manipulated during post-production.

Note that it is usual to refer to bit-depth (that is the number of bits) by channel, but occasionally you'll see it described as the total, all-channel bit-depth—24-bit meaning 8 bits per channel and 36-bit meaning 12 bits per channel.

Transformation, which works on blocks of eight pixels per side and is "lossy," meaning that some of the image information is thrown away. This results in some degradation, but this is quite often undetectable in normal image reproduction. It's important to run tests to assess what compression levels are acceptable to you for different purposes.

For the best image quality, and the ability to re-adjust all the camera settings after the event, there is Raw format. This is a file format that is unique to each make of camera, but what they all have in common is that settings such as white balance, hue adjustment, sharpening, and so on, are recorded and kept separately from the image data. The great advantage of this is that any of these settings can be altered during image editing, with no penalty in image quality. Another benefit is that the images are available at a higher bit-depth—typically 12- or 14-bit. The disadvantage is that Raw images need extra work when opening them in your editing program, which means spending time working on them.

RAW FILES

"Raw" is a generic name for the proprietary files produced by all DSLR cameras. Here, a .CR2 file (Canon's Raw file format) is adjusted using Canon's software, supplied with the camera. The alternative to Raw is to have the camera output a JPEG file instead. This will embed the camera settings in the image, reducing the ability to make changes to the white balance as easily, although less work is subsequently needed to view or print the image.

Compression vs. Image Quality

Although storage space, primarily in the form of memory cards, is becoming less expensive, there are still advantages in being able to compress the data for a photograph, provided that the image is not noticeably degraded. The key word here is "noticeably."

The raison d'être for JPEG in the camera's menu is that it is both a compression method and a file format, and this is usually the format to choose when it is important to squeeze the maximum number of images onto a memory card. In addition, the recording time will usually be less than it is for a Raw file, and so the images will move through the frame buffer more quickly—all good for shooting large numbers of images continuously.

Compressing a Raw image is a different matter. The space saving is in the order of 50%, but there is a time penalty, and this becomes important once the buffer has filled. This creates a potential problem when choosing whether or not to begin with compressed files—you will need to wait for the image(s) to be processed before you can change to uncompressed on the menu.

Compression and degradation

Most cameras offer a number of compression levels, ranging from high to low, and usually expressed along the lines of Basic, Normal, and Fine, with Basic offering the highest compression/lowest image quality, and Fine the lowest compression/highest image quality. However, the resulting file sizes depend on the image content. If you are going to make significant use of JPEG format, it is essential to run your own tests and judge what degradation you are happy to accept. The images will all be degraded slightly, but the key is to choose a setting that makes no visible difference. In practice, most people can detect no quality loss at normal viewing distances.

Basic Normal Fine

Compression: lossless vs. lossy

Compression can be applied in one of two forms—lossless or lossy. As their names imply, one compresses the file size without discarding any data (working instead by writing the data in a more succinct way), while the other throws away some of the information. Compression is sometimes described as a ratio (e.g. 1:4), as a percentage of reduction (e.g. 80%), or as a percentage of the original file size (e.g. 20%). The last two are easily confused.

The leading lossless compression system is LZW (named after its inventors Lempel-Ziv-Welch), used with TIFF images, and the amount of space saved depends on the image content. Typically, file sizes are reduced to about 40% to 50%, though less in high bit-depths. Raw formats can also be compressed without loss, using camera manufacturers' proprietary methods. One disadvantage of lossless compression is that it can add substantially to the recording time.

Lossy compression does degrade the image, but not necessarily to the point where it can be seen. The leading compression system is JPEG, and the amount of compression can be selected by the user. In-camera compression is normally limited to a choice of three settings, which vary among camera makes, but are typically 1:4, 1:8, and 1:16.

RAW
This photograph is the original image as photographed in Raw format.

JPEG
This is the same image compressed at the highest-quality level in JPEG format. At this size the two images are indistinguishable.

Measuring Exposure

The ability to review your images instantly using the camera's rear LCD screen has meant that getting accurate exposure has never been so easy.

Even if you insist on using Manual rather than Auto exposure, it is still quicker to guess the settings, shoot, and check the result than to work them out carefully.

If this sounds less than conscientious, remember that another set of skills is required—judging good exposure by means of the histogram and clipped highlight warning. As with film SLRs, most cameras offer a choice of matrix/multi-pattern metering, center-weighted, and spot readings. Each has its use, but again, it is the result on the LCD display that really demands your attention.

The metering principles are largely the same as for film cameras, with the possibilities of extra precision because each pixel can be measured. There are three principal metering systems used in DSLRs, and different modes that allow you to prioritize shutter speed or aperture and create custom combinations of both. Exposure compensation and exposure bracketing (in which bursts of consecutive frames are exposed at changing increments over and under the metered reading) are standard. Advanced measurement in high-end cameras takes account not just of brightness, but also color, contrast, and the area focused on, all in an effort to second-guess which parts of the scene you are likely to want accurately exposed.

Although instant review means that you can retake the shot if you're not happy with the exposure, there may be times when you don't have a second chance, so getting it right first time is always an important consideration.

Spot

The spot metering mode in most DSLRs allows you to make readings from a very small central area—often little more than 2% of the image area. This is the in-camera equivalent of a spot meter, in which you can measure very small parts of the scene. This is especially useful if you want to base the exposure on a particular precise tone.

For this scene, taking a spot reading from the brick building prevents the shaded foreground or bright sky from influencing the overall exposure.

Center-weighted

Center-weighted metering gives priority to the central area of the frame, on the reasonable assumption that most images are composed that way. Less attention is paid to the corners and edges. The precise pattern of weighting varies with the make of camera, and some models allow you to choose different weightings.

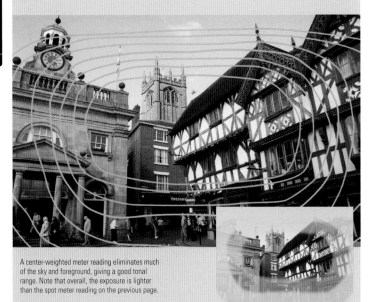

A center-weighted meter reading eliminates much of the sky and foreground, giving a good tonal range. Note that overall, the exposure is lighter than the spot meter reading on the previous page.

Center-circle metering

The center-circle metering mode can be seen as a more concentrated variant of center-weighted metering, using a defined circle in the center of the frame. This is a great solution to shots where the subject takes up much of the frame, though you might find it more appropriate to use spot metering when composing a different kind of image. If you were placing a figure according to the rule of thirds, for example, this would be less than ideal.

Here the subject takes up much of the center of the image, so a larger circle than spot metering is appropriate.

Matrix or Evaluative metering

The matrix, segment or evaluative metering mode found in DSLRs is a highly sophisticated metering system that has two components. One is the division of the frame into segments, which are each individually measured. The second is a database of many thousands of picture-taking situations based on either actual shot images or (less accurate), theoretically derived scenes. The pattern of exposure readings is compared with those in the database and the appropriate algorithm is applied. At its simplest, if there is a much brighter strip across the top of a horizontal frame, this will be assumed to be the sky and the exposure will be weighted more to the darker area below. Equally, a compact dark area close to the center of an otherwise light scene will be assumed to be the important subject, and the exposure will be adjusted for that.

The matrix records an average from areas of the image. Here the dark areas in the top of the image and light ones in the foreground are clearly shown in the matrix.

Controlling Dynamic Range

Compared to film, digital sensors are much more sensitive to light. This sensitivity can lead to problems when there is a wide tonal variation in the scene—in these contrasting instances it's often difficult for the sensor to record detail in the highlight areas.

The larger the photodiode, the greater the sensitivity and the wider the dynamic range, but this is in conflict with the need for smaller photosites on the sensor to increase the resolution. The photodiode must fit within the total photosite area, and still leave sufficient room for other components. Moreover, typical photodiodes still reach saturation (that is, a full tonal range) faster than is ideal.

Blocked highlights

In highlight areas, digital sensors tend to compare unfavorably with film because

Dynamic range: film vs. sensor

The shape of the red curve shown here, gives us a visual clue as to why film appears to have a greater dynamic range when compared with a sensor. The curve plots the brightness of the image (on a vertical scale) against the brightness of the light striking it (on a horizontal scale). With both film and sensors, most of the middle tones in a scene fall on a straight line—not surprisingly called the "straight-line section"—meaning that the image brightness marches in step with the subject brightness. At either end, however, film reacts in a special way. It falls off in a gentle curve in the shadows (lower left) and highlights (upper right). For example, in the highlights, twice the exposure results in less

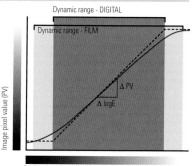

than twice the brightness, which is very useful, because it tends to hold highlight detail. The same applies to shadow detail. Sensors, however, inherently lack this smoothing out of the curve.

In a normal photograph of a normal scene, the shadows are at the lower left (the "toe") and the highlights at the upper right (the "shoulder"), with most of the tones in the middle, the "straight-line portion" of the curve. Significantly, this means that with film, highlights do not easily blow out—increasing exposure has less and less effect on the density. In other words, with increasing exposure to light, film response starts slowly (shadows) and finishes slowly (highlights). Photodiodes on a sensor, however, lack this cushioning effect. They reach saturation steadily, at which point there is no highlight detail whatsoever. In other words, film tends to be more forgiving of under- and overexposure, particularly the latter.

of their linear response. The typical film response to exposure shades off at both ends of the scale, hence the familiar S-shape of the characteristic curve.

Practically, this means that film has some latitude in the highlights and the shadows as its response is not linear. Digital sensors, however, have a linear, straight-line response, and this results in easily blocked highlights. Anyone familiar with film is used to there

being some hint of detail in most highlights, but this is not so when using digital. Once the charge in the photodiode "well" is filled up, the highlights are blocked, and it is as if you have a hole in the image—or "triple 255" when measured in RGB.

Histograms and dynamic range

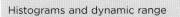

This image is overexposed, which has led to clipped highlights. The histogram reveals these in the form of a tall spike spilling out of the range at the far right—too much of the image, in other words, is white.

In this alternative exposure, the histogram shows the highlights now fall within the range of the histogram, so there are no areas in the image in which detail has been clipped.

Real World Dynamic Range

Despite often receiving requests from the photographic press and other reviewers, camera manufacturers rarely release dynamic range figures, primarily because it's very hard to create any really meaningful measuring test as there are so many factors that come into play.

One way to appreciate this is to make your own dynamic range test, as shown here. Typically, there are just-measurable, but visually insignificant differences at the shadow end of the scale.

When shooting, pay particular attention to the histogram display and to any available warning displays for clipped highlights. As long as the histogram fits comfortably within its left-to-right scale, you will have an average-to-low contrast image that can always be tweaked later. The danger lies in a histogram that spills over left or right, or both.

A dynamic range test

Begin the test by photographing a gray card or any neutral blank surface at a range of exposures, under consistent lighting. First, establish the mid-point by shooting at an average setting, either manually or automatically. Then take subsequent frames at equal intervals darker and lighter, in at least six steps in each direction, under- and overexposed. For greater accuracy, make these steps at one-half or one-third f-stop intervals, although for simplicity, the example here is at one-stop intervals. In Photoshop, assemble the images in order, and label each of the steps as shown. Use the cursor and info display to measure the values. Find and mark the step on the left-hand side that measures 5 (anything less is effectively black). Find and mark the step on the right-hand side that measures 250 (anything higher is white). These two extremes define the dynamic range. In this example, a Nikon DSLR captures nine distinct steps—that is, a range of 8 stops or 256:1. The test, however, reveals some other important characteristics. One is that the mid-point of this range is not the average exposure, but instead almost one stop underexposed. Not only this, but the increases in exposure reach saturation (255) more quickly than the decreases reach pure black. This confirms what we already expect in terms of a sensor's linear response. Note, though, that the response at the shadowy, underexposed end of the scale, is not exactly linear, but tails off more gently, as does that of film. All of this suggests that for this particular camera, it will be safer to underexpose in contrasty conditions while shooting in Raw format.

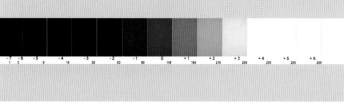

Checking channels

Clipping warnings may come into effect when just one or two channels have become saturated, and this is not a disaster. Thanks to interpolation, even blown highlights in a fully saturated photosite can be given a value of some use by the on-board processor. This is because each photosite measures one of three colors, and interpolation is used to assign full-color values to it. Some DSLRs display individual channel histograms, with white (the sum of all three) superimposed. The danger is when all three channels are clipped. Here, red is saturated, but green and blue are still within the frame.

RGB

Red

Green

Blue

Highlight warnings

Two valuable in-camera displays of overexposed areas are the histogram and a highlight indicator. When the right-hand (bright values) edge of the histogram appears like this, at least some of the tones are solid white. A more insistent warning available on some cameras displays the highlights with a flashing border. However, you should always check these in-camera clipping warnings against the values that appear when you have opened the image in Photoshop. Typically, camera manufacturers err on the side of caution, and the clipped highlights displayed in the camera's LCD are likely to be at a value less than 255. In other words, even with some parts of the image apparently clipped, there may actually be sufficient information to recover and edit.

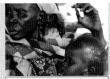

An on-camera histogram display can reveal clipped highlights.

Alternatively, there might be a flashing warning that is similar to this.

Dynamic range comparisons

These are slightly dangerous comparisons to make, not least because the brightness range of a real-life scene is not quite the same thing as the response of sensor and film. Film, as we've already seen, has a soft shoulder and toe to its characteristic curve, meaning that there is not the same sharp cut-off point for recording details in shadows and highlights as with a digital sensor.

Scene/device/medium	ratio	exponent	f-stops	density
Typical high-contrast sunlit scene	2,500:1	211	11+	not applicable
Typical sunlight-to-shadow range for a gray card	8:1	23	3	not applicable
Human eye normal full working range	30,000:1	215	15	not applicable
Human eye range when fixed on one part of scene	100:1	26-27	6+	not applicable
B/W negative film	2,048:1	211	11+	3.4D
Color transparency film	64:1 – 128:1	26 – 28	6 – 8	3.2D – 3.6D
Kodachrome transparency film	64:1	26	6	3.7D
Color negative film	128:1	28+	8+	2.8D
Typical DSLR at base sensitivity	512:1	29	9	2.7D
Typical DSLR at high sensitivity (ISO 1000)	128:1	27	7	2.1D
Typical digital compact at base sensitivity	256:1	28	8	2.4D
Typical CRT monitor	200:1			
Active matrix monitor	350:1	28+	8+	
Glossy paper	128:1 – 256:1	27 – 28	7 – 8	2.1 – 2.4D
Matte paper	32:1	25	5	1.5D

Note:
1. Range in stops is the number of intervals; thus, if 9 stops are captured, the range is 8.
2. Dynamic range reduces at higher sensitivity (ISO) settings, as it does with faster films.
3. Density is used principally for film and film scanners, and is included here for comparison.
 The optical density of film is the difference between the densest part (D-Max) and the most transparent part (D-Min). The formula is log10: thus a density of 2 = 102 or 100:1.
4. The density of film tends to be greater than the usable, recordable dynamic range, particularly with Kodachrome.
5. Dynamic range for monitor displays is normally expressed as contrast ratio.

Coping with Contrast

The optimum exposure for most images is when there is an even spread of tones, from dark shadows to bright highlights—or in other words, a fully expanded histogram.

Low contrast presents no difficulties at all, other than perhaps judgment, as it is a simple matter to drag the white and black points out to the edges. High-contrast images, on the other hand, are always in danger of being clipped, and image-editing tools need some image data to work with. This means getting

the exposure right—not necessarily the same thing as getting it averaged.

High-contrast scenes always need special care, even more so than with transparency film. As we saw on the previous pages, the response of a sensor to light is linear. Crudely put, it fills up to absolute white more readily than film, and this means being constantly on guard against clipped highlights. In digital imaging, these are usually more critical than clipped shadows, for two reasons: one is that even a very little light generates some

Assessing contrast

The importance of dynamic range and contrast depends on the form of the image. The tonal range of the entire image may be different from the range within a small part that you consider important. In the case of the modern office interior here, there are two different interpretations. On the one hand, you might want to retain shadow detail in the large outer part of the image, in which case you would consider the overall contrast. On the other hand, you could legitimately ignore the dark surround and expose just for the brightly lit, glassy corridor in the center. The tonal range within is one stop less than the entire image.

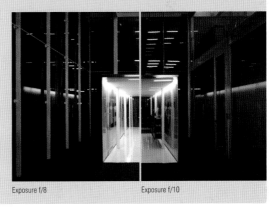

Exposure f/8 Exposure f/10

response at the darker end of the range, the other is that perceptually most of what catches our attention is in the brighter areas.

Reducing contrast

If you are shooting JPEG, contrast and exposure are the only in-camera controls that will help you to reduce contrast. Lowering the contrast setting is sensible. It is safer to underexpose the bulk of the image to preserve highlights, and then lighten the shadow areas during image-editing. Bracket exposures if you have time, both for safety and in order to be able to combine exposures. Adding fill-in lighting, even if this is just from the camera's built-in flash, will also reduce contrast by raising the values of the shadows.

Knowing in advance that you can optimize the image on the computer, one of the safest precautions is to avoid clipped highlights, even at the expense of an overall darker image. In conditions that you know to be contrasty, pay most attention to the clipped highlight warning on the LCD display. If the situation allows you time, make a test exposure to check this first and then switch to the histogram to make sure that nothing has been clipped at the shadow end. If the entire histogram is within the scale, even if the bulk of it is shifted toward the shadows, then you can usually optimize it satisfactorily, particularly if the image is in a high bit-depth.

For more extreme situations, in which no exposure setting will avoid clipping at one end or the other, there is an image-editing solution. It needs a static scene and a locked-down camera—on a tripod, ideally. Shoot three or more frames, adjusting the exposure each time to ensure that both highlights and shadows are captured accurately by at least one frame. Combine the images during post-production to create a high-dynamic range (HDR) image style.

Raw format

In difficult, contrasty lighting conditions, by far the best course of action is to shoot Raw. This makes the contrast settings irrelevant as they can be revisited later, and also allows higher color bit-depth, which in turn makes it easier to make strong adjustments without seriously damaging the image. Typically, you can expect to be able to adjust the original exposure by up to two stops darker and four stops lighter, while at the same time changing the contrast. However, Raw format will not help completely lost highlights. Once photodiodes have reached saturation, no amount of processing can recover the data. The image-editing technique of combining two exposures, one dark and one light, also works to an extent in Raw format with a single exposure. First open the Raw file and alter the settings to maintain highlights, even at the expense of losing shadow detail. Save this version, then open the same Raw image a second time, adjusting the settings to preserve shadow detail. Then, finally, combine the two versions.

What's the "right" exposure?

The first image below appears at first glance to be better exposed than the lower image, because the histogram shows an even spread of tones. However, some of the highlights are clipped, and these will be unrecoverable in image-editing. The exposure for the lower image (one f-stop less) produces an image that looks darker, but the shadows aren't noticeably more clipped, and the highlights are also better controlled.

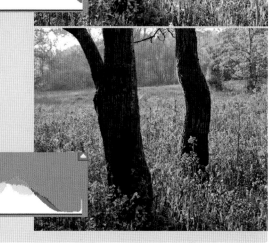

Lenses

The unparalleled flexibility of a DSLR is down to the fact that you can use interchangeable lenses of varying focal lengths, from fish-eye to super-telephoto.

The good news is that if you have a large collection of existing lenses for your film SLR, it's more than likely that you can use them on the same brand of DSLR, even though some new camera features will be unavailable with older models of lens. This is all straightforward, except for issues related to the smaller size of sensors and, at a deeper level of performance, the pixel size.

As it stands, there are broadly two sizes of sensors commonly used in DSLRs: APS-C/DX sensors that are smaller than 35mm film and "full-frame" sensors that are the same size as 35mm film and used in professional DSLRs.

The small size of the APS-C/DX sensors affects a whole raft of image properties, including some of the standards that photographers are used to, such as using focal length as a way of describing the angle of view. 24mm, for example, was a kind of shorthand for the dynamics of one type of wide-angle image, but as a smaller sensor covers less of the image projected onto it than would a full 24 × 36mm frame, the picture angle is less.

Practically, this means that a standard 50mm "wide angle" lens mounted on a digital camera with a sensor area of 23 × 15mm (APS-C) behaves like a lens of around 78mm focal length on a full-frame, or 35mm camera. Similarly, wide-angle lenses have less of a wide-angle effect, while telephotos appear to be more powerful.

Wide-angle implications

Because an APS-C/DX-sized sensor is around ⅔ the size of 35mm film, your old lenses lose ⅓ of their covering power. On the positive side, this means that telephoto lenses have that much greater magnifying power when fitted to a DSLR, but you lose out at the wide-angle end of the scale. This limitation has forced manufacturers to introduce new, wider lenses. If dedicated to digital cameras, these can be very wide indeed. A 12mm lens, for example, is the equivalent of an 18mm lens on 35mm film or a full-frame sensor.

Multi-megapixel sensors are making new demands on lenses, with the result that camera manufacturers are now designing lenses optimized for digital. Not only are high-density sensors less tolerant of poor resolution lenses, but the resolution needs to be smaller than the active area of the photosite. Using an old, film-optimized set of lenses on a new digital body may sound like a good, economical idea, but the trade-off is likely to be lower image resolution than you could be getting. The other problem is called "cornershading." Light from a normal camera lens diverges to cover the film or sensor, striking the edges at an angle—and with a wide-angle lens, this angle is more acute. This hardly mattered with film, but as the wells on the sensor are all parallel, light rays striking the furthest photosites—at the corners—may not fully penetrate, causing shading. This again suggests a change in lens design—one solution is a rear element combination that refracts the diverging light rays back to being more nearly parallel (a "telecentric" lens design).

"Digital" lenses

For some time, lens manufacturers have been producing lenses specifically for APS-C/DX cameras. Features can include the following: no mechanical aperture ring, apochromatic (high color correction) glass, very short focal lengths for wide-angles, and a small image circle that covers no more than the sensor. This last feature enables lenses designed specifically for smaller sensor sizes to be smaller, lighter, and have larger zoom ratios.

Nikon 12–24mm zoom lens

EFL

Since the advent of 35mm cameras, lenses have been described as having focal lengths such as 20mm, 50mm, and 180mm. These labels are so embedded in the working language of photography that they will continue to be used for a long time. Indeed, for full-frame DSLRs, they remain perfectly valid, but the variety of smaller sensor sizes leaves us without a convenient way of describing a lens's main characteristics—its angle of view and magnification. One solution is "equivalent focal length" (efl), which is what the lens would be if the image it delivered were on a 35mm frame. Efl is found by dividing the diagonal of a 35mm film frame (43.3mm) by the diagonal of the camera's sensor, then multiply the lens focal length by this. These are the equivalent focal lengths for typical sensor sizes:

Actual focal length	efl 23 x 15mm sensor	efl 24 x 16mm sensor
12mm	18.9mm	18mm
17mm	26.8mm	25.6mm
20mm	31.5mm	30.2mm
28mm	44.1mm	42.2mm
35mm	55.2mm	52.8mm
50mm	78.8mm	75.4mm
100mm	157.6mm	150.8mm
200mm	315.2mm	301.7mm
300mm	472.8mm	452.5mm

A series of focal lengths, from 20mm at the widest end to 300mm at the longest. (The intervals are 28mm efl, 35mm efl, 50mm efl, 100mm efl, and 200mm efl.)

Bokeh

A key aspect of controlling depth of field often involves deliberately throwing certain parts of the image out of focus. The overall appearance of the out-of-focus parts of an image, judged esthetically, varies according to the aperture diaphragm and the amount of spherical aberration correction, among other design features. It comes into play chiefly with telephoto lenses used at wide apertures, and it particularly concerns portrait photographers.

This has become fashionably and unnecessarily known in the West by the word "bokeh" (pronounced bok-e, with a short, flat e), which in this context means simply "out-of-focus." A major influence is the shape of the aperture, which tends to be replicated in specular highlights—polygonal in most cases, while a mirror lens produces rings. The more blades to the aperture, the more spherical these soft highlights become. The optics also have a subtle effect.

Depth of field is also affected (it is increased), and this has various consequences all the way back to sharpness. Sharpness is not a precise definition, but depends partly on resolution and partly on perception. High contrast, for example, increases apparent sharpness. As the image is magnified more, depth of field increases. This is generally good to have, but a problem when you need the extremes of selective focus, as in some styles of food photography, for instance.

There is a lower "quantum" limit on sharpness set by the size of the individual pixels on a sensor. A 24 x 16mm sensor that images 3,000 × 2,000 pixels, for example, has photosites measuring 0.008mm (8μm). As semiconductor technology reduces this size further, it increases the demands on lenses. Most high-quality lenses optimized for film can resolve to about 10 microns, while the pixel pitch on new multi-megapixel sensors can be as low as 5 microns. One important effect is that color fringes caused by chromatic aberration must be smaller than the size of a pixel. Old lenses often fail in this, while a further issue is cornershading, although this can be corrected.

This close-up portrait was shot using a 135mm lens with a wide aperture. The round shape of the out-of-focus elements in the background—the bokeh—are caused by the shape of the aperture blades in the lens.

Top: A grad filter
Above: A polarizing filter

Do filters have a place in digital photography?

Now that certain image corrections, such as white balance and hue correction, are taken care of digitally, there is no longer any need for light-balancing and color correction filters. Three front-of-lens filters do, however, remain valuable:

Ultraviolet filter

Reduces haze effects by cutting some of the short wavelengths. Also valuable for physically protecting the front lens element from scratching.

Neutral grads

These filters can be raised or lowered in their holder and rotated. With a landscape, align the transition zone of the filter with the horizon. Although skies can be darkened later during image editing, a grad filter at the time of shooting preserves more tonal data when positioned so that it covers the brighter part of the frame. Neutral grads are available in different strengths—for example, ND 0.3 darkens by 1 f-stop and ND 0.6 by 2 f-stops.

Polarizing filter (circular)

Cuts polarized light, so is particularly useful for darkening blue skies (most strongly at right angles to the sun) and reducing reflections from glass, water, and other non-metallic surfaces. Also has a strong haze-cutting effect. Polarization cannot be replicated by software.

The left side of this image shows the effect of polarization. Note how dark the sky is (making the clouds appear whiter) compared to the paler, non-polarized right side of the image.

Cutting down lens flare

In very bright conditions, light can enter the lens and reflect around the lens elements, rather than being directed to the sensor. Known as flare, this light can appear as a line of bright polygons stretching away from the bright light source (such as the sun) or as an overall light fog. Flare control means shielding the lens from any bright light outside the picture frame, and the ideal solution is to mask down the view in front of the lens to the edges of the image. Fitted lens hoods do a fairly good job, particularly if they are shaped to suit the image area, but they have the disadvantage of being close to the lens and on a zoom lens they can only mask accurately at the widest angle.

A professional adjustable lens shade is better, though slower to use, and typically features an extendable bellows and/or movable masks. This is particularly good for the special case in studio photography in which the subject is against a large bright background. The bright surface that surrounds the picture area creates a kind of flare that is not immediately obvious, but which degrades the image nevertheless. Finally, to shield against point sources of light, whether the sun or studio spots, the most precise shading is at a distance from the lens, using a black card or flag, or even your own hand held just out of frame.

- Use a lens shade—either a fitted shade designed for the particular lens, or a bellows shade that can mask right down to the image area. Many telephoto lenses have built-in shades that slide forward.
- Check the shadow on the lens. If the camera is on a tripod, stand in front and hold a card so that its shadow just covers the front of the lens.
- Keep the lens clean. A film of grease or dust makes flare worse.
- Remove any filter. Filters, however good, add another layer of glass that increases the risk of flare.
- Use a properly coated lens. High-quality, multi-coated lenses give less flare than cheaper ones.

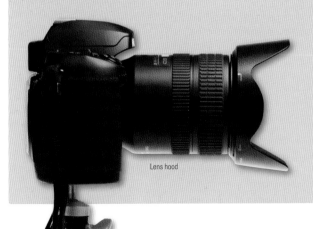

Lens hood

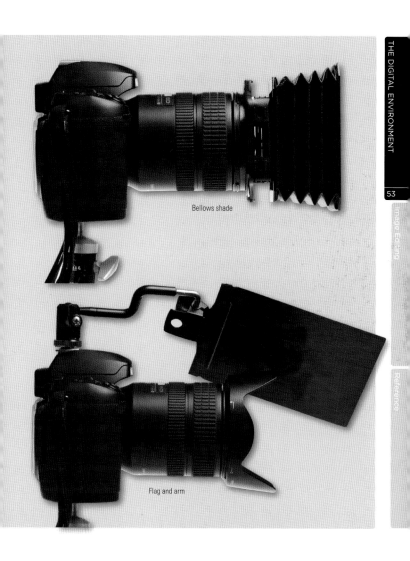

Bellows shade

Flag and arm

Standard vs. wide-angle lenses

There is a standard focal length; broadly speaking it is the length
that provides a view that corresponds with what we see with our
eyes—neither wide nor compressed, but in reality, it is imprecise.
The usual rule of thumb is that the standard focal length is equal to
the diagonal of the film frame or sensor. For a 35mm frame that
would be 43mm, but by convention 50mm has become "normal"
with 35mm film. The de-restriction of format with digital cameras
and replacement of prime lenses with zooms erodes this 50mm
"benchmark." This is, in any case, a perceptual issue, and a
realistic guide is the focal length at which the view through the
viewfinder and the view with your other, unaided eye are the same.

Olympus 11–22mm
wide-angle zoom lens

50mm efl

Below: 20mm efl

A 20mm efl lens (in this case, 13mm on a Nikon digital camera with a sensor size smaller than 35mm film) has a diagonal angle of view of just over 90°. The vertical crop inside this frame is the 45° coverage of a 50mm efl standard focal length.

Macro and Close-up Lenses

By its very nature, macro photography (and to a lesser degree close-up photography) has always caused challenges for lens manufacturers, and this is no different for digital cameras.

What has changed is the ease and precision of shooting at close distances, because the uncertainties introduced by the various optical calculations disappear with the instant feedback from a DSLR.

DSLRs are ideal for macro shooting, because the on-board processing of the image can deal with the problems of contrast, color, and even sharpness. Also, by shooting direct to a computer, you can use the larger monitor to check detail and tolerances. Moreover, with DSLRs that use a

sensor smaller than 35mm film, only the center of the lens is used for imaging, and this is relatively free of many aberrations, including spherical aberration, which is worse at close distances.

The two most usual measurements in close-up imaging are magnification and reproduction ratio, and they are linked. The commonly accepted starting point for

MACRO DEMANDS

Macro photography makes specific demands on lenses. Spherical aberration, for example, is more prominent. This is caused by the increasing angle of curvature toward the edges of the lens, which alters the focus slightly. Stopping down the lens helps to reduce it because the smaller aperture allows only the center of the lens to be used.

Conjugates

The lens focuses each point on the subject to an equally sharp point on the sensor (which is on the image plane). In photography at normal distances, the object conjugate is much longer than the image conjugate, which changes very little as you focus. But when the subject is close, the two conjugates become more similar in length.

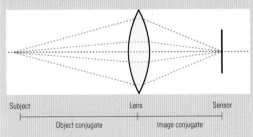

Subject	Lens	Sensor

Object conjugate | Image conjugate

close-up photography is between 0.1× magnification (1:10 reproduction ratio, meaning the image is one-tenth life-size) and 0.15× magnification (1:7). At 1.0×, the image is life-size (1:1). Across this range, as the lens racks forward in its barrel, the light-reaching the sensor falls off increasingly, but autoexposure takes care of this. Photomacrography, commonly known as macro, extends from 1.0× to 20× (a 1:1 reproduction ratio to about 20:1), at which point the laws of optics make it more sensible to use a microscope. (Macrophotography, incidentally, means something else entirely—photography on a large scale.) Photomicrography means photography using a microscope, for which there are a number of off-the-shelf systems for attaching a DSLR camera.

The most efficient method of magnifying an image is to extend the lens forward, away from the sensor, the way that most lenses are focused for normal photography. However, for close focusing, the lens elements need to move much further than normal, because of the relationship between the two conjugates (the distances from the principal point of the lens to the subject on one side and to the sensor on the other). When the subject is more than about ten times the focal length distant, the image conjugate stays more or less the same. Closer than this, however, and the image conjugate gets significantly larger. When the two conjugates are equal, you have 1:1 magnification and a life-size image.

This makes lens manufacture a little tricky because most lenses perform best when subjects are distant, but not so well when they are close. Aside from the mechanics of moving the glass elements inside the lens barrel, the sharpness suffers and aberrations get worse. A true macro lens is the ideal solution.

Close-up and macro lenses and accessories

Close-focusing lenses
Modern lens design makes it possible for standard lenses to focus down to close distances. The quality of the image at close focus, however, varies from make to make, and is likely to be compromised—at least in comparison to a true macro lens. The performance of a standard lens can be disappointing.

Macro lenses
These are designed to deliver their best image quality at close distances, and acceptable quality at normal distances up to infinity. Some manufacturers offer a choice of focal length between normal and long-focus; the advantage of the longer macro lenses is that you can use them at a greater working distance from the subject, which is useful, for example, with insects that might otherwise be frightened off by a close approach.

Extension rings and tubes
A standard method of increasing magnification is to increase the distance between the lens and the sensor, and the simplest way of doing this with an SLR is to fit a ring or tube between the lens and the camera body. The focal length of a lens is the distance between the sensor and the lens when it is focused at infinity. Increasing this distance by half gives a reproduction ratio of 1:2. Doubling the distance gives 1:1, and so on. Some, but not all, extension rings and tubes have linkages that connect the aperture and other lens functions to the camera.

Extension bellows
Flexible bellows moved by rack-and-pinion offer fine control over magnification, and are normally used for extreme close-ups. Because magnification is relative to the lens focal length, the shorter the lens attached, the more powerful the effect.

Above: Extension rings
Below: Extension bellows

MACRO LENS

Nikon's AF-S Micro Nikkor 105mm lens is a true macro lens—Nikon use the term "micro" to mean macro. It's a true macro lens in the sense that it can capture images at a 1:1 ratio (life size).

Back to front lens

Most camera lenses are designed to perform well when the image conjugate is smaller than the object conjugate. At magnifications greater than $1\times$ (1:1) this is no longer true, and the image is better when the lens is reversed. For optical reasons, this only works well with lenses of a symmetrical design and with certain retrofocus lenses. Once reversed, the lens must then be stopped down manually.

DIFFRACTION

Another optical issue that is more relevant to macro than normal photography, is diffraction. This occurs when an opaque edge obstructs the light path, causing it to bend slightly and spread. This is what the aperture blades in the diaphragm inside a lens do, and the result is unsharpness.

Stitching Images

Digital photography has made stitching together overlapping frames—to make a significantly larger image—a relatively straightforward technique.

The technique's most common use is to create panoramas, but there are other applications. Although this is strictly speaking a software matter, it is highly relevant to lens focal length and coverage, because in effect you are creating a wider-angle view.

Also, with this kind of imaging, even though it makes heavy use of software, all of the planning needs to be done at the time of shooting—photography and stitching are separate operations. This is known as planar stitching, and the result is a normal digital image, saved usually as a TIFF or JPEG. A quite different, but very important alternative is cylindrical or spherical images, which are usually saved as QuickTime movies.

In principle, you could combine the overlapping images manually in Photoshop, but there are two obstacles. One is that as you turn the camera to one side for the adjacent frame, objects in the frame change their shape slightly—noticeably so with a wide-angle lens—so that each frame later needs a distortion adjustment. The other is that it is difficult to blend the brightness of adjacent frames when there are large, smooth areas such as a sky—again, particularly with wide-angle lenses. Stitcher software does this automatically, in two steps. The software first finds a number of corresponding points in adjacent images and warps the images so that they fit perfectly, to within one pixel. It then equalizes the images so that there is a seamless blend of brightness at the edges.

Tiling for higher resolution

Shooting a sequence horizontally creates a panorama, with the added advantage of making a larger image file than normal. This is, indeed, the easiest solution to creating a high-quality large image file—take any scene that you have just photographed, switch to a longer focal length, and photograph it again in sections, before assembling these into a higher-resolution version. This is known as tiling. It can also fulfill another objective, which is to increase the FOV (field of view). Smaller sensors make wide-angle lenses less effective, but you can increase the coverage by tiling.

Panorama heads

Numerous QuickTime tripod heads are available, designed to assist in taking images at the exact angles required to build up a QuickTime VR scene. These are essentially 360° panoramas, which in some cases also allow the viewer to look up and down (hence the second adjustment on the Manfrotto head). In order to create panoramas, each shot should be taken from exactly the same spot. QuickTime VR technology includes specialized stitching software.

ReallyRightStuff

Manfrotto QTVR head

Kaidan QuickPan III rotator base

A panorama sequence

Step 1 Decide on the area of the scene you want to cover, and the lens focal length you will use. Longer focal lengths need more frames to complete the same coverage as a wide-angle focal length: this gives a bigger final image file (good for a high-resolution image, but it takes up more space on the memory card and hard drive, and is more demanding of the processing and less angular distortion.

Step 2 Mount the camera on the tripod and level the head. Use a QuickTime head, or equivalent, mounting the camera so that the nodal point of the lens is exactly over the axis of rotation. If the scene is distant and you

are using a telephoto, take care to line up frames. Shooting with the camera frame vertical gives a deeper panorama.

Step 3 Make a dry run. In the simplest case, pick a short panorama, loosen the tripod's pan head, start at the left (or right), and check the number of frames that you will need, panning to one side, allowing for an overlap of about 30% (between 15% and 40%). Judge the rotation between frames either by using the scale on the pan head (if there is one), or by eye through the viewfinder. If you have a grid focusing screen, use one of the vertical lines as a guide. Find a detail in the

scene that is either centered or on the leading edge of the frame, and pan the camera so that it appears on this grid line (see below).

Step 4 Select fixed settings for the exposure and white balance. Check these out for sample frames across the sequence, paying particular attention to the highlight clipping and histogram. You may have to sacrifice some highlight or shadow detail.

Step 5 Check for movement within the scene, such as a passer-by, objects moving in a breeze, or changing light, and try to shoot when there is none. Shoot the sequence.

Step 6 Check that you have all the frames. Missing a frame in a sequence is easy when you are tiling rather than doing a simple side-to-side panorama.

Three images, shown here in red, blue, and green, were used to create this panorama of Prague.

Creating HDR Images

High dynamic range imaging, or HDRI, is a relatively new way of capturing the entire range of tones in a high-contrast scene, from shadows to highlights, which is beyond the ability of a normal sensor to capture with one shot.

For instance, a typically bright, sunlit scene containing highlights and shadows has a dynamic range in the order of 2,500:1, and while the human eye can accommodate this (though it does it by scanning the scene rapidly and building up a cumulative image), a digital sensor cannot completely manage it. This is because, while a typical 12-bit sensor shooting Raw theoretically has a dynamic range of 4,000:1, its practical range is closer to 1,000:1, mainly because of noise. If the sun appears in the shot, the dynamic range will shoot up to something in the order of 50,000:1. Another typical high dynamic range scene is an interior with a view to a sunlit exterior—a situation where the dynamic range can reach 100,000:1.

If the camera remains steady, a sequence of frames at different exposures can capture all the detail. The software exists to combine such a sequence into a single HDR file format. There are several HDR formats, but typically they are 32 bits per channel, and instead of this extra bit depth being pre-assigned to a range of values, as happens with 8-bit and 16-bit images, it is used in quite a different

HDR PROCESSING
When processing an HDR image, it's possible to use setting values that create an artificial-looking result.

way. The bits are assigned to decimal points, so that any real-world tonal value can be given a precise digital value, and for that reason, this is known as floating point coding. A number of commercial programs exist for generating an HDR 32-bit floating point image file automatically from a sequence of exposures (normally shot about 2 f-stops apart). They include Photoshop, Photomatix, and easyHDR Pro.

The resulting HDR image contains all the information, but is essentially unviewable due to the limitations of the display media. Most monitors have a bit depth of 8 and can at best handle a dynamic range of about 350:1, while few papers do better than about 100:1. This requires a second step, which is to compress the data in the 32-bit image down to 8 bits per channel.

This is where HDRI becomes tricky, because there is in principle no ideal way to do this. Something has to go, and a satisfactory result depends on the way the tones were distributed in the original scene, on the range of exposures taken in order to create the HDR image, the algorithms and techniques used for compressing, and on top of all this the taste and judgement of the person doing it. The net result is deep unpredictability and many different appearances of output.

The process of assigning the original huge range of values from deep shadow to bright highlight is known as tone-mapping, for obvious reasons, but the methods vary according to the software. Photoshop offers four routes: Exposure and Gamma, Highlight Compression, Equalize Histogram, and Local Adaptation, of which only the last offers a useful "photographic" result. Photomatix, the leading dedicated HDR software, offers the

FULL TONAL RANGE
Created from a sequence of three exposures beginning with 1 second at $f/32$, which reveals all the shadow detail, and ending with a 1/125 second shot, which holds the brightest tones. These merge to reveal detail in both the shadow areas while holding the highlights around the windows.

choice of Tone Compressor (which features the powerful Tone Mapping control) and Details Enhancer. The former is the route for the more "artistic" HDR imagery, while the latter creates more naturalistic results.

Tone mapping an HDR image is unpredictable and often difficult to get exactly as you would like. Nevertheless, HDRI is hugely powerful and can enable photography of a kind that was previously impossible without the help of lighting, and makes high-quality, professional-looking existing-light photography perfectly viable.

Creating an HDR image

Although you can create an HDR image using Photoshop's *Merge to HDR...* command under *File > Automate*, the more popular route is to use Photomatix Pro, a dedicated HDR program. Photomatix Pro is available either as a standalone application or a Photoshop plug-in, providing a greater degree of control and allowing you to be a little more "artistic" with the Tone Mapping settings.

Step 1 To create an HDR image you need to start with a number of exposures of the same scene; three is usually sufficient. What's important is that, between them, the exposures capture the full range of tones in the scene, from the brightest highlights to the darkest shadows.

All DSLRs allow you to bracket exposures, and with the camera set to Continuous shooting, it's easy to capture the various exposures you need.

Alternatively, Photomatix will allow you create "faux" HDR images using just one Raw capture. Although this will not create an HDR image in the strict sense of the term, you'll be able to use the Tone Mapping settings to create HDR-like images.

Step 2 Open Photomatix and click Generate HDR. Navigate to the exposures and click OK.

Generate HDR – Selecting source images

Select image files taken under different exposures.

Either navigate to the files via the "Browse..." button or drag-and-drop the files from the Finder.

```
HDR-2.tif
HDR+2.tif
HDR1.tif
```

Browse
Remove

Cancel OK

Top to bottom: +2EV, 0EV, –2EV

Image Editing

Reference

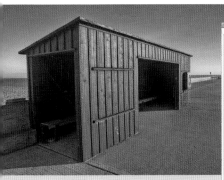

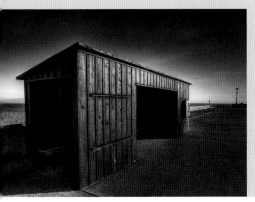

Step 3 Once Photomatix has processed the various exposures, select Tone Mapping; this is when you'll begin to see how your image will look. The most important settings are Light Smoothing and Micro-Smoothing. Experiment with these to determine how naturalistic you want your image to appear.

Step 4 In this final version, Light Smoothing and Micro-Smoothing settings were deliberately chosen to create a painterly effect. The 16-bit HDR image was saved, and further color and tone work was undertaken in Photoshop before the image was sharpened slightly and saved as an 8-bit TIFF.

The Zone System

The Zone System was developed by the famous 20th-century American landscape photographer, Ansel Adams, as a way of obtaining the optimum tonal range in a black-and-white print. The system combines both measurement and judgment—in other words, it amalgamates technology and opinion.

Still highly regarded by some traditional photographers as the meticulous craftsman's approach to considered, unhurried photography, it lost most of its purpose when color took over from black-and-white—particularly transparency film, which allows little to be done with it after exposure. Digital photography, however, returns image control to photographers, and the old Zone System has some valuable lessons to teach in the new context. Of course, it is at its most useful in shooting situations that allow time for reconsideration—landscape and architecture, for example, rather than reportage. However, in digital capture, providing that you are shooting in Raw format, you have the time to reconsider the image later and alter the tonal relationships. This assumes, of course, that in shooting you have not blown out the highlights or lost the shadows.

IDENTIFYING ZONES
This is an example of dividing an image into meaningful zones. Only reasonably sized areas are worth designating, as very small areas are unlikely to influence your exposure choices. However, this is not an exact procedure. In this architectural shot of a portico in quite bright sunlight, there are six obviously separated tonal blocks or zones.

Number of zones

Although Ansel Adams' original scale has ten zones, as shown here, some photographers who follow the system use nine or eleven zones. The argument for ten is that it follows the original description, but Zone V, mid-tone, is not in the center. Using an odd number of zones, Zone V is central and, with 11 zones in particular, the spacing is easy to calculate digitally—an increase of exactly 10% for each step from black to white. On the other hand, the response of many camera sensors is longer at the shadow end of the scale, which argues more for the original ten zones with Zone V off-centered.

NINE ZONES

I	II	III	IV	V	VI	VII	VIII	IX
1	2	3	4	5	6	7	8	9

TEN ZONES

I	II	III	IV	V	VI	VII	VIII	IX	X
1	2	3	4	5	6	7	8	9	10

I	II	III	IV	V	VI	VII	VIII	IX	X	XI
1	2	3	4	5	6	7	8	9	10	11

Visualizing the finished image

In the system, all of the tonal values in a scene are assigned to a simple scale of ten, from solid black to pure white, each one f-stop apart. The key to the process is to identify and place the important tones into the appropriate zones, and this demands what Adams called "pre-visualization." This is forward planning by another name, and means the process of thinking ahead to how you want the final image to appear—on-screen and/or in print.

The great value of the Zone System, still applicable today, is that it classifies and describes the tonal structure of any image in a commonsense way. Different photographers have different ideas about how an image should look tonally, and the Zone System allows for this individuality. As White, Zakia, and Lorenz put it in *The New Zone System Manual*, success depends on "how well the print matches the mental picture, not how well it matches the original scene."

Because the Zone System classifies tones in terms of how they look and what we expect from them, it is not the same as tonal range or dynamic range. Instead, it is a tool for making sure that the image has the tones you want for the parts of it that you consider important. The three most useful values are Zones III, V, and VII. Between them they cover the readable parts of most scenes and images—in other words, the five textured zones.

The most important action in the Zone System is called placement. This happens when, having decided on the critical area of the scene, the photographer assigns it to a zone. As the examples on the following pages illustrate, this can mean choosing an area of shadowed detail and placing it in Zone III, or a more interpretive choice. In all cases, it then involves exposing accordingly—or with Raw format, adjusting the exposure later.

Making a zone ruler

The ruler shown is made in much the same way as the dynamic range test, with the addition of texture. Instead of photographing a blank surface, shoot one with texture, such as cloth, unpolished wood, or smooth stone. Alternatively, choose areas from existing images in your stock library that conform to the descriptions of the zones. Arrange them in a stepped scale and adjust the overall brightness values. There is more information on measuring average values of an area under Exposure measurement.

The zones

Zone I	Solid, maximum black. 0,0,0 in RGB. No detail.
Zone II	Almost black, as in deep shadows. No discernible texture.
Zone III	First hint of texture in a shadow. Mysterious, only just visible.
Zone IV	TEXTURED SHADOW. A key zone in many scenes and images. Texture and detail are clearly seen, such as the folds and weave of a dark fabric.
Zone V	Typical shadow value, as in dark foliage, buildings, landscapes, faces.
Zone VI	MID-TONE. The pivotal value. Average, mid-gray, an 18% gray card. Dark skin, light foliage.
Zone VII	Average Caucasian skin, concrete in overcast light.
Zone VIII	TEXTURED BRIGHTS. Pale skin, light-toned and brightly lit concrete. Yellows, pinks, and other obviously light colors.
Zone IX	The last hint of texture, bright white.
Zone X	Solid white, 255,255,255 in RGB. Acceptable for specular highlights only.

| I | II | III | IV | V |
| 1 | 2 | 3 | 4 | 5 |

| VI | VII | VIII | IX | X |
| 6 | 7 | 8 | 9 | 10 |

Applying the Zone System

The Zone System is just as relevant today as it was in the days before digital capture. The reasons for this are twofold: easy, accurate measurement and the ability to adjust brightness and contrast after the event. Using it in the run-up to shooting, as was originally intended, is even better, but in real-life situations, this may be an unattainable luxury.

To begin with, concentrate on the following three important zones: Zone V (midtones), Zone III (textured shadow), and Zone VII (textured brights). Identify them in the scene and then, if you have the time, measure them with the meter (camera's spot or handheld).

It's important to understand the differences in dynamic range between the camera and the media on which you intend to display the image. Even if a digital camera has a smaller dynamic range than film, it is still far higher than that of any paper. Basically, from the original scene through digital capture to final print, the range becomes smaller.

Placement in practice

In this dramatic architectural image, the detail in the foreground shadow area was felt to be essential to the overall composition, and so was placed in Zone III. It was also important to retain detail in the well-lit areas in the center of the image, though with a degree of choice: if they were to be only just visible, they could be in Zone VIII, but to be definite, they would have to be in Zone VII. Settling for Zone VII put the rest of the image into context. There would need to be a five-stop difference between these two areas to give the overall image suitable contrast, so the foreground area was placed in Zone II and the exposure set accordingly for the final result.

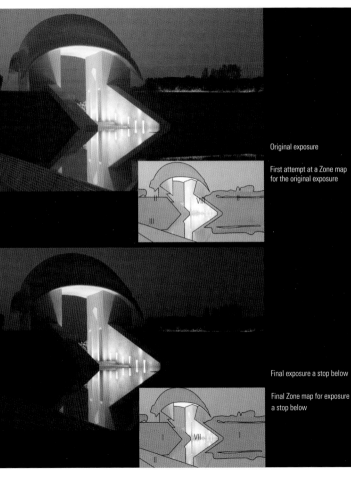

Original exposure

First attempt at a Zone map
for the original exposure

Final exposure a stop below

Final Zone map for exposure
a stop below

High-dynamic range scenes

When confronted with a scene in which the dynamic range exceeds that of the capacity of the camera, the Zone System approach is to identify the important zone and expose for that. Indeed it is a very practical way of thinking through these situations. In practice, there are three possible options:

1 Expose for textured brights (Zone VII), and accept loss of shadow detail.
2 Expose for the midtones (Zone V), and split the loss of texture at both ends: shadow and highlight.
3 Expose for textured shadow (Zone III), and let the brighter tones go to featureless white. Visually this is usually the least acceptable option.

...expose for brights

...expose for midtones

...expose for shadows

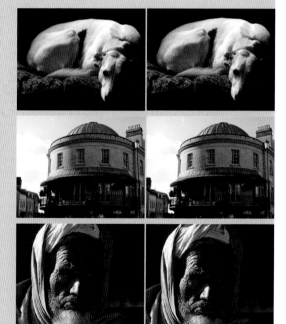

Common Lighting Scenarios

Almost all scenes that you photograph can fit into one of several distinct types of lighting situation. The three main divisions (the three technically most important) are based on contrast, and are Average, Low Contrast, and High Contrast. Of these, the one likely to cause the most problems is High Contrast.

This is particularly so in digital capture, partly because highlights are more easily blown out digitally than with film, and partly because low-contrast images are simple to adjust.

What makes up these lighting situations is a combination of the light (bright sun,

spotlight, overcast, and so on), the subject (its color, brightness, shininess), and how you identify the subject. This last point is critical. What one photographer identifies as important in the frame may well not be the same as that chosen by someone else. "Subject" doesn't necessarily mean "object," but might instead be a patch of light or an area of shadow. Thus, you might have a scene that measures average for exposure, but the key tones are in the bright areas— say, the texture of some prominent clouds in a landscape. There are endless sub-divisions possible, but the more there are, the less useful they become.

Average contrast

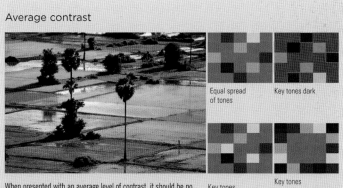

Equal spread of tones

Key tones dark

Key tones bright

Key tones average

When presented with an average level of contrast, it should be no problem to select the correct exposure, bearing in mind all the usual caveats about avoiding blowing highlights as opposed to shadow detail.

High contrast

Where there is a lot of contrast, it is especially important to identify
the subject and key tones, as often something has to give way.
Sacrifice detail in the less important areas of your image.

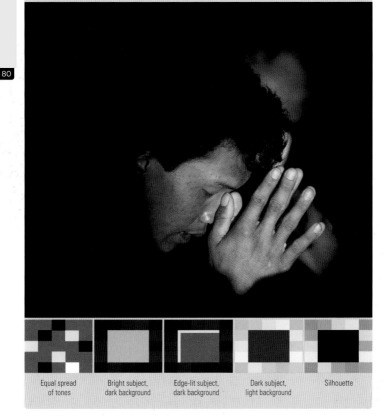

| Equal spread of tones | Bright subject, dark background | Edge-lit subject, dark background | Dark subject, light background | Silhouette |

Low contrast

In situations like this, it is important to decide if contrast should stay low, given how easy it is to increase contrast by setting black and white points.

Average High key

Noise

Numerous comparisons have been made between noise and grain, and in a sense this is understandable because of the relationship between sensitivity/film speed and the amount of noise.

However, the similarities end, as not only are the causes different, but so are the treatments. Indeed, the one good thing about noise in digital photographs is that it can be dealt with. Not perfectly and not easily, but there are various solutions.

In order to treat noise, we have to define it, and this isn't as simple as it might seem. Technically, noise is artifacts or errors introduced into the image by electrostatic charge, and the scientific approach to it revolves around the signal-to-noise ratio. However, this does not take into account the very important perceptual component. After all, at the pixel level, noise and detail are indistinguishable. In other words, it is largely the eye and mind of the viewer that distinguishes between subject detail (wanted) and noise (unwanted). As a parallel, any retoucher who has worked on scanned film images knows that with some subjects, such as an unswept floor or a rocky landscape, it may be impossible to decide what are dust specks and what is texture.

Noise is detail, but unwanted detail. This immediately creates a problem, because the definition of "unwanted" is completely subjective. This has major implications when it comes to treating a noisy image, and it also means that there are two distinct stages in digital photography at which noise can be suppressed. One is at capture, the other during image-editing. Noise is heavily dependent on a number of variables, and so can vary from shot to shot according to the camera settings and the conditions. You can

Variations of noise

Photon noise
This is noise caused by the way in which light falls on the sensor. Because of the random nature of light photons and sensor electrons, it is inevitable with all digital images. It appears as dark, bright, or colored specks, and is most apparent in plain mid-toned areas, least apparent in highlights.

Readout noise (or amp noise, or bias noise)
This is noise caused by the way in which the sensor reacts and the way in which the signal is processed by the camera. Similar to electronic noise in recorded music, this is generated by the processor itself, and the more it is amplified, the more prominent it becomes. Thus, increasing the ISO setting by turning up the amplifier creates more noise. It is to some extent predictable and can be reduced by in-camera processing.

Random noise
Caused by unpredictable but inevitable differences in timing and the behavior of electrical components.

Dark noise (also known as fixed-pattern noise and long-exposure noise)
Noise caused by imperfections specific to each individual sensor. Increases in proportion to the exposure time and to temperature increase, but is independent of the image, so can be reduced by in-camera processing by means of "dark-frame subtraction." This extra process takes as long again as the original exposure. Cooling also helps.

Reset noise
After each shot, the camera resets the sensor to a zero position, ready for the next exposure. Multiple clocks in the processor may cause slight differences in the timing of this, which generates noise.

In-camera noise reduction

Many cameras have a noise reduction option to deal with long exposures. It doubles the processing time, but saves a great deal of work later. This in-camera option tackles the known pattern of noise that occurs with long exposures by subtracting the predictable behavior of the sensor. The principle is to make a second exposure for the same exposure time, but with no image. The pattern of noise will be the same as for the exposed image, and can be subtracted from the noisy image by an appropriate algorithm. You could do this yourself in image editing with a lot of effort, but it is unnecessary if you choose the noise reduction option in the camera's menu—it does the same thing more efficiently.

expect to encounter noise with long exposures, high sensitivity, high temperatures, and in images with large, smooth shadow areas, but it is difficult and time-consuming to check while shooting. As much as possible is controlled by the camera's processor, and this varies according to the make because it depends on the algorithms used and on the processing techniques chosen by manufacturers. Most camera menus offer the choice of noise reduction.

HIGH NOISE

This image exhibits extreme digital noise. The noise is caused by one photosite in the sensor picking up significantly more light than its neighbors. As digital sensor chips are typically arranged in a color filter array, the "rogue" pixels tend toward a single color; red, green, or blue.

The appearance of noise

Certain types of noise have a characteristic appearance,
as you can see from these enlarged examples.

LUMINANCE NOISE:

Appears as variations in
brightness—a basically
monochrome, grainy
pattern.

**CHROMINANCE
NOISE:**

Variations in hue are
prominent.

HOT PIXELS:

"Stuck" pixels appear as bright spots—very noticeable and visually disturbing.

JPEG ARTIFACTING:

Blocks of eight pixels are sometimes distinguishable—a result of the JPEG compression processing.

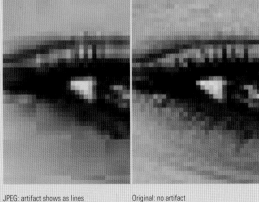

JPEG: artifact shows as lines Original: no artifact

White Balance

Our eyes are so good at adapting to different lighting conditions that generally we perceive white as white. But the color of light varies, and the two most important ways in which this affects photography are color temperature (between reddish and bluish) and the off-color glow of fluorescent and vapor discharge lamps.

To the human eye, white is normal, and any deviation from this appears tinted—not necessarily wrong, but not balanced. Unless you specifically want a color cast for a particular reason (the warm glow of a setting sun on sandstone rocks, for instance), it's normal to strive for lighting that appears white—that is, neutral.

With film cameras, the solution was to use an appropriately balanced film (either daylight or tungsten) and filters. Digital cameras sidestep this by processing the color information according to your choice. With a DSLR you can do this manually, or choose from a number of standard settings, or let the camera find the balance automatically. The manual method (also known as "custom" white balance) involves aiming the camera at a known neutral surface, such as a piece of white paper or a standard gray card. The camera's processor then stores this information and applies it to subsequent images, making it the most accurate method when you are shooting for a period of time in a situation with unchanging light. The simpler alternatives are either to choose one of the standard settings in the white balance menu, or to select Auto and let the camera work it out.

Automatic white balance requires the camera's processor to analyze the scene, identify highlights, and adjust the overall

The color of light

The principle of color temperature is that when a material is heated, it first glows red, then yellow, increasing to white at higher temperatures (hence "white-hot"), and then blue. This applies to any burning light source, including the sun and tungsten lamps, and it gives a way of calculating the color of light by its temperature (measured in degrees Kelvin, which is similar to Celsius/centigrade but starts at absolute zero). For photography, the normal limits between reddish and bluish are from about 2,000K (flames) to 10,000K (deep blue sky). The mired shift values are a standard measure of the numerical differences between temperatures. You will need to refer to these when using certain image-editing software, such as Photoshop's Camera Raw plug-in.

balance, and for most situations is a good choice. Some high-end DSLRs supplement the sensor analysis with separate through the lens (TTL) color meters and incident meters mounted on the camera.

Bracketing white balance

Some DSLRs offer a bracketing option that works in a way similar to exposure bracketing—a burst of several consecutive frames in which the white balance is altered incrementally.

Top to bottom:

In this shot, a custom white balance was set, with a light temperature of 4,500 degrees Kelvin.

In this variant, the camera's automatic white balance mode was used.

This shot was taken with the white balance set to the preset "shade" option.

White balance settings

Although the actual descriptions vary from make to make, most DSLRs offer a similar range of choices to cover commonly encountered lighting conditions as shown in the examples below. The precise values can also be adjusted.

Auto Sunlight Cloud

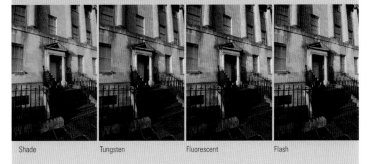

Shade Tungsten Fluorescent Flash

Setting a custom white balance

This varies in practical details according to the make of camera, but what all have in common is the measurement of a reliably neutral target. White paper or card will do, but for greater accuracy consider carrying a standard gray card. This is a typical sequence of steps.

1 Select the White Balance option from the Shooting menu.

2 In the White Balance menu, scroll down to the Custom or Manual option (here it's called Preset).

3 Photograph a neutral target that is large enough or-close enough to fill the target area, in this case a large expanse of white wall.

4 Wait for confirmation that this was successful, or repeat if overexposed, underexposed, or out of compensation range (warning message in display). Confirm the setting by selecting OK.

5 Choose Preset from the White Balance menu to use this setting.

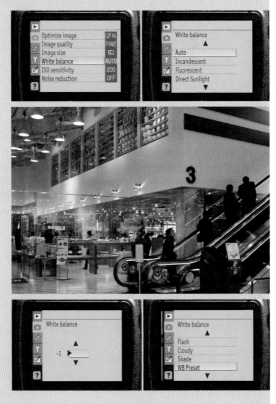

Managing Color

Getting accurate color has always been an issue with photography, and never more so with digital photography. In a way this may seem a little strange, because film photography was just as affected by color temperature and other color differences in lighting.

With digital photography, however, it can be managed, and so must be. There are two sides to color management. One is linking the different ways in which the various devices in the workflow reproduce color, from camera to monitor to printer. The other is staying faithful to the colors of the subject.

First, color-managing the devices. This involves all of the equipment, not just the camera. Ultimately, it depends on a description of how a device reads and renders colors. These descriptions, which can be read by other machines, conform to the standards of the International Color Consortium (ICC), and are known as profiles. Every piece of equipment in the workflow should have one, including the camera.

Basically, the ICC profile rules, but fine-tuning it is the key to absolute accuracy. Normally, a generic profile of the camera is automatically embedded in the image file, and major software applications like Photoshop can read it (with the help of additional updates).

But device performance is not always consistent, and it can drift with time. Keeping the profile up-to-date is the answer. In principle, for a camera this means checking how it copes with a standard color target and altering the ICC profile accordingly. In practice, this involves profile-building software that can compare an image with stored information. You shoot a target such as the GretagMacbeth ColorChecker under known lighting conditions,

HUE ADJUSTMENT
You can adjust the hue from a menu on your camera in much the same way that you can adjust the image later using your image-editing application's **Hue/Saturation** tool.

Selecting color space

Somewhere in the camera's menu is the option to select the color space, which may be called something else, such as color mode. A typical choice is between Adobe RGB and sRGB. For most serious use, select Adobe RGB. This has a wider gamut, which means that the camera will capture more colors from the scene.

Color and the Raw format

Shoot in Raw format and the precise white balance settings do not matter. This is because the Raw format bypasses the processing that normally applies these settings in camera. All the data is kept separate in Raw format, including the white balance settings, which can be adjusted in image-editing.

and the software does the rest. See the following pages for setting up this procedure.

Using a standard target

Calibration is also affected by the subjects and scenes that you photograph—they may differ wildly in the way they are lit, and this is the second aspect of color management. The eye accommodates so well to different color casts that it may not be a great help. Under skylight from a clear blue sky, it reads what you think should be white as white, even though it actually is a definite blue. With film, even though a slide might have had a color cast, at least the image was locked into the physical transparency, and could be identified. With digital, only the photographer is in a position

to say what the colors should be and, if you can't remember, no one else is in a position to say. Setting the white balance to one of the presets, such as Cloudy or Shade, gets you close, as does a visual check of the LCD screen after shooting, but the only way to guarantee the colors is to make a test shot with a standard target—any of the same targets needed for device calibration. If you do this just once for any given lighting situation, you have the means to adjust the colors accurately in image-editing. Depending on the camera, there may also be a separate hue adjustment control, allowing you to shift hues around the spectrum in a way similar to the Hue slider in Photoshop. Typically, the adjustments are measured in degrees.

Color Targets for Consistent Color

If getting color accurate is essential–to match the colors in a company logo, for example–then use a standard color target.

For normal photography, the two most valuable are the Kodak Gray Card and the GretagMacbeth ColorChecker shown here. Their colors are known quantities, and so they can be used to judge and correct your captured colors. At the very least you can use them for visual reference, but the ColorChecker has the more valuable function of helping to create ICC camera profiles. Under highly controlled conditions, such as fixed studio lighting set-ups, some lighting manufacturers recommend using an IT 8.7/2 target, which is normally used for scanning.

GretagMacbeth ColorChecker
Based on the Munsell System (the source of the hue, saturation, brightness model), this 24-patch mosaic of very accurately printed colors is the color chart of choice for photography. Not only is it a known industry standard, but it contains "real-life" colors such as flesh tones and the complex greens of vegetation. Importantly, the colors reflect light the same way in all parts of the visible spectrum, meaning that they are consistent, whatever the lighting, and they are printed matte to avoid reflections that would upset the readings.

The top row contains memory colors that include skin tones, blue sky, and foliage, the second row medium-saturated colors, the third row the three primaries and secondaries, and the bottom row a gray scale from "white" to "black." Note, however, that the dynamic range of matte printed colors is much less than any of the other color displays you are likely to come across, and the "black" is really a dark gray.

To preserve the color accuracy of the target, avoid fingerprints, high temperatures and high humidity, expose it to light only when using it, and replace it about every four years in any case.

GretagMacbeth™ ColorChecker Color Rendition Chart

GRETAGMACBETH COLORCHECKER
The classic GretagMacbeth ColorChecker has applications in graphic design, television, and publishing as well as photography. Its 24 colored inks are prepared accurately in the lab.

GRETAGMACBETH COLORCHECKER DC
The ColorChecker DC features 177 colors across 237 squares. It is 8.5 x 14in (22 x 35cm) and is specifically designed to meet the needs of digital photography. It can be used with profiling software to create an ICC camera profile. The large white square in the center is designed to assist digital photographers in setting their white balance.

GretagMacbeth ColorChecker DC

This is the newer, more sophisticated version of the basic 24-patch ColorChecker, designed specifically for digital cameras, and extremely expensive. It could be considered overkill for most photography, as while it covers a wider range of colors, it demands more precision in setting up for profiling. The central white patch is larger than the others to facilitate white-balance presets. A strip of glossy primaries and secondaries is controversial—they are intended to increase the range of "knowable" colors but demand an absolute avoidance of any reflections. Some camera profiling software, such as inCamera, has an option to automatically ignore these patches.

Kodak Color Control Patches and Gray Scale

Less useful than the ColorChecker for photography, but better than nothing, this set of two small strips has traditionally been used as a color reference by repro houses and printers. The strips are conveniently sized for placing next to still-life subjects and paintings, and are an approximate guide for printing. The Gray Scale has 20 steps in 0.10 density increments between a nominal "white" of 0.0 density and a practical printing "black" of 1.90 density. The letters A, M, and B represent reflection densities of 0.0, 0.70, and 1.60 respectively. The Color Control Patches are based on web offset printing inks similar to AAAA/MPA standard color references, and include the three primaries, three secondaries, plus brown, white, and black.

Using a color chart or gray card

1 Place or have a model hold the chart full-face to the camera.

2 Make sure the lighting is even across the chart and avoid reflections.

3 Use a low ISO sensitivity and meter as average.

4 For profile building, follow the software instructions (normally includes turning off automatic camera settings and using either daylight or electronic flash).

5 Evaluate in image-editing.

Gray Card

The 18% reflectance Gray Card has long been a reference tool in black-and-white photography, being a standard mid-tone. In a digital image, it should measure 50% brightness and R128, G128, B128. The reason for 18% as a mid-tone is the non-linear response of the human eye to brightness. It is matte to avoid reflections, and has a reflection density of 0.70, which it maintains across the visible spectrum.

DIGITAL COLORCHECKER SEMI GLOSS

Like the ColorChecker DC, the Digital ColorChecker Semi Gloss is designed for real-life situations. Its 140 patches include colors designed to reflect skin, foliage, and blue sky, in addition to GretagMacbeth's standard colors,

GRAY CARD

Shooting a gray card under the lighting in which you're working in order to set a customized white balance, is the most effective way of getting faithful color reproduction.

Creating a Camera Profile

For the vast majority of us, creating a specific color profile for the camera is not necessary—we're unlikely to notice any minor color discrepancy, and on the rare occasion when color really has gone awry, it's usually relatively easy to fix in post-production.

However, camera profiles can be useful when a photographer works regularly in a repeatable kind of lighting. A studio with photographic lights is the most obvious example. Personally, I do quite a lot of location shooting in low sunlight, and so find it useful to have a profile just for this. The profile is a small text file, readable by the computer, that describes the exact way in which any of these devices displays colors. As everything begins with the digital capture, the camera profile occupies the first place in the chain of events.

DSLRs normally have default profiles, also known as "canned" profiles, built in to their systems and attached to the image files they

The GretagMacbeth ColorChecker in use on location.

STUDIO PROFILE
An IT8 target is typically shot in studio conditions, once the lighting has been adjusted for the subject.

Care of your target

Color targets are expensive and delicate items, so take the following precautions:
• Handle them carefully to avoid kinks and scratches.
• Remove any protection sleeve before use.
• Return the target to its protective wrapping immediately after use.
• Keep out of strong light, particularly sunlight, because of its high UV content.
• Store in a cool, dry, and dark place, preferably below 70° F (21° C) and below 50% RH. Avoid sudden temperature changes that might cause condensation.
• Use a dry, lint-free cloth to clean the surface, and do not use alcohol or any other cleaning fluid.
• The colors of the target will change with time. Ideally, replace the target every couple of years.

create. Photoshop, for instance, will read the attached profile automatically. So far so good, but the canned profile may only be an approximation for an individual camera working in specific lighting conditions. If, like most photographers, you begin by relying on this default profiling—in other words, doing nothing—you may come to recognize certain peculiarities. One of the traits of my current DSLR, for example, is a pink cast to light tones in sunlight. This kind of trait is correctable in image-editing, but a better solution is to create an exact profile for the camera when shooting in these conditions. The profile, in effect, compensates for the camera's color misbehavior.

Two important words of warning, however. One is that camera profiles must be specific to be of any use—specific to one camera and to the kind of lighting. The other is that total accuracy is rarely necessary, and unless you have an exact need, such as in the copying of paintings or the reproduction of a commercial product's brand colors, you may well be wasting your time fretting over minute differences in color values.

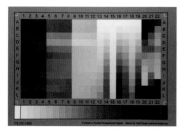

IT8 TARGET

The IT8 target is a standard pattern, with 19 columns of 13 colors, with three additional columns (20-22) which are "vendor independent," in that different manufacturers can place their own colors there. It also features a 24 shade grayscale along the bottom.

Photograph the color target

1 Place the target so that it is evenly lit and in the illumination that you expect to use. If the light source is concentrated, such as the sun or a flash, make sure that the target is angled to the light to avoid reflections.

2 Make sure that all the camera settings are at average or neutral—for instance, no hue adjustments. Select either the appropriate white balance choice or, better still, create a custom white balance by referencing either a white or gray patch (or a larger Gray Card).

3 If you can adjust the capture through the camera exposure control or lighting, aim for a gray scale range that is full but not total. Remember that the "black" on a ColorChecker is by no means zero, but a dark gray instead. InCamera profiling software recommends the values shown below. Note in particular how much lighter at 52 the black is than "pure" 0 black. You can fine-tune this exposure later in image-editing.

4 An added sophistication recommended by inCamera is to construct and include a light trap—a black box with a small aperture. This will be close to total black, but is probably overkill.

5 Set up the camera perpendicular to the target to avoid perspective distortion.

A light trap is a box, painted entirely with light-absorbing black on the inside and with a small hole cut in it. The black seen through the hole will have no reflections, and be close to total black.

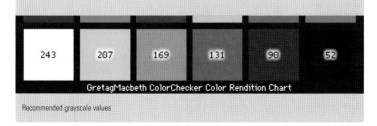

| 243 | 207 | 169 | 131 | 90 | 52 |

GretagMacbeth ColorChecker Color Rendition Chart

Recommended grayscale values

Create the Profile

Once you've photographed the target, the next step is to create a profile. For this you will need camera-profiling software.

Each follows its own procedure, but the example here is the inCamera plug-in for Photoshop. You will need to shoot and create profiles for each major type of lighting that you expect to use—and for each camera.

1 Ensure that no color profiles are attached to the image by checking all the possible opening warnings in the *Color Management Policies* section of the *Color Settings* dialog.

2 Open the image. If the warning dialog reads "*Embedded Profile Mismatch*," choose "*Discard the embedded profile (don't color manage).*" If the warning dialog reads "*Missing Profile*," choose "*Leave as is (don't color manage).*"

3 Check that the gray scale values are as recommended. Adjust *Levels* and/or *Curves* to bring them into line. If there is a strong color bias, then the RGB values will be quite different, in which case convert to Lab and aim for the following: White point RGB 243 = Lightness 96 and Black Point 52 = Lightness 20.

Embedded Profile Mismatch

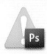

The document "My Photo.tif" has an embedded color profile that does not match the current RGB working space.

Embedded: Adobe RGB (1998)

Working: sRGB IEC61966-2.1

—— What would you like to do? ——

○ Use the embedded profile (instead of the working space)

○ Convert document's colors to the working space

◉ Discard the embedded profile (don't color manage)

Cancel OK

Chart Type:
✓ ColorChecker®
ColorChecker®DC
IT8.7/1 or IT8.7/2

Data Reference File...
ColorCheckerRefile.txt

4 Launch the profile-building software, in this case a plug-in under the Filter menu: *Filter > Pictographics > InCamera*.

5 Choose the appropriate target, and its reference file.

6 Align the grid by dragging the corners. This also compensates in case you shot the target at an angle.

7 Give the profile a name that you can later identify, e.g. "studioflash_raw.icc." Note that the standard suffixes are .icc and .icm. The software may append these automatically.

8 Save the profile in the appropriate folder. This varies according to platform (Windows or Mac), operating system, and Photoshop version. The software will usually suggest the default location.

Naming the profile

In addition to the name, there is also a Profile Description Tag (a description found inside the profile file) used by some applications to display it as a choice. If you decide to rename a profile, these applications will not recognize the change unless you use a utility to alter the Tag as well. Apple's ProfileRenamer does this. If you overwrite an existing profile (which you might want to do if, for instance, you made a mistake the first time), Photoshop may need to be restarted before it recognizes the change.

One-off profiles

If the lighting conditions for a single shot are unusual, consider making a profile for that shot alone. Simply shoot the target as part of the take and make the profile as described here—but use it only for that shot.

Profiles and Raw conflict

In principle, do NOT use both Raw editing tools and a custom camera profile. When Photoshop CS opens a Raw file, it does so without asking for profile assignment, and then offers an impressive choice of color adjustment tools. If you make use of these, and then, once the image is open, assign a profile, you can expect strange results. Consistency is the key. To begin with, create the Raw profile by making no adjustments at all—just the default settings—and then do the same when opening all subsequent images. If you vary this by tweaking images in the Raw editor before applying the profile, remember that you are adding an extra level of judgment to a standard procedure. Try to limit the Raw editing to making sure that neither highlights or shadows are clipped. The alternative is to abandon the profiling and work solely in the Raw editor. For most photography, outside controlled conditions, this usually works best and it's what I normally do.

Memory

Just as digital cameras have developed enormously in the last ten years, so too have the storage devices on which images are temporarily stored—namely memory cards.

The two major card formats are CompactFlash (CF) and Secure Digital (SD), with Sony's proprietary Memory Stick a minor third for a selection of its own (primarily point-and-shoot) cameras.

Cost is a consideration, as the high-capacity cards can be expensive, and the cost per megabyte is much more than it is for desktop or laptop computer memory. In other words, memory cards are for shooting, NOT long-term storage. Calculate your memory card needs by estimating your typical rate of shooting and the file format. With a large megapixel sensor, there is a major difference between JPEG and Raw, for instance.

Memory cards of whatever capacity are only temporary storage, and you will need to transfer the images from them at regular intervals. How often depends on the capacity of each card, which varies enormously, from 128MB to 32GB. For example, a 128 MB memory card will take about 50 JPEG images shot at normal compression on a 10-megapixel camera, but only about 15 in Raw format compressed. A 32 GB card can store more than 240 times this amount. Considered as digital storage, memory cards are, relatively, more expensive than computer hard drives and image banks, but you may be willing to pay for the convenience of being able to continue shooting for long periods without needing to download. A 4GB card, for example, has almost the capacity of a standard DVD. Another consideration, however, is the safety of having so many images without backup in the camera.

CompactFlash

As far as DSLRs go, CompactFlash is currently the most widely used type of memory card. Using flash memory technology, CompactFlash (CF) cards give non-volatile storage and can retain data without battery power, and do this in a much smaller size than normal flash cards, with 50-pin connections. They measure 43×36mm and come in two types with different thicknesses—Type I (CF-I) is 3.3mm, Type II (CF-II) 5mm. DSLRs will accept both. Typical capacities are 1GB, 2GB, 4MB, 8GB, 16GB, and 32GB—a vast improvement considering that maximum capacity in 2001 was 512MB. CF cards are sturdy, have a long usage life (around 100 years), and operating temperatures from -13°F to +185°F (-25°C to +85°C). They are PCMCIA-compatible, so easy to read from laptop PC card slots.

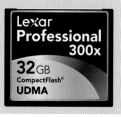

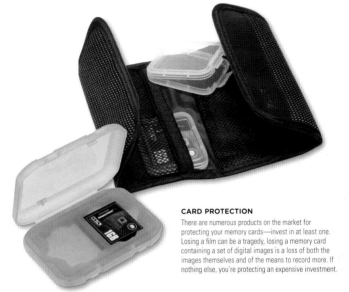

CARD PROTECTION

There are numerous products on the market for protecting your memory cards—invest in at least one. Losing a film can be a tragedy, losing a memory card containing a set of digital images is a loss of both the images themselves and of the means to record more. If nothing else, you're protecting an expensive investment.

SD and SDHC

The SLR market is less driven by miniaturization than that for compact cameras and mobile phones, but the size of that marketplace has a broader impact. The most successful of the consumer formats is Secure Digital, which has recently been updated to support up to 32GB (SD 2.0 or SDHC), though older cameras and card readers are limited to 2GB and, much like sofware versions on computers, will not recognize the new cards. These cards are increasingly widely supported by DSLR manufacturers, as well as device manufacturers (so, for example, many computers and even DVD players can read them).

Also consider write and read speeds when choosing memory cards. These are partly influenced by the camera processor and the format in which you choose to shoot (compression adds time), but also by the make of card—the best incorporate write acceleration. A good speed currently is in the region of 20MB/second. High-end manufacturers such as Lexar produce a "professional" range that is designed to tighten quality controls—in much the same way as pro film used to differ from regular—and has a higher write speed than normal.

Memory requirements

In principle, you need sufficient memory card capacity to continue shooting until the images can be downloaded to a computer hard drive or portable storage device. This depends on the following:

1 Image file size, taking into account whether you are using compression or not.

2 Rate of shooting and number of shots likely in a session.

3 Whether or not you or an assistant can begin downloading while you are still shooting.

4 Whether you are prepared to delete images from cards before you have made a backup.

5 Cost: memory cards are more expensive per megabyte than computer hard drives.

CARD READERS
Although the camera can itself be connected directly to a computer to download images, it is usually more convenient to use a card reader. Downloading speed depends on the bus, with USB 2 and Firewire the fastest.

Memory Stick

Launched in 1999, Sony's Memory Stick was designed for the company's own digital cameras and camcorders. It uses a form of flash memory and was shaped a bit like a stick of chewing gum, with a 10-pin connector. Newer variants—the most common of which is the PRO Duo—are shorter and smaller.

A Wireless Option

Recent innovations in digital photography include the option of transmitting image data wirelessly, where a wireless transmitter is attached to the camera for immediate image transfer.

First introduced by Nikon for its D2H, this is an extremely valuable option for any photographer who needs to deliver images quickly without leaving the shooting location. Sports events are the classic situation.

Wi-Fi, which stands for Wireless Fidelity, is the most widely used standard for wireless networking, and is also known as 802.11n (other common versions are 802.11a/b and 802.11g). It is relatively fast (a bandwidth of 11MB/second, which translates to transmission speeds of 1 to 2MB/second) and has a medium range, which depends on obstructions and on

data rate, but is typically up to 100ft (30m) with a standard antenna, and up to 500ft (150m) with large antennae at the camera and base station. This is the standard used for increasingly common small wireless computer networks, such as you might already have at home. If you do, adding a camera to the network is easy.

The basic networking set-up consists of the camera and its transmitter, a Wireless Access Point (WAP), also known as a base station, a router/hub/gateway, and one or more computers. The router distributes the images within the local network (Local Area Network, or LAN) or, through the gateway, to a larger network (Wide Area Network, or WAN). There are many permutations, and setting up the network calls for some experience.

A typical Wi-Fi network

The most basic network of all is camera to WAP/base station to FTP server, by which means you transmit the images to one computer. More advanced is a network which also allows access, via the router/hub/gateway, to the Internet and to several computers. The camera and photographer's laptop can access all of this via the WAP/base station.

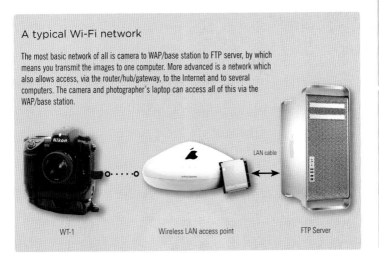

WT-1 Wireless LAN access point FTP Server

LAN cable

Basic network

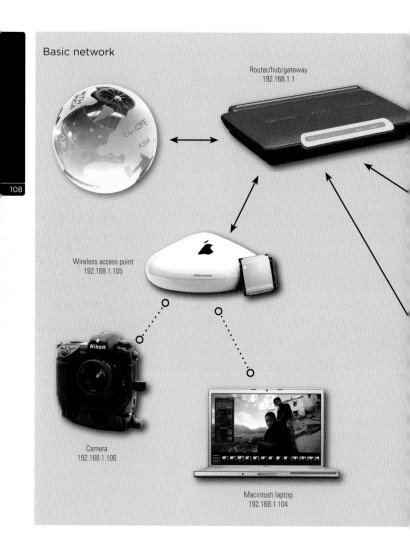

Router/hub/gateway
192.168.1.1

Wireless access point
192.168.1.105

Camera
192.168.1.106

Macintosh laptop
192.168.1.104

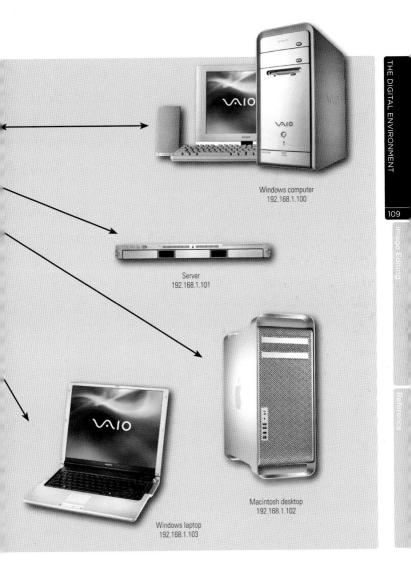

Windows computer
192.168.1.100

Server
192.168.1.101

Macintosh desktop
192.168.1.102

Windows laptop
192.168.1.103

Editing In-camera

Traditionally, shooting and editing were separate activities, divided by the time it took to process the images. You took the pictures and later reviewed them on a light box or contact sheet, or possibly with a slide projector.

The DSLR's playback menu gives you this option right away, for better or worse. The better is that it gives you the certainty of confirming the image and the chance to reshoot and improve if the first frame is not exactly as you would like it to be. The worse is that it can interfere with the flow of

shooting and even cause you to miss shots by distracting you. It can also push you into deleting images before you have given them your full attention.

The usefulness of in-camera editing depends on the kind of photography and on exactly what image quality you are assessing. In studio and still-life photography—in fact, any situation in which there is no urgency and in which you can repeat a shot—reviewing and deleting until the image is right is a sensible procedure. In unrepeatable situations, however, there is a considerable

IN-CAMERA EDITING

A typical in-camera editing procedure. Out of a sequence of five frames, two were deleted immediately for poor framing, on closer inspection a further two were deleted for either poor composition or inaccurate focusing.

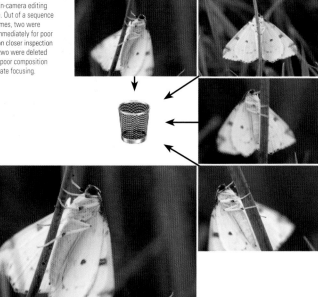

risk of making a hasty, and wrong, judgment in deletions. The pressure of available space on the memory card is the usual reason for doing this, but it needs to be exercised with caution. More spare memory cards may be a better answer. The camera's LCD screen is a useful guide but is by no means ideal for examining images, and is much less accurate in color, contrast, and resolving detail than a laptop screen or desktop monitor. In particular, checking detail—such as for camera shake or focus accuracy—involves zooming in, and this takes time that can interfere with shooting.

Data-embedding options enable different kinds of information to be attached to an image file for later use when browsing, building a database, and image editing. Some of this is automatic (e.g. file format, image size, lens, and exposure settings), some of it user-adjustable automatic (e.g. date and time), and some manual input (e.g. subject ID and place). So far, no manufacturer offers a built-in GPS for automatic location coordinates, but no doubt this will happen.

Reviewing images

Check exposure accuracy

Multiple-frame option
Useful for displaying sequences.

Zoom
Check for sharpness and motion blur, and details such as facial expression.

Protection
Locking key for safety.

Delete
The most dangerous action without an on-screen computer review.

Adding data to images

Date and time
Always useful in identifying the subject. When traveling, make sure to allow for time zones.

Comments
Some DSLRs include the facility to add a short text comment that will later be displayed in the browser.

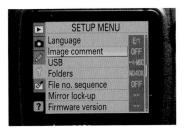

ADDING COMMENTS
The comment facility in this Nikon menu is accessed via the Setup menu. The comment is added to photos taken afterward, until you ask the camera to stop. It therefore requires regular attention if used. Since cameras do not feature full keyboards for obvious reasons, text entry is limited to video-game style cursor movement. This takes time, so keep your comments short and helpful.

Powering the Camera

One of the biggest drawbacks of digital cameras compared with traditional film SLRs is their total reliance on and consumption of power.

With a film camera, even if the batteries failed you could take a photo as this was a purely mechanical operation (although you wouldn't be able to use the camera's light meter), but digital cameras require power—and plenty of it to operate at all. For this reason, battery management is important, never more so than when you are traveling and are far from reliable power sources. There are a number of issues here, but all are to do with ensuring that you have enough power to shoot from day to day.

Depending on the model, digital cameras have either custom batteries or accept AA size. In the case of the former, you have no choice but to buy that manufacturer's design, and the custom charger. The number of spare batteries that you will need depends on how much you intend to shoot and the frequency with which you can recharge. Usually, on location, it should be possible to recharge each evening. Check the specifications for battery life but do not take the manufacturer's claims at face value; test it for yourself. Some SLRs can accept an additional AA battery pack. Having this along on a trip can be a back-up in case of difficulties in charging the custom batteries.

Battery types

Alkaline Widely available, not rechargeable, moderate capacity, keeps charge when not used.

Nickel-Cadmium (NiCd) The least expensive type of rechargeable battery, gradually loses charge if not used. Suffers from "memory effect" in that if they are recharged before being fully discharged they "learn" to have a smaller capacity. Smart chargers can solve this problem.

Nickel-Metal Hydride (NiMH) More expensive and higher output than NiCd. Also gradually lose power when not used, but do not suffer from "memory effect."

Lithium (Li) Not rechargeable, light, powerful, long life, expensive.

Lithium-Ion (Li-Ion) Rechargeable, but like Lithium are light and powerful. A popular choice.

How to recharge

Follow the camera manual, but also bear in mind the following:

- With NiCd and even NiMH, try not to recharge before the battery is fully discharged. With Li-Ion batteries, however, shallow discharge actually increases the cycle life (a cycle is a full charge followed by a full discharge).
- Do not overcharge.
- Smart chargers may be able to do the following: discharge the battery prior to recharging, top-up charging, and switch off once a full charge has been achieved.
- Follow a charging regime that suits the way you work. At minimum, this probably means one spare, with the discharged battery put on charge as soon as possible.

Rating

The power capacity of a battery is measured in Milliamp-hours (mAh). This indicates the battery's overall charge storage capacity, and the higher the mAh, the longer the performance. Higher capacity batteries are more expensive, but valuable for digital cameras, which have a high drain. A rating of around 1800mAh is considered high.

Battery memory

NiCd batteries (but not NiMH batteries) are prone to memory problems. "Memory effect," as it is known, is a loss of capacity caused by recharging the battery before it has fully discharged. Small gas bubbles reduce the area of the battery cell's plates, and over time, the charge becomes smaller and the battery fails faster. To correct this, the battery needs to be reconditioned.

Adapters

The most convenient solution to different plug/outlet types around the world is an adapter, and this is essential for a charger or any other device that has a sealed casing. Hot-wiring (attaching bare wires from a local plug with insulating tape to the prongs of the charger or adaptor) is not recommended because of the dangers of electrocution.

AA-compatible cameras offer much more choice because of different battery types and manufacturers, but battery life is likely to be less than custom batteries (usually Li-Ion, see Battery types box). High-capacity rechargeable batteries are the ideal, but in an emergency, you can usually find AA alkalines anywhere to keep you going. There is a wide choice of chargers from independent manufacturers. It is important, however, to check the manual for batteries that are NOT recommended. Lithium AAs emit heat and may not be suitable for all makes of camera.

Wherever there is a convenient power supply, it may be more convenient to use an AC adapter, usually available separately. It will also save batteries. Whichever AC device you carry with you, charger and/or adapter, you must be prepared for the plug/outlet types in the countries you will visit.

Know your chargers

If you are carrying more than one device, such as a
laptop or stand-alone storage as well as the camera,
you are likely to have similar-looking charger units or
AC/DC converters. To avoid confusion, and possible
damage to circuitry, label each one clearly.

UK plug to standard "8" plug

US plug to standard "8" plug

Laptop charger

Electricity Abroad

If you've traveled relatively extensively, you'll be aware that voltages vary in different parts of the world.

Generally, voltages are divided between 110–120v and 220–240v. Countries with 110–120v are principally the US and those falling under its sphere of influence for reasons of proximity or history (Latin America and Japan, for example), while those on 220–240v tend to be European and former colonies. A few countries have both, though not necessarily in the same place.

Cycles are in Hertz (Hz), usually either 50 or 60. Almost all of the plug-in electrical equipment associated with cameras and

Auto inverters

DC/AC inverters make use of one universal power supply—the lighter socket in an automobile (and also some aircraft power outlets). The output plug is often either figure-of-eight or clover leaf. It may seem odd to convert from DC to AC when devices like cameras, laptops, and accessories need DC anyway, but the variation in the voltage and cycle of transformers makes it potentially damaging to fool around with DC supplies.

PLUGS
This is just a selection of the array of plugs and sockets from the rest of the world that I have collected on my travels.

TRAVEL ADAPTERS
These socket adapters are designed to accept a number of different kinds of plugs. Neither is entirely universal, but both work with more than one kind of plug type.

computers (chargers, transformers, and so on) are designed to switch automatically between these voltage ranges, so there should be no problems on that account (but it's worth checking to make sure that you don't have a primitive single-voltage item). More of an issue is the plug-and-socket fitting, as these vary greatly. The basic solution is to always carry an adapter that will handle a good range of sockets. Beyond this, check the fittings in the countries on your itinerary and buy a specific adaptor. The fail-safe is to buy plugs locally and replace your existing ones—but there is a risk here in that equipment often has permanently attached, non-removable plugs. So that you can continue to use existing fitted plugs, carry a simple adapter like the one shown here, with a short cable attached, and leave the wires stripped at the end.

There are four major plug-and-socket types, with variations within each, particularly in the 220–240v "European" group. Note that some countries have more than one plug type.

Plug adapters

An adapter that accepts two or three of your own country's plugs saves the cost of having more than one foreign-socket adapter.

Also, some sockets are incompatible with some plugs even of the same pin type and layout. Particularly obstructive are two-pin recessed sockets—you may have the right configuration of pins on your adaptor, but it won't necessarily fit.

DIY adapter

With an adapter like this, leave the ends of the wires bare and attach local plugs as necessary. Most chargers and transformers are sealed units and so should not have their plugs cut and changed.

World sockets

Across the world there are four basic mains electricity socket types, and variants within all of these. When traveling it's essential to have the correct adapters. The voltage also varies from around 110v in the Americas and Japan, to the 220-240v systems common in Europe. Many camera chargers can tolerate either, but you must check.

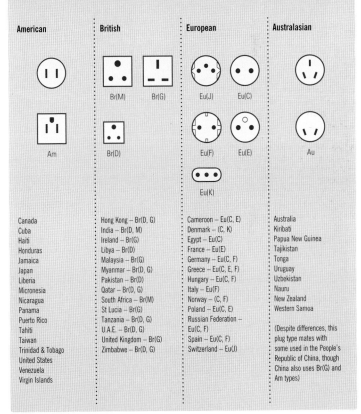

American

Am

British

Br(M) Br(G)

Br(D)

European

Eu(J) Eu(C)

Eu(F) Eu(E)

Eu(K)

Australasian

Au

Canada
Cuba
Haiti
Honduras
Jamaica
Japan
Liberia
Micronesia
Nicaragua
Panama
Puerto Rico
Tahiti
Taiwan
Trinidad & Tobago
United States
Venezuela
Virgin Islands

Hong Kong – Br(D, G)
India – Br(D, M)
Ireland – Br(G)
Libya – Br(D)
Malaysia – Br(G)
Myanmar – Br(D, G)
Pakistan – Br(D)
Qatar – Br(D, G)
South Africa – Br(M)
St Lucia – Br(G)
Tanzania – Br(D, G)
U.A.E. – Br(D, G)
United Kingdom – Br(G)
Zimbabwe – Br(D, G)

Cameroon – Eu(C, E)
Denmark – (C, K)
Egypt – Eu(C)
France – Eu(E)
Germany – Eu(C, F)
Greece – Eu(C, E, F)
Hungary – Eu(C, F)
Italy – Eu(F)
Norway – (C, F)
Poland – Eu(C, E)
Russian Federation –
Eu(C, F)
Spain – Eu(C, F)
Switzerland – Eu(J)

Australia
Kiribati
Papua New Guinea
Tajikistan
Tonga
Uruguay
Uzbekistan
Nauru
New Zealand
Western Samoa

(Despite differences, this plug type mates with some used in the People's Republic of China, though China also uses Br(G) and Am types)

Caring for your Camera

The sheer quantity of electronics found in a digital camera in many ways renders them less robust than their conventional, film-based counterparts.

The convenience of not needing boxes of film on a shoot is offset by the extreme care that has to be taken of the sensor. There is only one sensor, and any significant damage to it will render the camera practically useless.

Gone are the days when a set of jewelers' screwdrivers and long-nosed pliers might get a faulty camera back on the road. When a digital camera goes wrong, you either have a spare body ready or you stop shooting. This places even more importance on basic camera care than in the days of film.

A largely unresolved issue is how to keep the sensor clean in a digital SLR. Unlike

Photographing in sandy conditions is especially dusty. The images (right) show the marked area in close-up, revealing dust on the sensor. By increasing the contrast, the dust particles become easier to see, though their effect can still be perceived before the effect is applied.

Preventing and removing dust spots

Take the important precaution of keeping the backs of lenses and the camera's mirror box interior clean. It is relatively safe to use a compressed air can for this—but use from a distance, and horizontally, to avoid propellant contamination. For cleaning the sensor, invest in a high-pressure hand blower, and use a small battery-powered light, for example a white LED torch.

The Nikon LCD screen with its protective cover in place

Swab cleaners

Blower

Lens Pen

fixed-lens prosumer models, SLRs are by their nature unsealed, and dirt enters. The sensor is never directly exposed to the air, but that doesn't prevent it from collecting particles, and this happens in two stages: when you change a lens, the mirror box is exposed and if the air is anything less than laboratory-clean, particles can enter; when the mirror flips up for exposure, those particles are free to reach the sensor. The sensor itself carries a charge when in use, so it attracts particles, and if you make slow exposures, there's more time for the particles to slip past the flipped-up mirror. The shadows of small particles may well be undetectable against detailed parts of an image, and also if the aperture is wide open. Any that are noticeable can, of course, be removed with the Clone Stamp tool during image-editing, but this takes time.

Most camera manufacturers have made attempts to address this problem, with various technologies that "shake" dust from the sensor, but this isn't guaranteed to work in all instances. The standard advice is to try and avoid changing lenses when there is dirt around, but as this is largely impractical, the only solution is to check regularly and then take the inevitable risks of cleaning the sensor yourself. Have it cleaned by the manufacturer or an accredited repair shop as often as is practical.

Warning!

- Compressed air is effective but dangerous because of the risk of propellant splattering the sensor. Camera manufacturers do not recommend it, but it may be the only way of removing some particles. Minimize the risk by holding the can level and use from a distance.
- DON'T touch the sensor—EVER. Don't use a blower brush.
- DON'T blow directly with your mouth. Any spittle will have to be cleaned professionally.

Make regular spot checks

At regular intervals while shooting (you have to decide how often, depending on how clean the air is and how often you are changing lenses), check for dirt by shooting a featureless subject such as a white wall or the sky. Any particles will be most obvious if the aperture is stopped down and the subject out of focus. Check initially at 100% magnification, scrolling from one corner across the entire image. When possible, also check the image on a computer screen.

Cleaning the sensor

Although the sensor itself is protected by a low-pass filter, which affords some protection, the filter itself is delicate, and scratching means expensive replacement, hence manufacturers' warnings against touching it. If you detect dirt in an image, clean the sensor as follows:

- Make a mental note of where in the frame are the obvious particle shadows. Because an SLR image is inverted, the actual particles will appear in inverted positions when you examine the sensor.
- Find a clean-air area and remove the lens. Ideally, put the camera body on a tripod so that you can work with two hands.
- Follow the manufacturer's instructions for locking the mirror up to expose the sensor. This is important, because if you simply set the shutter speed to B or T, the sensor will carry a charge that will attract even more dirt. Typically, you would need to connect the camera to an AC adapter.
- Shine a bright light, ideally a point source, onto the sensor and inspect from different angles.
- Use a hand-operated bulb blower as shown. If this weak flow of air fails to remove everything, consider (at your own risk) the next step—compressed air (see Warning box opposite).

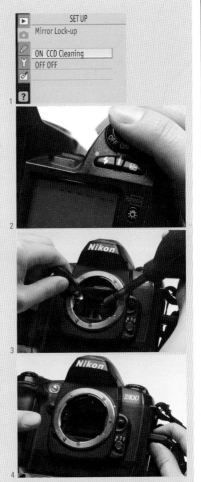

On-camera Flash

Most digital SLRs feature a built-in, pop-up flash unit, and although this type of flash is of limited use, it can be helpful as fill-in flash for backlit subjects.

Furthermore, if there are absolutely no other forms of lighting on offer, at least a pop-up flash gives you the ability to capture an image, as basic as it may be.

On-camera flash of this kind has the inevitable drawbacks of frontal lighting (almost shadowless and falls off in proportion to the distance from the camera). At the same time, on-camera flash gives clear, crisp results with bright color, so that, for example, it often works well for close-up shooting of colorful subjects. High-end digital SLRs with built-in or dedicated flash units use a variety of sophistications to improve exposure accuracy, including focus (to favor the distance to the chosen subject in a scene).

Guide number

This is the standard measurement of light output, and varies according to the ISO sensitivity. It is equal to the aperture (in f-stops) times the flash-to-subject distance (in meters, feet, or both). A typical rating, for example, might be "Guide Number 17/56 at ISO 200," meaning meters/feet. Divide the guide number by the aperture you are using to find the distance at which you can use it. In this example, if you were using an aperture of $f/4$, it would be 14ft (4m).

On-camera flash drawbacks

1 Exposure is good for one distance only because the light falls off along the line of view. If the foreground is well lit, the background will typically be dark, while obstructions in front of the subject can easily be overexposed. *Solution*: Rearrange camera position and composition; change flash mode to fill-in so that exposure is long enough for the ambient lighting.

2 Specular reflections in shiny surfaces facing the camera. *Solution*: Change camera position; retouch highlights in image-editing.

3 Red-eye; reflections from the retina, particularly with a longer focal length lens. *Solution*: Some cameras offer a pre-flash to make the subject's iris contract, but this adds a delay; retouch in image-editing.

4 Flat, shadowless light that gives a poor sense of volume. *Solution*: Use flash as fill-in; increase ISO sensitivity to record more ambient light.

Using bounce flash

The principle of bounce flash is to aim the unit at a ceiling or wall rather than the subject, to take advantage of the much more diffused light from this reflection. It greatly reduces the light reaching the subject, and you should also check that the ceiling or wall is white, or expect a color cast. A few cameras have the facility to angle the head, but otherwise this is a feature for detachable on-camera units.

Rear-curtain sync

A special variation of fill-in flash is streaking with rear-curtain synchronization. In this, the exposure and flash output are balanced as for fill-in, but the flash is timed at the end of the exposure. If there is movement, either in the subject or because you move the camera, there will be trails of light that end in a sharply frozen image. This works particularly well at night in locations where there are bright lights—for instance, a panning shot of a motorcycle with its lights on.

Multiple flash

Some advanced detachable camera flash units feature wireless linking. The unit mounted on the camera serves as the "commander," from which any number of other, independently mounted units can be controlled. The initial flash from this unit triggers the others via their remote sensors. With the Nikon SB-800 unit shown here, flash units are grouped, and their flash modes and output levels can then be altered from the "commander," and their channels can be assigned also.

Fill-in flash

One of the most successful uses of on-camera flash is as shadow fill. In this, the shutter speed is set low enough for the ambient lighting across the scene, and a smaller-than-usual dose of flash is added. All SLRs have a program for this in the menu, but as the exact balance between flash and ambient light is very much a matter of personal taste, the ideal is to try different variations and check the results on the spot on the LCD screen. For full control, use a manual exposure setting and lower the flash output by increments.

Off-camera Flash

If you're after the highest-quality image in studio conditions, then you'll really need to turn to off-camera flash units.

The advantages of using professional high-output flash are: precise color temperature (daylight), short duration to freeze most movement, and a quantity that allows it to be diffused, reflected, or bounced, and yet still provides good depth of field.

Typical studio systems are split between those in which several flash heads are served by a power unit, and monoblocs designs, in which the transformer, rectifier, capacitor, and flash tube are all housed in one self-contained unit. In addition, there are portable flash systems with a much higher output than the usual detachable on-camera units, using battery packs.

With digital SLRs, in-camera color balance and generally higher base ISO sensitivity admittedly reduce the value of these, but not much. The old disadvantage of flash—that you could never be absolutely certain of the result unless you did Polaroid tests—has disappeared. Digital SLRs make flash a dream to use.

More than anything, it is the endless variety of light fittings that make professional flash units so useful. Not only is the output high enough to survive heavy diffusion and reflection, but the low temperature at which the lights work make it possible to enclose them without risk. The better studio flash units have a slave sync built in, to do away with one set of messy

STUDIO FLASH
Serious indoor photography will make use of daylight-balanced adjustable lights and a variety of modifiers. Most of these will feature modeling lights: a continuous light to help set-up.

cables. In a typical studio flash system, the power supply is AC at a relatively low voltage. The first part of the circuitry is a transformer to step up the voltage and a rectifier (more than one in large units) to convert the AC to DC. This uni-directional, high-voltage source then supplies the capacitor which stores the charge. When triggered, the high-voltage output in the capacitor is discharged through the flash tube. Output is measured in watt-seconds, or joules, and typical units are between 200 and 1,000 joules. To make use of the extremely high output of the mains flash capacitors, the flash tubes are much larger than in on-camera units, and one result of this is that the peak flash duration is longer than that of an on-camera flash, which is sometimes as slow as a few hundredths of a second.

Flash meters

Despite modeling lamps, which are standard on studio units, previewing the actual lighting effect is still one of the problems with flash—and calculating aperture against output even more so. Although hit-and-miss calculation is not difficult with a digital SLR, it may still take a few exposures to arrive at the right settings. A flash meter is essential for regular studio photography, and the most useful method is to take an incident light reading. Incident readings are of the light falling on the subject and so are uninfluenced by the tone, color, or reflectivity of the subject itself.

SNOOT

HONEYCOMBS

SOFTBOX

Continuous Lights

One drawback with flash units is that you can't accurately predict how the image is going to look until the flash has fired.

Although in these days of instant review it's easy to adjust the units and shoot again, the advantage with continuous lights is you can see exactly what lighting effect you are getting as you adjust the lights. This also makes it easy to combine with existing, ambient light.

As for types, incandescent is the traditional source, but fluorescent and HMI are becoming increasingly popular in studios. The most efficient type of incandescent lighting is the tungsten-halogen lamp, which uses a coiled tungsten filament as in ordinary tungsten lights, but burning at a much higher temperature in halogen gas. As a result, the light output and color temperature stay more

Utilizing daylight

Continuous light is ideal for interiors, where the size of the subject and the complex relationship with other existing light sources (such as daylight through a window) make it much easier if you can see the effect precisely by eye. The important precaution with incandescent lamps is to balance the color temperature with a gel.

FLUORESCENT LIGHTING

This Lupo Quadrilight delivers light at a temperature of 5,400 Kelvin, ideal for product shots. The metallic barn doors allow control of the spread.

Flash or continuous lights

Flash: pros
Freezes movement.
Cool.
Daylight-balanced, mixes easily.

Flash: cons
Small units give no preview; others have modeling lamps that call for dim ambient light to show the effect.
Fixed upper limit to exposure, beyond which needs multiple flash.
Technically complex.
High unit cost.

Tungsten: pros
You get what you see.
Exposure adjustments simple—just change shutter timing.
Mechanically simple and easy to use.
Some makes very small and portable.

Tungsten: cons
Not bright enough to freeze fast movement.
Hot, so can't accept some diffusing fittings, and dangerous for some subjects.
Needs blue filters to mix with daylight.

High-performance fluorescent: pros
You get what you see.
Exposure adjustments simple—just change the shutter timing.
Daylight-balanced, mixes easily.
Mechanically simple and easy to use.
Low running costs.
Cool—none of the heat problems of incandescent.

High-performance fluorescent: cons
Not bright enough to freeze fast movement.
Bulky.
High unit cost.
Tube dimensions restrict light design.

HMI: pros
Exactly as for tungsten, but cool.

HMI: cons
Expensive.
Needs a bulky balast.

or less the same throughout their life. Available wattages range from 200 to 10,000, but for still photography 2,000W is about the highest. Used alone, incandescent lamps simply need a 3,200K "incandescent" white balance. However, used on location, they are often in combination with existing daylight, fluorescent, or vapor lighting, and in this case it is usual to filter the lamps toward daylight.

A newer development, particularly relevant to digital photography, in which the camera's white balance settings can take care of color differences, is high-performance fluorescent. The lamps used are flicker-free, almost as bright as incandescent, color-balanced for 5,400K or 3,200K, as well as being cooler and less expensive to run (though more expensive to buy in the first place).

Reflector angle

Incandescent light housings have a reflector behind the lamp to increase its output and help control the beam. Most general-purpose housings have reflectors that give a spread of between about 45° and 90°. The beam pattern can often be adjusted by moving the lamp in and out of the reflector, or by moving hinged panels in front.

Daylight control and tungsten conversion filters

There is a wide range of heat-resistant gels available, that are designed to fit in front of incandescent lamps to adjust their color temperature. They are fitted either in custom holders or in an outrig frame that attaches in front of the light.

The most commonly used gel is "full blue," which is designed to change the color temperature of an incandescent light from tungsten (3,200K) to daylight (5,500K). An alternative is a dichroic filter—a partial mirror that fits to the front of the lamp, reflecting red back to the lamp and passing blue.

For partial conversion, a "half blue" will adjust the temperature from 3,200K to 4,100K to compensate for voltage reduction or retain some of the warmth of tungsten lamps when mixing them with daylight or flash.

Fluorescent lights

High-output, flicker-free, daylight-balanced tubes make fluorescent lights a realistic alternative to incandescent, with some clear advantages. The light is cool, and so convenient for still-life subjects. In these designs, several tubes are arranged in parallel with mirrored reflectors to form a light bank.

Lupo Quadrilight and Superlights.

Tripods

There's no doubting that a tripod will provide cleaner, sharper images, particularly in low-light conditions when a slower than ideal shutter speed has to be used.

However, when traveling they can be awkward, so much depends on the type of shots you expect to do. Tripod efficiency depends on two things: design and materials. The first essential quality for any tripod, as for any bridge, is that it stays firm and still under average conditions. The acid test is to fix the camera, use a long focal length, and tap the front of the lens while looking through the viewfinder. Common sense will show whether the slight vibration is acceptable, but to make sure, shoot a few times at around 1/60 sec to 1/125 sec while tapping the lens. Examine the images on the computer at 100% magnification. Torsion is another indication of tripod stability—with the camera detached, grasp the head firmly and try to twist it clockwise and counterclockwise. There should be no significant movement. Note that center-pole extensions can, if not very well built, reduce stability. This is particularly true of rack-and-pinion movements operated by a rotating lever; convenient, certainly, but not necessarily solid.

Tripod heads are as important as the tripod itself, and a weak head will destroy any advantage you have from a strong tripod. There are two basic designs: pan-and-tilt, in which each movement is mechanically separate, and ball-and-socket, which allows full play in every direction with one unlocking movement. Which is better is entirely a personal choice.

In a studio, a heavy, solidly built tripod is an obvious choice, and for large-format cameras a studio stand is even better. Location shooting or traveling over a period,

Focal length and camera shake

Camera shake is the condition that tripods and other supports are intended to prevent, and its symptoms are a blur of a characteristic "doubled" kind across the entire image. As long focal lengths magnify images, they also magnify shake. Long focal-length lenses (for SLRs) also tend to be heavy, which can be an advantage on a tripod as the weight makes the setup more solid, provided that you mount the lens near its center of gravity (use the lens's own tripod bush).

Using a tripod

- Low is more stable than high.
- Make sure that the surface is steady. Sand shifts, as do loose wooden floorboards.
- Adjust the legs so that the platform (immediately below the tripod head) is level. Do not level by the tripod head alone.
- With a long lens on an SLR, use its tripod bush rather than that of the camera, in order to get closer to the center of gravity.
- Shelter the tripod from wind.

Shutter speeds to watch

Fast shutter speeds don't need a tripod, and at very slow speeds, such as a second or longer, the camera has time to settle down after the shutter is released. Moderately slow speeds, however, such as 1/30 sec and 1/15 sec, can produce camera shake with a long focal length, even on a tripod. Check for this.

however, puts a premium on lightweight construction. Just as there is no point in even considering a lightweight tripod that is too flimsy to hold the camera firmly (or too short for normal use), neither is there any reason to have a tripod that is over-specified for a small camera. Cost enters the equation because strong, light materials are available and they are always more expensive. The material of choice for tripods is carbon fiber (30% lighter than aluminum, and more rigid), and for heads, magnesium alloy, but the price difference from standard is considerable. For all the above choices, if you are buying a tripod and head, compare models side by side for shake, torsion, weight, and so on.

There are good impromptu alternatives to tripods, depending on how slow a shutter speed you need. To hold the camera more steadily, a rolled-up cloth, jacket, or soft camera bag on a solid surface (such as a wall or part of a vehicle) works very well—if you press down on the camera or lens as you shoot, you may be able to use shutter speeds as slow as one second. Very long exposures are possible if your camera accepts an electronic cable release; find a solid surface at a workable height, prop the camera up with whatever is handy, and trigger the release. To avoid uncertainty in these conditions, shoot several times.

Head types

Ball heads allow movement in all directions, whereas two- and three-way heads offer more control in either direction.

Ball head

Two-way head

Three-way head

Monopods

A single adjustable pole can improve the shutter speed at which you shoot by about a factor of two. If you are hiking, look for a walking pole that is equipped with a screw thread that will accept a small tripod head.

Mini-tripods

Surprisingly useful, and light enough to carry without noticing, mini-tripods may lack elevation, but there are often surfaces to give height, such as a vehicle roof. One good technique is to press the mini-tripod against a vertical surface, such as a wall.

Camera to Computer

Many high-end digital cameras can be tethered directly to a computer through a high-speed cable, such as FireWire or USB, and then with the help of specific software from the camera manufacturer, the camera can be operated from the computer.

This kind of use is intended mainly for studio shooting, although with a laptop computer, there are no real limits to the kind of location. It makes most sense when the camera is set up on a tripod in front of a static subject, as in a still-life set, and in this kind of circumstance, the computer really can add a new dimension to photography.

The example on the following pages is an automobile shoot in a Nissan auto showroom, using available tungsten lighting, with muted daylight inevitably leaking in from outside. In film photography, the first steps would be to measure the light and the color, set the aperture and shutter speed accordingly, and choose a combination of filter and film (either Daylight or Type B). Then a Polaroid test or, if there were no Polaroid back for the camera (heaven forbid), wide bracketing of both the exposures and the filtration.

Digitally, the exposure and color balance issues are taken care of by the preview, but the striking advantages of shooting direct to the computer are that the image can be viewed large and accurately on the calibrated (of course) screen of the laptop. With the camera on its tripod, everything can be adjusted in comfort from the computer, using the appropriate software—in this case, Nikon Capture 3.5. The control panel offers access to all the essential settings: the ISO-sensitivity, shutter speed, aperture, focus, and color balance. A click of the mouse fires the camera.

The laptop's LCD screen is more accurate and convenient for judging the image than the camera's own small LCD screen, particularly in the critical areas of highlight exposure and color balance. Results can also be judged by looking at the histogram. Because the image that appears on the screen is large, the advantage of being able to go into the real set and alter things is clear. If a client is present, this is also a very useful way of having the image approved on the spot, with no uncertainty. Even if they're not present, there are many means of instant transfer.

COMPUTER CONTROL
Most manufacturers provide software to enable the camera to be used directly from the computer.

1 Half of the menu options are displayed on this first camera-control screen, titled Exposure 1, and include exposure mode, shutter and aperture settings, and compensation.

2 The Image Processing window gives access to sharpening (normally used with caution when shooting), tone compensation (affecting the contrast range), and the color mode for later image-editing. Hue adjustment allows further fine control over color, and noise reduction is checked by default.

3 When the Shoot or AF and Shoot button is clicked, the status window shows the downloading progress as the image is saved, not to the memory card in the camera, but to a selected folder on the laptop's hard drive.

4 In shooting a high-performance Nissan car, the technical issues are high contrast (hold the specular highlights) and color balance (mixed tungsten and cloudy daylight), calling for a carefully chosen white balance compromise.

Status

Download folder: Bimbo:Users:michaelfreeeman:Pictures:

29.14 GB available on this volume

Number of images downloaded in this session: 0

Last image saved:

Current task: Downloading image

Canon users will find a tool called Camera Window with their application suites which can perform similar functions using a simulated LCD display. Here, for example, the exposure compensation has been selected, and can now be adjusted using the cursor keys or icons beneath. The large round button acts as the shutter release, after which the resulting image is passed to the Browser program (below).

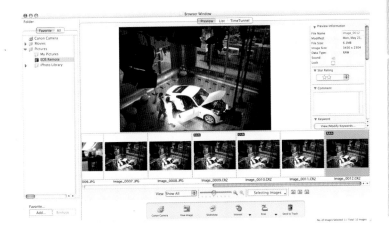

Traveling with Equipment

On the whole, digital equipment is a little lighter than conventional kit. However, thanks to the electronics involved, digital kit requires more accessories in the form of batteries, cables, and adapters if you're traveling abroad.

This means that there is an even more marked difference between what you need to travel with and what you need for actual shooting. So it makes more sense to consider dividing the packing between a case for transportation and a bag for shooting while simply walking around. A backpack is worth considering for hiking, climbing, and other outdoor photography. For transportation, well-

padded protection is a high priority, given that digital equipment tends to be delicate.

The three worst conditions for digital equipment are water, dust, and heat, and the best protection for the first two is a properly sealed case—meaning with a gasket or rubber ring of some sort. Water shorts electrical circuits and corrodes metal parts (though there are fewer of these than there used to be). Salt water is the worst of all, while light rain simply needs wiping off. Full immersion, on the other hand, is likely to cause a write-off. If it happens, remove the lens, open everything that can be opened, and dry the camera quickly.

This Latigid case from Lightware is padded, but designed to be stacked.

Rigid plastic cases, like this from Pelican, are a superbly protective environment for a camera, but their padding can be limiting.

Cases made of light, shiny metals reflect heat and are very sturdy. Some are even strong enough to stand on for a better view.

SECURITY
A padlock is a vital precaution when traveling. Regrettably there are a number of places where you should be on your guard against hotel staff and even airport workers.

Packing checklist

Camera body
Spare battery
Battery charger and cable
Plug adapter
USB or Firewire cable, camera-to-computer
Laptop or image bank
Memory cards
Card reader
Lenses: zooms, wide-angle, telephoto, macro, shift
Blower brush
Lint-free cloth for cleaning
Tripod
Cable release
AC/DC converter
UV filters
Polarizing filter
Neutral grad filter
Rubber pad for removing stuck filters

The danger of dust and sand is that particles can work their way into the camera's mechanism, causing scratching and jamming of moving parts—and most immediately adhere to the sensor. Even a short exposure can be damaging, so in dusty conditions keep the camera wrapped or sealed except for actual shooting. Sand on beaches is insidious because salt makes the grains sticky.

Heat can affect the electronics at temperatures of typically 104°F (40°C) and more. A bright metal case is better at reflecting heat than any other kind. In sunlight in hot climates keep cameras in the shade when you are not using them. Where the air is humid as well as hot, pack sachets of silica gel in with cameras—its crystals absorb moisture. When the silica gel has

absorbed all it can (some types change color at this point), dry it out in an oven.

Cold weather is less of a problem in itself, although batteries deliver less power and need to be replaced more frequently. Cell capacity is very low below -4°F (-20°C), and a little lower than this the electrolyte will freeze (although when it thaws, it will start functioning again). More serious potentially is condensation caused by moving equipment between cold exterior and heated rooms. After cold-weather shooting, warm the camera up slowly, or wrap it tightly in a plastic bag so that condensation forms on the outside rather than inside.

IMAGE EDITING

In the world of conventional film photography, the photographer's responsibility in terms of the final image creation ended more or less with composition and accurate exposure. Processing the film and handling the printing was usually done via trusted and reputable third parties, but with digital imaging all that has changed. Today's photographer must now be fully acquainted with a whole new raft of digital steps and techniques to ensure images appear as they should.

These new digital steps are often collectively referred to as "workflow" and need to be undertaken in an orderly fashion. Of special importance is smoothly integrating the mechanical side of photography with the various procedures on the computer. Software is, indeed, the big new addition, demanding a new set of skills so you can edit your images and show them off in their best light—whether for print or for screen. There are several good software packages for making adjustments to images, but Adobe Photoshop dominates, and is constantly improving, version by version. It's commonsense to assume that most photographers will use it, and the examples in this section follow suit. The aim is to lay out the sequence for handling the image as it moves from one state to another, and from one device to another, to bring out the best in the final edited version.

The Digital Photography Workflow

Much of the digital photography workflow is concerned with preparing the image for final viewing. This involves ensuring that images have accurate colors, a full dynamic range, are sharp, free from blemishes, and so on.

Because so much can be done once the image is on a computer, for most conventional photographers it means a radical rethink in their working method. It stands in marked contrast to shooting color transparencies, where very little flexibility in processing means that the photography virtually ends at the moment of shutter release. If anything, it is more akin to the kind of black-and-white photography practiced with an eye to lengthy darkroom work (think Ansel Adams). Digital workflow needs to be planned, and that implies shooting with a good idea of what can (and should) be done later, on the computer.

Comprehensive workflow

In digital photography, the image workflow typically goes like this:

1 Shooting, ideally as Raw files for later control and flexibility.
2 Transfer images from memory card to an appropriate folder on the computer hard drive: from the camera, or from the card using a reader, or via an intermediate storage step such as a portable image bank.
3 Examine the images in a browser, delete any obvious mistakes, rotate where necessary, rename and reorder if appropriate.
4 Basic edit to identify selects.
5* Make a contact sheet and/or low-res JPEGs to send to client for review, possibly with selected optimized images.
6* Client reviews low-res images and requests optimized TIFFs of some.
7 Optimize selects by opening in a Raw editor and adjusting white balance, hue, exposure, shadows, brightness, saturation, and contrast. Save as 16-bit RGB TIFFs.
8 Continue optimization in Photoshop, adjusting black-and-white points, color, curves, and the saturation and brightness of individual hues. Retouch artifacts including sensor dust. Possibly reduce noise.
9 Where necessary, perform more extensive image editing to content. If editing procedures had been pre-planned when shooting, undertake these.
10 Proof certain images on desktop printer.
11 Embed caption information, and save and archive final images as 8-bit RGB TIFFs. Also archive Raw files. Enter into image database.
12* Deliver final RGB images to client, who signs off on them.
13* Pre-press preparation of images, including CMYK conversion, appropriate sharpening, and dot gain.
14* Color proofs.
15* Corrections.
16* Press date.

Professional assignment.

Flexible Raw

Knowing the power of the imaging tools available in programs such as Photoshop, doesn't it make more sense to divide the work between the camera and the computer? If you can more accurately set the brightness range and the distribution of contrast using Photoshop, isn't it better to adjust the camera settings so that you capture the maximum information rather than go for the best appearance straight out of the camera?

Minimum workflow
(excluding Raw files)

1 Shooting.

2 Transfer images from memory card to hard drive.

3 Examine the images in a browser, delete mistakes, rotate.

4 Identify selects, optimize, and caption.

5 Save and archive all images.

This is the thinking behind shooting in Raw format, in which most of the settings can be altered later. When you press the shutter in Raw mode, as much information as possible is transferred to the file: the highest bit-depth color your camera is capable of recording, the shutter speed, exposure program, f-stop, aperture value, ISO setting, lens, flash, and so on (each camera model creates a slightly different Raw file). Even if you are shooting JPEGs, there are many steps that can be taken on the computer to get the best out of the captured image.

Typical hardware workflow

Once a picture is taken and processed by the camera, it is stored on the memory card. This is transferred to the computer via a card reader (or direct cable connection) before being processed, and then sent to the final destination medium.

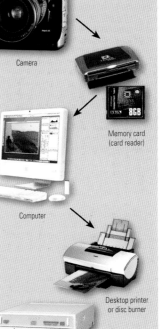

Camera

Memory card
(card reader)

Computer

Desktop printer
or disc burner

Typical software workflow

In-camera processor

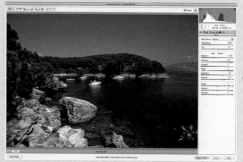

Raw editor

The specific software workflow route your image will follow will depend on the way you work: whether you shoot in Raw, for example, or whether you choose to edit any of your files and, most importantly, what your output medium is likely to be. The first "computing" will always take place in-camera, though with Raw this will simply be saving the information to the memory card. The final step shown here—archiving—is essential for digital photographers. The discs, or whatever medium you create, are as irreplaceable as negatives.

Image database
(pre-press applications)

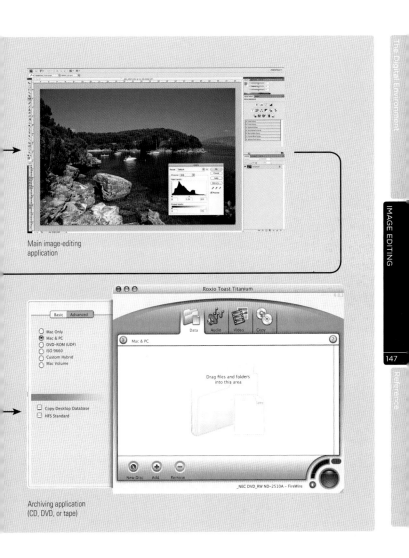

Main image-editing
application

Archiving application
(CD, DVD, or tape)

Computer Requirements

If you intend to undertake all your own post-production work—in other words prepare your images for final viewing—you'll need a high-specification computer system. This is because digital image files are large (and getting larger), are often very complex, and require accurate rendering and powerful (memory-hungry) software to edit them.

Image editing, as we'll see, is the primary function for computers in photography, but other key software applications are for downloading, browsing, databases, printing, slide shows, scanning, archiving onto CDs, DVDs, or tape, and access to the Internet, including sending images to other computers. There are, in addition, very many plug-ins

intended to work with your main image-editing software—these are independently written applications that do not stand alone, but are accessed through Photoshop or whichever image-editing program you choose.

The key performance issue is processing speed, which depends on the chip and is measured in megahertz (MHz) or gigahertz (GHz). It is the main determinant of the cost of the machine, and for processing photographs, the faster the better—and with no upper limit. Multi-tasking is another strategy for improving the workflow, permitting operations such as batch processing to run in the background with little effect on other applications that you might be using. Active memory is known as RAM (Random Access Memory), and in

RAM allocation

For the highest performance in image editing, allocate the maximum RAM and a high cache size to the application, and run that alone. On the Mac go to *Photoshop > Preferences > Performance...* (the Preferences option is accessed from the Edit menu on the Windows version). For technical reasons, Photoshop is limited to accessing a maximum of about 4 GB.

MEMORY
RAM chips, in this case in the form of a DIMM (Dual Inline Memory Module), are relatively easy to fit. Cards like this simply plug into slots inside your computer.

Graphics tablet

A cordless stylus and graphics tablet allow an intuitive way of working, particularly for digital brushwork. The stylus response can be customized to the way you work, for instance, altering the angle of tilt at which it will respond, and the tip pressure from soft to firm.

combination with the processing speed determines how quickly you can open and manipulate images. Like processing speed, it is almost impossible to have too much, and the ideal for image-editing is about five times the size of the image file. This file size can easily grow beyond what you might expect. Take a 10-megapixel camera. The RGB image from this will be 30MB (10 × 3 channels) in 8-bit colour, but 60 MB if you choose to save as 16-bit. If you then start to add layers, it will become much bigger still. And you might well want to open more than one image at a time, for comparison or compositing. At the very least, you will need RAM of three times the image size if you are to work within the active memory, because the program needs to hold copies of the image while you make changes.

A workaround to insufficient RAM is virtual memory, in which free space on the hard drive is used temporarily as memory—useful, but it slows down performance.

In choosing an operating system—which essentially means choosing the computer itself, consider the following: performance, ease of use/ease of interface, software availability, and cost. Of the normally available operating systems, Windows is by far the most common, although Apple Macintosh machines are more widely used by imaging professionals for reasons of speed, ease of use, and tradition. Unix and Linux are extremely robust systems (and indeed Mac OS X is based on Unix), but suffer from having a limited range of image-editing software written for them. Photoshop is available for Windows and Mac and works equally well on either platform.

Peripherals are the extra pieces of hardware that connect to the computer. What you choose depends on what is already built into the computer (perhaps a DVD writer), and on your preferred way of working (such as using a graphics tablet instead of the mouse).

Long-term storage

External hard drives are fast becoming the only sensible archiving method, and capacities are increasing all the time. RAID units (Redundant Array of Inexpensive/Independent Disks) are grouped hard drives with a combination of software and hardware that preserves data integrity in case of the failure of one. A simpler alternative is mirrored hard drives. Some photographers use DVDs as an extra level of archiving safety.

Monitor Types

If undertaking serious post-production work on your images, it's essential that you give serious thought to the type and quality of your monitor. The monitor is the primary interface between your image data and how it will eventually appear in print or on-screen. Spare no expense on it.

The four main decisions are size, brand, and model, and whether cathode-ray or active-matrix LCD (also known as TFT).

CRT (cathode-ray tube) monitors follow the traditional television design, with electron guns at the back of the tube firing toward the inside of the phosphor-coated screen. This is tried-and-tested technology, not particularly expensive, but the necessary depth of the tube makes the monitors bulky—and large displays, such as 20in, are heavy pieces of equipment.

LCD displays are the alternative, and their technology has improved to the point where the best models offer superior brightness, saturation, and sharpness, all without bulk. An earlier disadvantage was the limited viewing angle, which meant that even a slight shift in your position altered the apparent brightness of the image on the screen. This was not merely inconvenient; it made accurate judgment of brightness and color very difficult, but now, in good displays, this has been overcome. Failed pixels, appearing as white dots, are also now less common—there should be no more than four on a new display. Laptop screens without backlighting, however, are still not up to standard for accurate color and brightness judgment. If you use a laptop for shooting and downloading, try to defer optimization until you can put the images on

Palette monitor

If you have sufficient space, consider a second, smaller monitor display for the various palettes and windows needed for the software application you are using, such as Photoshop. This avoids obscuring parts of the image, and allows you to run the image full-screen. An alternative to this is a wider-than-standard cinema display, on which the palettes can be positioned to one side of the image.

Monitor setup

The eye is so good at adapting to different light levels and color casts that it actually works against us in setting up the monitor. The following precautions are essential:

1 The light levels in the room should be low, meaning around half the brightness of the screen. Too bright and you will not be able to register pure black, too dark and you may end up editing the image so it is too dark.

2 The room lighting should be somewhere close to "artificial daylight"—D50/5,000K.

3 The room interior should be neutral, not brightly colored. The same applies to your shirt or blouse—it will reflect a little in the screen.

4 Set the desktop pattern to neutral mid-gray. This will give the eye a constant neutral reference.

5 An optional accessory, which you can build yourself, is a black projecting viewing hood over the monitor. This can be cut back toward the base of the screen as its purpose is to shield reflected light from above and the sides.

the main home or studio computer. Otherwise, limit yourself to adjustments that can be made by the numbers instead of visually, such as setting black-and-white points.

It is essential to calibrate monitors as a first step toward overall color accuracy. At the very least, this means representing neutral grays as neutral, and ideally this should be not only for the mid-tones but also for the blacks and whites. This is dealt with on the following pages, but the conditions under which you view the monitor are also important. There are two issues here, and both relate to the surroundings: One is the ambient light level, the other is the ambient light color. Perception is always relative, and both brightness and color are judged by the eye in relation to adjacent parts of the scene. If the surroundings, for instance, have a yellowish cast, the eye will tend to over-compensate and see the screen as more blue than it is. What matters most is consistency. The eye is very capable of accommodating to different light levels and color casts, perhaps rather too capable. As a rule of thumb, try to keep the brightness level in the room where you keep the computer at about half the level of the monitor screen. A completely darkened room will allow you to distinguish every shadow detail, but it will also push you to edit images that will appear too dark under normal conditions. A bright room will have the opposite effect. The ideal is complete artificial lighting with daylight color-corrected lamps, but this may well be impractical, not to mention less pleasant than an office with a view of the garden. Consider translucent neutral roller blinds to cut down direct sunlight. The color temperature of daylight fluctuates also, so take this into account. For the same reasons, it is best to have neutrally painted walls, and above all, a neutral gray desktop pattern.

14-bit display

14-bit processing, as in the Eizo range of monitors, gives 16 times more grayscale accuracy than 10-bit processing, and because of the gamma scale, this means a much greater degree of color detail in the shadows. However, 14-bit monitors are considerably more expensive.

LCD monitors

High brightness and contrast levels.
No glare from screen.
All-digital signal means no distortion.
Viewing angle not an issue, as it is with smaller laptop displays.
No flicker as with CRTs.
In some cases less power consumption than CRTs.

Calibrating your Monitor

Calibrating your monitor is essential if you want to render color accurately and consistently.

For good color management, using system level color software (introduced by Apple in 1995 as ColorSync 2 (now ColorSync 4) and later by Microsoft in Windows 2000 and XP), your computer will automatically go some of the way to setting the displayed colors by accessing the monitor's ICC profile. This, however, is only a starting point.

At the very least, use the system's calibration setup assistant to work through the settings. The key steps are to adjust the brightness and neutrality of the black, white, and mid-points; to set the gamma (see opposite for definition); and to set the color temperature. The resulting settings are then saved with the name of your choice as a profile.

The standard gamma for Windows is 2.2, which is higher (therefore darker and more contrasty) than the standard for Macs, which is 1.8; although this is set to change as with OS 10.6, or Snow Leopard, which has a default gamma of 2.2. This means that images optimized on a Mac with default gamma 1.8 will appear darker and more contrasty when viewed on a Windows machine—and there

are many more of these than there are Macs. Conversely, images prepared on a Windows PC will tend to look paler than expected when seen on the screen of a Mac. This is an issue mainly for Mac users, and there is a difference of opinion, even among experts, when it comes to choosing the gamma for a Mac. If you work entirely within a Mac system, then native 1.8 gamma is clearly the way to go, but if your images are likely to be viewed or reviewed on PC monitors, there is an argument for working in 2.2 gamma— because that is how others will see the photographs. There is also room for choice in the color temperature of the target white point, which for use in a normal daylit room might be 6,500K, but in a color-corrected studio could be 5,000K.

With Macs, there is a built-in Display Calibrator Assistant, which can be found in the System Preferences menu (under the Color tab of the Displays panel). Windows computers have never had a direct equivalent, although Adobe Gamma installs into the Control Panel as you install Photoshop CS2 and earlier versions. Photoshop CS3 and later, however, do not do this, although third-party solutions are available.

Gamma

Gamma is a measure of the slope or gradient of the response of an imaging device or medium to exposure. It is the result of plotting density against log exposure, and so is one way of representing the contrast of the middle useful section of the curve. It is therefore a good way of representing the intensity output of a monitor screen relative to the input. Raising the gamma is similar in effect to moving the midtone slider in *Levels* to the left—it brightens the image without affecting the black and white points. Lowering the gamma does the opposite—it darkens the image. Another way of putting this is that gamma is the intensity of the output signal relative to the input. The minimum input is zero and the maximum is one, so that the default value for gamma is one—output equals input in a linear curve. In practice, gamma can be set to between 0.45 (bright, weak) and 3.00 (dark, intense). Note that the human eye's response to gamma is a subjective one of brightness and contrast. Due to the different ways in which Windows and Macintosh systems process the video signal, their default gammas are different—2.2 for Windows and 1.8 for Mac. Although this has changed recently with the introduction of OS 10.6 (Snow Leopard) which has a default gamma of 2.2.

Standard Mac gamma 1.8

Standard Windows and television gamma 2.2

Calibration with Windows

In Windows, there is no default monitor calibration tool. However, included with Photoshop and Photoshop Elements— but no longer automatically installed—is the *Adobe Gamma* tool. If installed, this will appear in your *Control Panel*. Simply open it up in the usual way and (depending on your version of Windows) select the *Other Panels* or *Classic* views to locate it.

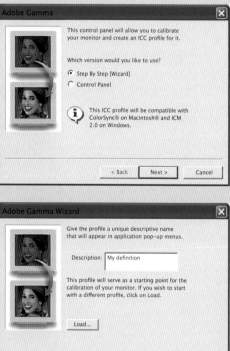

1

2

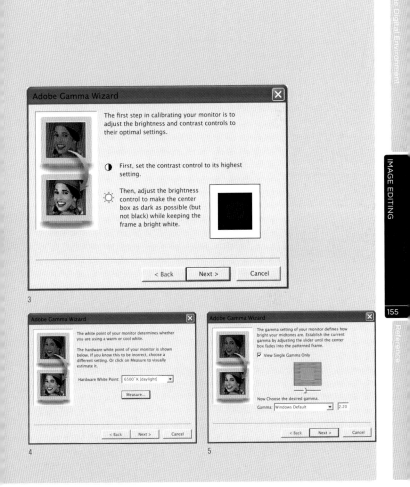

Adobe Gamma Wizard

The first step in calibrating your monitor is to adjust the brightness and contrast controls to their optimal settings.

First, set the contrast control to its highest setting.

Then, adjust the brightness control to make the center box as dark as possible (but not black) while keeping the frame a bright white.

< Back Next > Cancel

3

Adobe Gamma Wizard

The white point of your monitor determines whether you are using a warm or cool white.

The hardware white point of your monitor is shown below. If you know this to be incorrect, choose a different setting. Or click on Measure to visually estimate it.

Hardware White Point: 6500° K [daylight]

Measure...

< Back Next > Cancel

4

Adobe Gamma Wizard

The gamma setting of your monitor defines how bright your midtones are. Establish the current gamma by adjusting the slider until the center box fades into the patterned frame.

☑ View Single Gamma Only

Now Choose the desired gamma.

Gamma: Windows Default 2.20

< Back Next > Cancel

5

Calibration on a Mac

To use Adobe Gamma on your Mac, open the *System Preferences* dialog from the Dock, and select the *Color* tab from the *Displays* menu (1). You can then follow the steps on screen (2). You'll be asked to select a target gamma (3): if you're working exclusively on your Mac then stick with the 1.8 "standard." If you're using OS 10.6, Snow Leopard, the standard is 2.2.

1

2

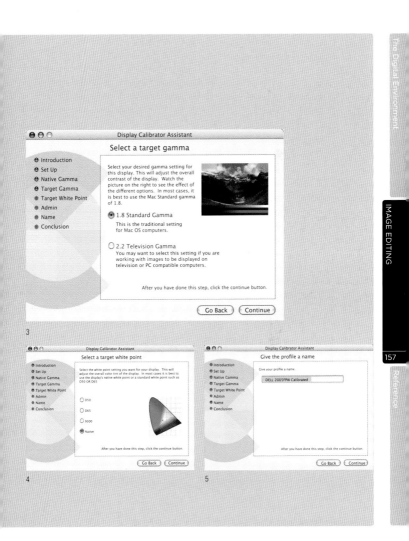

Display Calibrator Assistant

Select a target gamma

- Introduction
- Set Up
- Native Gamma
- Target Gamma
- Target White Point
- Admin
- Name
- Conclusion

Select your desired gamma setting for this display. This will adjust the overall contrast of the display. Watch the picture on the right to see the effect of the different options. In most cases, it is best to use the Mac Standard gamma of 1.8.

○ **1.8 Standard Gamma**
This is the traditional setting for Mac OS computers.

○ **2.2 Television Gamma**
You may want to select this setting if you are working with images to be displayed on television or PC compatible computers.

After you have done this step, click the continue button.

(Go Back) (Continue)

3

Display Calibrator Assistant

Select a target white point

- Introduction
- Set Up
- Native Gamma
- Target Gamma
- Target White Point
- Admin
- Name
- Conclusion

Select the white point setting you want for your display. This will adjust the overall color tint of the display. In most cases it is best to use the display's native white point or a standard white point such as D50 OR D65

○ D50
○ D65
○ 9300
● Native

After you have done this step, click the continue button.

(Go Back) (Continue)

4

Display Calibrator Assistant

Give the profile a name

- Introduction
- Set Up
- Native Gamma
- Target Gamma
- Target White Point
- Admin
- Name
- Conclusion

Give your profile a name.

DELL 2005FPW Calibrated

After you have done this step, click the continue button.

(Go Back) (Continue)

5

Color

In digital photography there is no longer a physical reference (such as film or a transparency) to which people can refer when gauging color accuracy.

When it comes to color, digital imaging allows us undreamed of freedom to make the scene look just how we perceived it at the time of shooting. Managed properly, the freedom that digital photography gives you to adjust the colors and brightness to suit your taste is wonderful, and it puts the photographer firmly in charge. Badly managed, it can be a nightmare.

The scenario that all of us dread is when the image has been optimized and worked on until it looks perfect on the screen, is then printed or sent for repro, and finally appears looking terrible—such as muddy, pale,

unsharp, dark, contrasty, or any of the other things that you have been assiduously trying to avoid.

Be warned that this is a bottomless issue with no single consensus among professionals about the best procedure. This does not mean, however, that it can't be managed. The key is to adapt the way in which you work to the system that you have chosen. This may be a simple closed loop in your own studio or home, in which all your photographs are printed on your own printer, or it may involve sending images to a client or lab that has its own particular way of doing things. If you are a professional photographer, you will often be dealing with several different clients and this may simply mean that you have a set of different procedures. The rest of this chapter will work carefully through all of this.

Color management is the procedure for making sure that the appearance of a photograph remains the same (or as close as possible) as it moves through the workflow. This means that the picture you thought you took stays that way on your computer screen, on other people's computer screens, and on any printer that it is sent to. You may or may not want to get heavily involved in the process, but there is one uncontestable certainty in all this—the photographer is the only person who knows how the colors should look. Obvious though this may sound, it sometimes gets lost in the discussion. It means, above all, that you must deliver the images as you would like them to appear. Nobody else can do that for you. The

It was essential to keep the soft greens in this moss-covered Angkorean bas-relief in order to capture the sense of rain, dampness, and undergrowth.

Sunset over the Nile. A range from pale orange to mauve is set off against pale blue reflections where a breeze has ruffled the water in a muted relationship of complementary color.

Color must be carefully managed throughout the workflow, particularly in cases where the relationship between colors is important. Here, the pink of the man's robe is in almost direct opposition to the hue of the grass.

Brown, which is technically a heavily desaturated red, is the classic broken color, with earthy connotations, as demonstrated in this shot of henna being applied to a Sudanese woman's hand.

161

examples here attempt to make this important point clearer. Even having established a good color management system and having an accurate ICC profile for your camera, as described on the following pages, there still remains a wide and legitimate choice. Consider for instance color temperature. In a late-afternoon shot, would you want a white dress to appear neutral white or warm? There is a good case for either.

We already touched on color when it came to the color space settings for the camera and profiling, but the first place where you are likely to start judging it seriously is on your monitor display.

Managing Color

If you want the colors in your images to appear consistent as the images pass through the digital workflow, from camera, through computer to printer, it's essential that they are managed.

Digital imaging hardware varies in how broad a range of colors each can handle and in how each distinguish colors. Left to themselves, each device will present different color versions of your photographs. In other words, color is device-dependent.

What is needed is a procedure for keeping the appearance of colors the same from shooting to final display. The software that coordinates this is called a Color Management System (CMS for short), and for any serious photography you do need it. The good news is that nowadays color management is at least partly built into the software and devices that you are likely to be using. A perfectly sound system comprises Photoshop Color Settings, an accurate camera profile, and, of course, monitor calibration.

A CMS maps the colors from a device with one particular gamut to another. Obviously this is at its most useful when the color gamuts of the devices are substantially different. Printing presses (and desktop printers) have relatively small gamuts;

certainly smaller than a high-end digital camera. A typical CMS uses a Reference Color Space that is independent of any device, and a color engine that converts image values in and out of this space, using information from the "profile" supplied by each device. The Mac OS has a particular advantage in color management—ColorSync, which is a CMS built-in at system level.

In practice, a CMS works like this. To convert screen colors to printer colors, for example, it first converts the monitor RGB color values to those in a space that is larger and device-independent, such as L*a*b*. It then converts these to CMYK values in the smaller color space of the printer, while changing some of the colors according to the render intent. The render intent determines the priorities in the process, in which inevitably some colors will change.

All of this sounds, and can be, complex. In print production a full knowledge is critical, but for several reasons it is not something for most photographers to get too worked up about. First, the industry is gradually taking care of color management in ways that make it less necessary for individuals to get involved. Color management depends heavily on each device (camera, monitor, scanner, printer, and so on) having a profile. Camera profiles are known, particularly the high-end models that most professionals use. Preserve the profile in the images you save and send, and the client or repro house will be able to deal with it. Second, ask yourself how much you want or need to immerse yourself in print

Color management components

1 A working color space that is independent of the device.

2 ICC profiles for the devices. These describe to the computer the characteristics of each.

3 A Color Management Module (CMM). This interprets the information in the ICC profiles and acts on it.

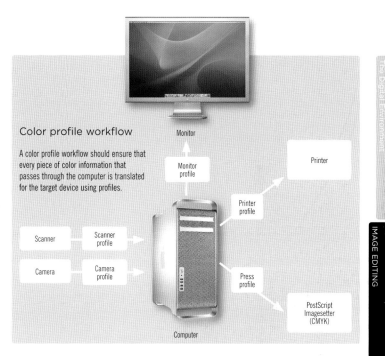

Color profile workflow

A color profile workflow should ensure that every piece of color information that passes through the computer is translated for the target device using profiles.

Monitor

Monitor profile

Printer

Printer profile

Scanner

Scanner profile

Camera

Camera profile

Press profile

PostScript Imagesetter (CMYK)

Computer

production. Given all the software tools available, and the now seamless workflow from camera through to final printing, you may think you ought to, but many photographers think their time and energy is better focused on taking pictures. Third, the default settings for the camera will already be close to standard, every bit as much as a normal film camera with normal film. Moreover, you can measure the important color variables, meaning that as you edit the images on the computer you can check that neutrals are neutral and that specific colors have the right RGB numbers. If you use one make of digital camera, very little will change, and you will become increasingly familiar with its color characteristics. In other words, as

long as you deliver an optimized image, with the shadows and highlights where they should be, and with no distinct color cast (unless intentional), you will have fulfilled your normal photographer's duties. What follows are the basic core skills to do just this.

The only important qualification is that the monitor is calibrated, because this is the color space in which most of the work on a photograph gets done. Calibration is important, fairly straightforward, and nothing to lose sleep over. And there is one golden rule—if for any reason you find yourself making major overall changes to images from a digital camera, something is wrong. You shouldn't have to, and the problem is likely to be in the monitor calibration.

Regular Downloads

The fact that digital images exist as a hugely complex series of binary 1s and 0s renders them extremely fragile in a number of ways.

First, as they have only a digital presence, not a physical one, this puts them at a considerable risk of being altered unintentionally, deleted, or corrupted. The very simplicity and immediacy of recording digital images, which revolutionizes photography in certain ways, also makes them intangible and temporary—until they are processed and stored.

Second, there are no unique originals in digital photography, although Raw files can be regarded as such. Instead, there are versions. In film photography, the exposure onto one frame of film is a unique event, and that film becomes the master image—this simplifies the issue of handling. In digital photography,

there will typically be several versions of any good, useful image, including corrections and small, low-resolution images to send out for easy viewing. To avoid confusion, it is important to set this production train in motion as soon as possible.

At a convenient break in shooting, such as at the end of the day, the initial step is to download the images to a convenient and secure location. In most situations this will be your computer's hard drive, either your main studio machine or, if shooting on location, a laptop. The two usual methods are by either connecting the camera to the computer, or by connecting just the memory card through a card reader. In either case, it is important to choose appropriate browser software to control the downloading (also known as ingesting). In the following example, the browser is Photo Mechanic, which offers a number of useful

Modern DSLRs, with their high-resolution sensors, create large image files. No matter how large the storage capacity of the memory card, sooner or later you'll have to download the images from the card to a more permanent device.

options, such as incremental downloading (adding just the new images shot on a memory card since the previous download) and sequential filenaming. The software can also be set up to launch as soon as the camera or memory card is connected. Alternatively, if you are using someone else's computer, for example, you can copy the files from the card as you would from any external drive.

A daily download to a portable computer provides an excellent opportunity to back up your photographs and type up notes. Laptops can be very lightweight, so are ideal for traveling photographers.

At this stage, or soon after, enter all the images into your standard filing system. The camera will already have numbered the images in its own way, and although on a high-end camera you can alter this to your own preferences, the file-names are unlikely to be exactly what you would like. Changing or adding to the file-names while you are shooting takes time and distracts from actually taking pictures. The time and place to do this is on the computer, and if you do not rename the image files, there is a risk of overwriting them. It is common to have different images from different shoots sharing the same file-name—and it's a recipe for disaster.

Backing-up

Step three is to put into practice your back-up regime. Depending on how you plan this, you may want to make an immediate back-up, typically onto an external hard drive. It is important to remember that at this stage you are securing the raw, unedited image files, not retouched or corrected versions. That comes later. The browser software should allow you

to rename files, even automatically (although be very careful with this if it does not allow you to undo or revert).

The procedures up to this point are the basic minimum for safety. The workflow sequence continues, although how much you choose to do daily is up to you. If you are shooting professionally for a client, you will need to present the images in a viewable way. In the first instance, it would be normal to prepare low-resolution files in a universal format, such as JPEG. If you are shooting in Raw format, the simple solution is to take the selected images that you want to deliver, and batch-process them to create smaller-sized copies in a new folder.

Download workflow

The first time your files are on a computer is the first real opportunity you get to ensure that you're using the correct file-names and that any important metadata is added. You can refine everything later, but the sooner you create back-ups, and the sooner you type up the day-to-day details from your notebook, the safer your pictures and information are going to be.

The best way to ensure that your photographs are always safe is to follow the same procedure reliably. The sequence here uses Photo Mechanic.

1 Copy images to hard drive, either direct from the camera or via a card reader. If you store your images on an alternative storage device such as an image bank, copy from this instead.

2 It is a good idea to rename your files when you download them. This will help you avoid overwriting existing files that have been named by the camera if it numbers your shots from the same starting point each time you format a memory card.

Do you want to burn the disk "2010_05_03_backup"?

You can use the disc on any Macintosh computer or PC.

Burn Speed: Maximum

Eject Cancel Burn

3 Make a backup of your images to CD or DVD.

4 Make an initial edit, rotating any selected images that need it.

Rotate Image(s) DSC_2344.NEF

Apply to all

Close

CCW 90°

CCW 90° CW 90°

Apply Skip

5 Batch-process copies of these selections. If you're importing Camera Raw files from the same session, you can apply your settings to the whole batch. In Photoshop's File Browser, select *Automate > Apply Camera Raw Settings...* either to create settings for a batch, or select one image and copy the settings from that.

Apply Camera Raw Settings

Update: All Settings

Selected Image

Update

Cancel

☑ White Balance
☑ Exposure
☑ Shadows
☑ Brightness
☑ Contrast
☑ Saturation

☑ Sharpness
☑ Luminance Smoothing
☑ Color Noise Reduction

☑ Chromatic Aberration
☑ Vignetting

☑ Calibration

Adjust Detail Lens Calibrate

○ Basic
◉ Advanced

White Balance: As Shot

Temperature

Tint

Exposure +0.80

Shadows 0

Brightness 50

Contrast +43

Saturation +14

6 Deliver the copies. Send copies to your client or to a secure server.

Intermediate Storage

One thing that hasn't changed with the advent of digital photography is the planning required when shooting on location for more than a day or two.

Although you no longer have to estimate the quantity of film you will need, or plan to replenish stock at dealers along the way, you do have to plan for storing the images in digital media; more than that, you need to have a sensibly worked out "production flow" of image transfers that will keep pace with the way you shoot.

The numbers are easy to calculate, and start with the file size of one of your typical image. Memory cards are relatively expensive storage media, and the faster you can transfer the images to less expensive media, the better. The most efficient strategy for long-term

shooting (over a period of time, such as when traveling) is to have sufficient memory cards to be able to continue shooting until you can empty them conveniently onto a larger hard drive. The quantities depend on your individual way of shooting and on the kind of subjects that you expect to come across on a trip—parades and special events, for instance, tend to consume images faster.

This shines the spotlight clearly on portable long-term storage, and the most immediately obvious answer is to carry a laptop and download images onto its hard drive with additional small external hard drives. For additional safety, add extra levels of backup by transferring files from the laptop also to, for instance, an iPod and cell phone. An alternative is a stand-alone

Creating CDs or DVDs

More recent computers, whether Mac or Windows PCs are now capable of burning CDs without recourse to additional software. The process is one of simple drag and drop, though it is worth remembering that CD-Roms can only be written to once, so try to use as much space as possible.

Do you want to burn the disc "2010_05_03_backup"?

You can use the disc on any Macintosh computer or PC.

Burn Speed: Maximum

Eject Cancel Burn

You inserted a blank CD. Choose what to do from the pop-up menu.

Action: Open Finder

Name: 2010_05_03_backup

Make this action the default

Eject Ignore OK

portable storage unit that features a small, typically 2½–in, hard drive and a port that accepts memory cards directly. There are several models available, with capacities up to 160GB, that can be AC or battery-powered. These PDA-sized devices, which weigh in the region of just a few ounces, are convenient enough even to consider carrying in a shoulder bag as you shoot. All of this bypasses the computer completely. This is an improving technology, so monitor the latest developments: the first generation of portable storage devices often did not even have a viewing screen.

For short-term back-up protection, it's also sensible to aim to transfer the images, or at least those selected, onto non-digital media, of which the cheapest and most

practical are CD-ROMs and, for larger quantities, DVDs. This makes a laptop with CD- or DVD-burning ability useful.

In digitally developed countries, many film-processing labs and camera dealers offer inexpensive copying from memory cards onto CD-ROMs. If you check in advance that this service is available at your destination, it saves time and effort and removes the need to carry your own storage media. Even in less sophisticated places, if you have a card reader you could look for an Internet café or computer center, or even the business center of a hotel, that would be willing to download your images and then burn them for you onto a CD-ROM or even a DVD.

Portable hard drives

There are a number of portable hard drives available with a preview screen. The input port accepts any of the standard memory-card formats, while USB or Firewire output allows the images to be downloaded to a computer at the end of a trip. Indeed, many portable hard drives can be used for image storage, even music players such as the iPod.

EPSON P-7000
With a 4-inch LCD screen and a 160 GB hard disk, the P-7000 provides excellent storage and playback. Images can be copied directly from the CF or SD card slots to the hard disk, making this a handy traveling companion.

BELKIN MEDIA READER FOR IPOD
The iPod is ubiquitous these days, and if you have one, there is no need to invest in a portable hard drive. This Belkin adapter allows you to back up images to it via a USB socket. Some iPods, however, are not compatible.

Image Browsers

Image browsers are an important and integral part of the digital software workflow. They allow you to organize images into folders, give the files meaningful names, and view them.

Browser software is normally supplied free by the camera manufacturer, but may not be as useful and well-designed as standalone software designed to work with all standard cameras and formats. With the increasing use of Raw shooting, it is important that the browser you use is capable of reading this manufacturer-specific file format, and that the software designers are committed to keeping pace with updates and new camera models.

In normal shooting the images are downloaded from the memory card to the computer through an interface cable that is normally USB or FireWire. This can be done either directly from a port on the camera, or by removing the card and inserting it in a

Naming and numbering

Even if you accept the default method, your images will be given a name or number identification as they are transferred. Typically, there are three parts to this—a prefix, an identifier, and a suffix, the latter separated by a period. You may choose to assign a permanent file-name that fits into your long-term filing system as you download, or deal with this later when you have more time. In the latter case, the browser has an automatic batch-renaming program.

Rename file(s) (112 files)

Choose method:

○ Add suffix to the original file name

Suffix: Rename

Sample: imgRename.jpg

● Rename with new numerical sequence

Prefix: April10.

Number of digits: 3 digits

Sample: Apr10.001.jpg

Cancel Start

File-naming conventions

Windows
Although in the past Windows allowed only 8-letter file names, these days there is just one practical restriction on file naming: never use a period (.) since Windows traditionally uses these as the divider between the file-name and extension (for example name.jpg is a JPEG file). In Windows XP, Vista, and Windows 7, where long file-names are supported, the maximum length is 255 characters.

Macintosh
The maximum length for legacy systems (before OS X) is 31 characters. More non-alphanumeric characters are allowed than for Windows (for example the period), but if images are to be used cross-platform or transmitted by e-mail or FTP, it is better to stick to the conventions mentioned above.

card reader which is plugged into the computer. The transfer software, which is either part of the browser or linked to it, allows you to select which images to transfer, to choose transfer options, specify the destination folder, and choose how the images are to be numbered or named. Take care to avoid over-writing image files with the same name, although the software will probably anticipate this and either give a warning or else assign different file-names. Some cameras are equipped with a dedicated transfer button.

Browsing

A browser such as Adobe Bridge (included with Photoshop), or external software such as iView Media Pro, allows you to view images, and make changes to file information, including the metadata.

Rotating images

Some cameras are able to sense when they have been turned to shoot a vertically composed image, and embed this data so that the browser can automatically rotate the image. Otherwise, you can identify and rotate vertical images manually in the browser. There is a slight risk of image degradation if you do this with JPEGs, but some browsers compensate for this by rotating JPEGs without decompressing them first. Check the browser manual for the recommended procedure.

The importance of metadata

Metadata is embedded file information, some added by the camera, some by the user. It includes the following:

File Properties
Characteristics that include size, creation, and modification dates.

Camera Data (EXIF)
Added by the camera, EXIF information includes the camera settings that were used when the image was taken, such as the time, date, ISO, shutter, aperture, and other extended details. EXIF (Exchangeable Image File) format is an industry standard developed by JEIDA (Japan Electronic Industry Development Association).

GPS
Some digital cameras have GPS (Global Positioning System) technology that allows the location of a photograph to be recorded.

Edit History
A log of changes made to an image.

IPTC
The only user-editable metadata, this allows you to add caption and copyright information to an image.

Viewing the EXIF camera data in the Nikon browser.

Editing the IPTC metadata.

Databases

Databases differ from browsers in that although it's possible to view images with database software, their primary function is to help you manage a large collection of photographs.

In order to make the most efficient use of a database, you will need to plan from the start exactly how you allocate file names. There are many possible ways, but whatever you choose it must be logical and allow easy searches. Most large image databases use a numerical identifier, but you can add a

secondary description. Searching is normally performed on keywords. There may be occasions when you need to save different versions of an image, and these will need either a different suffix (for instance, .jpg and .tif if you save an image in two file formats) or some extra identifier. For instance, you may want to keep both an unsharpened and

Database tools can rename your files in batches, and add serial numbers. Expression Media's thumbnail view is an efficient browser.

Editing EXIF data

EXIF data is embedded in the image by the camera, and includes time, date, ISO, shutter, aperture, and more. There is limited software available for altering it, because in principle this is useful information that other programs can use, such as databases, noise reduction software, and others that rely on knowing the precise settings. Nevertheless, there are reasons for wanting to make changes, and the most common is to correct the time and date—it is all too easy to forget to change the camera time and date settings when crossing time zones. Some databases permit limited adjustments; iView MediaPro, for example, has a time and date change function. Otherwise, use command-line instructions in a specialized program such as EXIFutils, but use with extreme care, as changes are non-reversible.

sharpened version, in which case you could use something similar to the following: "15624_flamingo" and "15624_flamingo_usm". Check how your database handles attempts at duplicating filenames, as it is essential to avoid overwriting original images unintentionally. Workflow software may avoid the need by means of its non-destructive editing features.

There are several contenders, and the one featured here is Expression Media (formerly known as iView MediaPro), not least because I use it. There is a considerable amount of work involved in using a database, and it is continuing work, so selecting one demands some thought. Unless you opt for workflow software that incorporates database functions, your database should be the core of your picture-managing operations. The more it allows you to do, including selection,

captioning, moving and copying files, and so on, the more useful it will be.

One decision to make early is whether to use the database for importing/uploading/ingesting images from the camera or memory card, or whether to do this with a browser. The advantage of using the database is that it keeps one more operation under a single roof. The possible advantage of using a browser to do this is that the browser may be quicker and more flexible.

New Workflow Software

Recent innovations in workflow software have seen the emergence of a number of programs that attempt to offer a "one-stop shop" solution to digital imaging workflow.

Examples of such software included Adobe's Lightroom, Apple's Aperture, and Phase One's Capture One.

What they all aim to replace is the workflow model that relies on a browser to

LIGHTROOM

Lightroom's Develop mode offers all the same features as Adobe Camera Raw, which is no accident. Edited, the image does not affect the original file; instead a list of changes is kept in Lightroom's database. When the image is exported the changes can be implemented, or saved as a "sidecar" file which the next application can use to apply the changes. This is why there are few pixel edits, aside from some cloning (where source and target points can be referenced).

download, an image database to organize, and Photoshop to do post-production. The advantage of one-stop software is speed and neatness, and the ability to concentrate on essentials rather than pick through the many features of the latest Photoshop that are of little value to photography. Against this, they require learning a new workflow system, creating a resistance among photographers

who have invested years in learning the "traditional" photographer's workflow.

In order to streamline the workflow and create an attractive visual interface and experience for users, the major workflow software programs have, to some extent, buried the workings of the post-production tools that are more transparent in Photoshop, and there are divergent views on whether or not this is a good

thing. For photographers with long experience of Photoshop and who prefer to stay firmly in control of image quality, there may be no clear advantage in changing their tried and true system, but for photographers who are either new to digital imaging, or who prefer to limit their involvement to the essentials, this kind of software may be ideal.

The main contenders in this software market vary in their approach, and are also constantly upgrading and evolving, as this is a relatively new area that still calls for user feedback. Three

features that all have in common, however, are a Raw-focused approach, strong comparison and selection tools, and non-destructive processing.

Assuming that most original files will be in a Raw format is sensible, given the target audience of serious amateurs and professionals; compare-and-select procedures are essential for a program that promises to handle a large shoot which must eventually be whittled down to a few selects; and non-destructive processing, while not breathtakingly new, is one way of preserving the original files while

Workflow

Import Images
Workflow software will generally allow a wide range of options when importing images, including whether you create a copy of the file, move it into a folder organized by the application, or simply reference it. You can also add your copyright presets and any keywords for the batch of images you are importing.

Organize
As with database applications, a fully featured browse view allows you to sort through your images, add and search on keywords, perform renaming operations on your files, and so on. Although renaming is permanent, most information about your images is stored in the database rather than altering the files.

Review, rank, and select
Viewing images full-screen and adding ratings is a quick way to isolate good shots.

Process
This is perhaps the key differentiator between

workflow software and databases: that it is posssible to enter into an edit mode and make changes to the image, both wholesale fixes and some local repairs.

Distribute
Lightroom, for example, can generate HTML or Flash web pages, slide shows, and of course various prints including contact sheets.

Re-Order
It is always possible to go to the browser and re-arrange or sort the database.

allowing them to be processed. Key technical issues still being addressed are performance speed for various operations, open architecture, and the possibility of third-party plug-ins in the future. As it stands, these can be very efficient and intuitive tools, if for no more than the ability to scan quickly through images at full-screen, identify the best, and begin that work without leaving the program. The full range of tools, all of which are non-destructive and light on storage consumption, is a huge bonus.

A few more words on non-destructive processing—in principle, this simply means keeping the various steps in post-production, such as setting black and white points, curve corrections, sharpening, and so on, as separate instructions, and there are other ways of doing this. It happens in the camera, of course, whenever you shoot Raw. Raw converters such as Camera Raw save the settings last applied to an image as a sidecar file, while Photoshop CS3 and later has a *Smart Filters* feature that can be applied to a *Smart Object* layer.

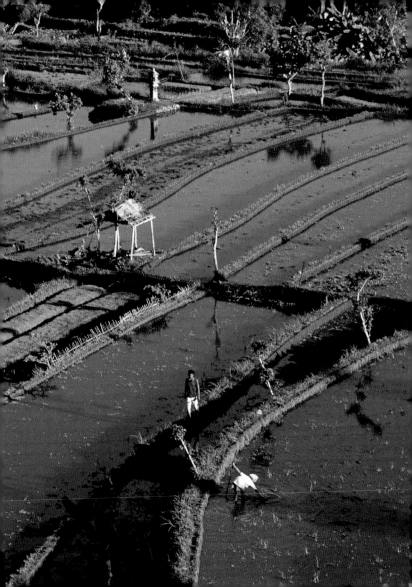

Captions and Keywords

An important part of managing your images is using captions and keywords. These can be added at any stage of the workflow, and help to make accessing and retrieving images quick and easy.

The standard for doing this is called IPTC (International Press Telecommunications Council) and it includes entries for descriptions, keywords, categories, credits, and origins. This is important not only for cataloging, but also for selling reproduction rights in images. Captioning images may seem like a chore, but now that stock sales play such an important part in the business of photography, it is essential. Noting the key details of what you shot is useful for your own records, but the real reason is so that other people can find your images. This is very much a feature of being digital and online because the descriptions that are easily attached to the image file can be used by search engines. In pre-digital days, there were only two ways for a picture researcher or art director to find a specific photograph: call up stock libraries and ask, or look at the printed catalogs from the same libraries. Now stock-agency websites allow the people who want pictures to search for themselves, and understanding how that happens in practice helps to sell images.

Captions sell photographs. At least, they sell content-based photographs, and the more specialized the subject matter, the more important it is to know exactly what you shot. The best time to do this is on the spot, while you can still ask, and before you forget. A notebook or tape recorder are the easiest means; inputting directly into the camera seems efficient, but takes longer. As part of a normal workflow, captioning fits most easily into the image editing, either before or after

The Five Ws

Who Name if famous, newsworthy, or relevant. Ethnic origin. Job or position if relevant. Gender if a baby.

What Decide first whether action or object is the subject (consider what motivated you to take the picture). If action, describe it in first sentence. If object, give name (if a known building, landmark, geographical feature), description, and if a plant or animal, give the scientific name. In some cases, the concept will be appropriate—that is, an idea that you were trying to express (such as harmony, love, security).

Where Location as precisely as possible, ideally with a hierarchy (e.g. Montmartre, Paris, France).

When Date.

Why If the action is not immediately obvious to a viewer, explain it (usually in the second sentence).

optimization. A successful caption is informative, focused, and succinct, and the first skill is to identify the salient facts and then prioritize them. With stock images, the aim of the caption is to present all relevant information to other professionals rather than general readers, while the keywords add to the searchable information. All this information can be extracted by image-management programs and other databases. The time to enter the caption information is

Creating keywords

- Keywords supplement the caption for the purpose of searching.
- There is no need to repeat a word that is already in the caption/description.
- Too many keywords is as bad as too few. Aim for no more than 10.
- Think of what words your target audience is likely to use (for example, a natural history picture researcher may use the scientific name).
- Include different spellings and usages (for example gasoline/petrol).
- Include the plural unless it simply has an "s" added.

as early as possible in the inevitable chain of image versions and copies. It may be worth maintaining a master caption list in a word-processing program as a reminder of which images have already been captioned and also as a source for cutting and pasting. Several images may share the same basic information, or at least some of it—you could then copy parts of entries from the master list into Photoshop's File Info for each new image. Alternatively, save the metadata where it can be retrieved from another image's File Info dialog (*see Metadata in Photoshop*, below).

Metadata in Photoshop

Metadata can be viewed and edited either in the Metadata palette of the File Browser or in the various windows of File Info (*File > File Info...*). Having entered the IPTC information (caption under Description, keywords, copyright information, and so on) you can save this for future use in other, similar images: either save as a Metadata Template or as an XMP (Extensible Metadata Platform) file from the *Advanced* tab of the *File Info* window in Photoshop.

6965.07_Dashimaki_Tamago

Description

Document Title: 6965.07 Dashimaki Tamago

Author: Michael Freeman

Author Title:

Description: Dashimaki Tamago, a Japanese egg roll. Made with beaten eggs and Japanese dashi (a flash and seaweed-based soup stock), rolled and sliced.

Description writer:

Keywords: cooking, eggs, omlette, cuisine, food, yellow

ⓘ Commas can be used to separate keywords

Copyright Status: Copyrighted

Copyright Notice: ©Michael Freeman

Copyright Info URL: http://www.michaelfreemanphoto.com

Go To URL...

Created: 2/9/10
Modified: 6/5/10
Application: Adobe Photoshop
Format: image/tiff

Powered By
xmp

Cancel OK

(Left side menu list:)
Description
Camera Data 1
Camera Data 2
Categories
History
Illustrator
Adobe Stock Photos
IPTC Contact
IPTC Image
IPTC Content
IPTC Status
DICOM
Origin
Advanced

Keywords

Being able to retrieve images quickly and easily is the core function of any image database. As images accumulate in the database, it becomes increasingly difficult even for the person who took them to remember the details. If you want other people to be able to search through your library of pictures, for instance if you are selling them as stock photography, you will certainly have to anticipate how they might search. The software issues are highly technical, but common to all is the concept of keywords. These are words describing some aspect of an image; when someone enters a word in the search box of the database, the program will look for images that have the same word attached. The more varied yet relevant the set of keywords attached to each photograph, the better the chance of matching the searcher's request. The trick is in imagining what other people might look for, beyond the obvious description. Where there is competition, it is of great benefit to have spent just a little more time and energy adding keywords than your competitor, though obviously it's important that your database doesn't "cry wolf" by using keywords that don't describe the picture.

In this database, the fields to complete are: Short Caption, Long Caption, and a list of Keywords. The short caption, "Dashimaki Tamango, a Japanese egg roll" does not tread on the toes of the Keyword list: cooking, eggs, omelette, cuisine, food, yellow.

Long-term Storage

Unlike film and transparencies, which have a physical fragility and are susceptible to being scratched or suffering some other type of damage, digital files in one sense are much more robust.

However, as we know digital files can easily become corrupt or even lost, so it's important to keep them safe.

Your computer's hard drive, no matter how large, will eventually fill up, and for this reason alone it is important to move the files to other media. Moreover, having a backup is a part of good computer housekeeping—remember that the high-volume solution for most people is an external hard-drive, and preferably more than one. Mirrored hard drives, meaning one carrying an exact copy of the other, are standard insurance. In addition, depending on the volume you shoot, yet another backup

on a DVD has the advantage of being a different medium, and non-magnetic. DVDs are also universal and compatible. Most computers come fitted with a CD-writer at least, and some with a DVD-writer. The various flavors, as they are known, are described here. Backup policy involves two actions: make an identical copy of everything you store, and keep it in a different physical location.

There are many backup programs available. The simplest, but least efficient method is to simply copy all the files onto the destination. True backup software allows you to perform incremental additions, making it unnecessary to copy existing files over again. As a general rule, backup software that devotes a lot of energy to making the interface comfortable and idiot-proof performs more slowly than stripped-down, leaner programs.

Backup to tape

Many professional photographers, who have a very large number of images, rely on traditional backup technology—tape. Its two considerable advantages are capacity (tens and hundreds of gigabytes, even terabytes with some systems) and cost. Security and longevity are high, and while there is constant development going on, and therefore many different formats, this is such a universally accepted back-up method that it will be around for a very long time. Formats include ADR, DLT, AIT, SAIT, and DAT.

Tape drive

Tape media

Writing DVDs

DVD, often thought of as digital video disc but more correctly known as digital versatile disc, is a development of the CD, with a seven-fold increase in data capacity and a basic transfer rate of about nine times that of CD. The track pitch (distance between each) is less than half that of CD, the pits are much smaller, the laser wavelength is smaller, data can be burned to and read from more than one layer (by changing the focus of the laser) and from both sides. With the same 5-in (12cm) diameter, 1.2mm thick dimensions as CD, DVD has the following capacities:

- DVD-5 - 4.7 GB single-sided, single-layered disc.
- DVD-9 - 8.5 GB single-sided, double-layered disc.
- DVD-10 - 9.4 GB dual-sided, single-layered disc.
- DVD-18 - 17 GB dual-sided, dual-layered disc.

There are five recordable versions of DVD:

DVD-RAM
The first rewritable DVD format, DVD-RAM uses phase-change technology similar to that in CD-R. Of all the DVD formats this is the least compatible with different players. It has some distinct advantages in terms of rewriting and data recording, however, since it does not need to record a lead-in and lead-out each time the disc is used.

DVD-R and DVD-RW
Similar to CD-R, DVD-R (or, DVD-Recordable) is write-once. Recording takes place on a dye layer that is permanently altered by a highly focused red laser beam. As with CD-R, there are three areas: lead-in, user data, and lead-out. Also, as with CD-R and CD-RW, the write-once -R format is compatible with more DVD read-only drives than its -RW counterpart. (This is the format used by Apple's built-in DVD writer, the "Superdrive.")

DVD+R and DVD+RW
This third rewritable DVD format has the highest compatibility. Like DVD-R it comes in write-once and rewritable flavors with varying degrees of compatibility. Some drives can now write to both +R and -R formats, and are typically designated ±R. If you're buying a DVD writer, this is a good way of hedging your bets. At the moment, only DVD+R supports dual-layer burning.

Newer DVD writers, such as this one from Sony, are capable of writing dual-layer discs. The 8.5 GB discs are fully compatible with the DVD9 standard.

RAID

RAID stands for Redundant Array of Inexpensive (or Independent) Disks, and is a hardware-plus-software technology designed for high-storage safety. A RAID device is a stack of hard drives (typically four or five) that function as a single unit. Depending on the RAID level you choose to implement, the device can store files in such a way that if one disk crashes, all the information can be rebuilt from the remaining drives. The safer the RAID level chosen, the less the total capacity. Individual drives are hot-swappable, meaning that you can pull them out safely while the device is connected and running.

File formats and compression

While there are a number of file formats in which you can save images after optimization—see the list available in Photoshop's Format drop-down menu in the *Save As...* dialog—there is little reason for photographic images to stray beyond the two most widely recognized: TIFF and JPEG. Universal readability is important if the images are likely to be seen and used by other people, and if you want to open them in different applications. TIFF offers a lossless compression method, LZW, and this can typically reduce the file size by more than half. This is for 8-bit images; it does little for 16-bit. JPEG is both file format and compression system, and ideal for transmission. You can choose the degree of compression in the dialog box as you save, but beware of saving JPEGs more than once—this simply multiplies the artifacting.

Basic Optimization

Optimization is simpy a term for improving the look of an image and preparing it for final viewing. In its most basic sense, optimizing an image is a way of getting the image to look as you think it should.

This seemingly straightforward idea hides the issue of how you define the best appearance, and in practice this is a combination of objective technical standards and the subjective ones of your personal preference. As the person who saw the scene and chose to take the photograph, only you are fully qualified to decide what the optimal brightness, contrast, and color should be, and for this reason it is always best to perform these adjustments as soon as possible, while your memory is fresh.

The key here is the sequence—the order in which you make the several different adjustments to the image. The aim is to avoid making a change that will later be changed again, as would happen for instance if you first altered a specific hue and then made a global color change. The most logical approach is to work from global corrections to selective, and the following four stages do this:

1 Balance the overall color, eliminating any unwanted cast. Either identify this bias by eye and use any of the usual tools (Color Balance sliders, individual channels in Levels or Curves), or use a Gray Point "dropper" on any tone that you think should be neutral.

2 Set the black and white points. The simplest way is to close up the ends of the histogram

Quick optimization

It is possible to make an independent, objective adjustment that traces and eliminates a color cast, closes up the ends of the histogram to make the range from black (0) to white (255), and performs a pre-set saturation. This takes no account of the content of the image, but is a useful starting point as an unbiased suggestion of how the image might be improved. One of the reasons it works so well has to do with the psychology of perception—in a side-by-side comparison, most people prefer brighter, richer, crisper versions of an image. In Photoshop, tools to consider are those in the *Image > Adjustments >* menu, such as *Auto Levels* and *Shadows/Highlights*. There are also third-party applications that can help, such as I-Tricks 2, a standalone color-repair program.

Subjective assessment

The process of optimizing for color has one serious built-in flaw. It tacitly assumes that every image deserves the same basic standards of brightness, a full contrast range, neutral grays, and so on. Most of the time this is true, and "automatic optimization" nearly always looks instinctively better. Yet this may not suit the purpose of the shot. For example, if part of the appeal of a landscape is its limited range of muted colors and softness, there is no point in closing up the *Levels* to give it a range from black to white. The very first step in optimizing any image is to assess it from a creative viewpoint. What was the effect you were aiming for when you shot? Will it suit the image to be other than normal?

in Levels. Otherwise, use Black Point and White Point "droppers" on the darkest and brightest parts of the image, respectively.
3 Adjust brightness, contrast, and saturation overall. Curves gives excellent control over

brightness and contrast, while saturation is most easily adjusted in the Hue/Saturation (HSB) dialog.
4 Adjust individual color ranges, for instance by using one of the hue ranges in HSB.

In many cases, optimization involves making subjective judgements as to the final appearance of the image. Both of these shots of elephants under a tree in the African savannah are perfectly valid. The lighter top image perhaps evokes more strongly a sense of bright heat, while the lower image plays more on contrast and color.

Basic optimizing procedure

The iCorrect EditLab provides an excellent example of an ordered optimizing workflow. The approach can just as easily be achieved in other software; balancing the overall color, then the levels histogram, before making more personal adjustments to brightness, contrast, and individual tones.

1 Correct the overall color balance by setting a neutral.

2 Set the black and white points.

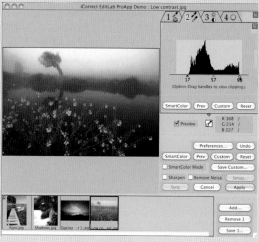

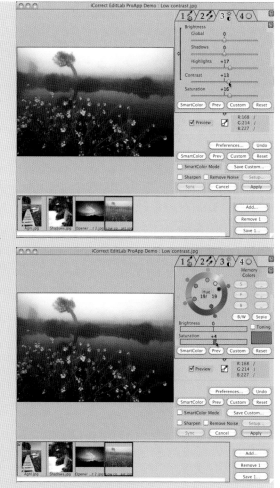

3 Adjust brightness, contrast, and saturation.

4 Correct specific colors (hues) individually.

Advanced Optimization

Every image requires its own level of optimization; some will simply need tweaking in terms of, for example, contrast, others may require a lot more work.

Even if you think you have a duty to do everything possible, in the real world there may simply not be enough time to work on every photograph. In any case, optimizing is subject to the law of diminishing returns —lengthy tweaking of details may not have a significant impact. Nevertheless, the recommended procedure for a full optimization is as described here. Remember, however, that this is not cast in stone, but just an example of one reliable sequence.

A Raw adjustment

For anyone serious about good image quality, the first step is to shoot Raw. The latest Photoshop Raw adjustment window offers an exceptional range of controls, where it is possible to do almost all of your image-optimizing work.

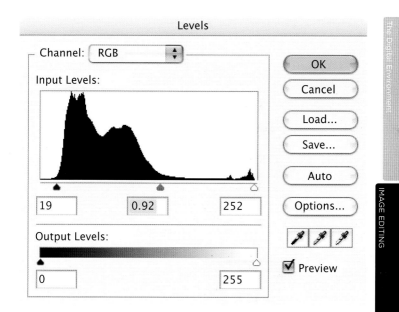

B Assign profile

This is best seen as an alternative to Raw adjustment, and it is not practical to make full use of both. If color precision is important, you may want to adjust the tonal range in the Raw dialog, and then assign a prepared profile.

C Levels

Again, if you have made good use of Raw adjustment, in particular the Exposure and Shadows sliders, going to *Levels* may not be necessary other than to check the histogram. Otherwise, the key procedure in *Levels* is to set the black and white points. Any adjustments to the tones between these points, however, is better left to the *Curves* dialog. Moving the midpoint slider alters the brightness around the exact midtone only, while *Curves* allows you the flexibility of biasing the lightening or darkening toward the shadows or highlights.

D Curves

This has long been the precision tool for tonal adjustments, Nevertheless, it now has two strong competitors in Photoshop—one is the Raw adjustment dialog (A), and the other is the new *Shadows/Highlights* dialog (E).

E Shadows/Highlights

This extremely useful control is slider-based in operation, designed for photographs, and actually exceeds the ability of *Curves* to manipulate contrast in the midtones. Because of its unique method of working, this is almost always worth looking at before finalizing an image.

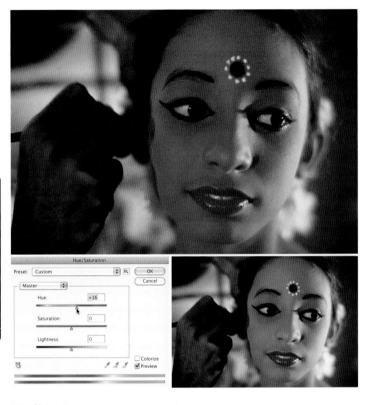

F Hue/Saturation

While saturation can be manipulated in *Curves*, the simplest control for it is the *Hue/Saturation* dialog. Once again, however, Raw adjustment also allows great control over hue and saturation, and may make this step unnecessary.

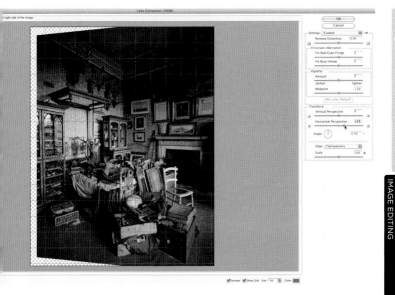

G Distortion, correction and cropping

Distortion may occur because of tilting the camera in a situation that calls for vertical verticals, or through over-enthusiastic use of an extreme wide-angle lens, or because of lens barreling or pincushion distortion. Correction usually leaves some gaps that need cropping, so that if you plan to crop the image for compositional reasons, it is best to run these two operations together. Photoshop's distortion-correction tools are either those under *Edit > Transform*, or the *Lens Correction* filter, and there are many third-party plug-ins for dealing with lens distortion of the barreling and pin-cushion varieties.

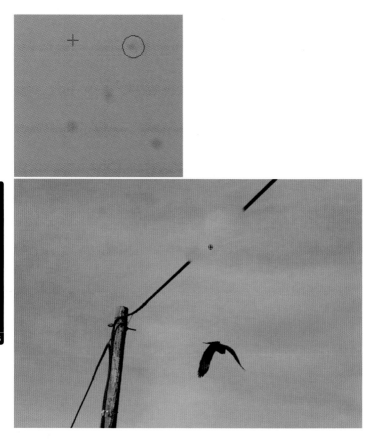

H Retouch

Finally, and there is little point in doing this before the above procedures, remove artifacts with the *Healing* or *Clone Stamp* tools. The main culprits are dust particles on the sensor, but you might then decide to move on to more elaborate image-editing, such as removing power lines from a landscape, or skin blemishes on a portrait.

Optimization Tricks and Tips

Image-editing tools, particularly those such as Photoshop, Paint Shop Pro, and so on, are immensely powerful programs that offer a number of ways of achieving almost identical results.

For this reason the steps outlined on the previous pages are no more than my recommendation. This is partly because there are so many ways of making similar corrections, but also because any evaluation of a photograph is ultimately subjective and part of the creative process . Allied to this is the concept of "tips and tricks," which in other circumstances would just be sloppy methodology. Yet in optimization and image-editing generally, tips and tricks are—strange though it may seem—a part of the methodology. Here are some key ones.

Edit at high bit-depth

Despite the fact that normal 8-bit color can display 16,777,216 separate colors in an image—well beyond the eye's ability to discriminate—any major change to the contrast, brightness, or colors, such as you might make with the *Curves* or *Levels* tools will destroy some of these as it shifts certain pixel values. The tell-tale sign is in the histogram— after an adjustment there will typically be white line gaps and black spikes above, instead of a smoothly curved, solid-black mass. The way to avoid this is to edit in 16-bit. It's double the file size and overkill for a final image, but there are sufficient color steps (well over 281 trillion of them) to accommodate any changes. If you shoot in Raw, Photoshop will automatically convert the image into 16-bit. Otherwise, if you have an 8-bit image, it is still worthwhile converting it to 16-bit for editing. But in this case, convert to Lab mode and edit the Lightness channel for the least damage.

Before

After (8-bit)

After (16-bit)

Use Photoshop profiles

If part of your workflow includes managing color in Photoshop, you will need to calibrate your monitor, using either the visual method or by using a colorimeter. The first time you launch Photoshop after installing, you're asked "Do you wish to cutomize the color settings?" The default setting is Web Graphics, which is designed to maintain color graphics consistently on screen. It may be that you don't need to alter this at all; however, if you're planning another kind of workflow, click Yes to be taken to the *Color Settings* dialog. If you're not installing Photoshop for the first time, you can access the dialog via *Edit > Color Settings…* (or on older Mac versions via the Photoshop menu). In order to maintain consistency, make sure that you use the same settings in any other color-managed applications that you use. Colors might also seem different in non-color managed software.

Color Settings

Unsynchronized. Your Creative Suite applications are not synchronized for consistent color.

OK

Cancel

Load...

Save...

Fewer Options

☑ Preview

Settings: Custom

Working Spaces

RGB: Adobe RGB (1998)

CMYK: Euroscale Coated v2

Gray: Gray Gamma 2.2

Spot: Dot Gain 20%

Color Management Policies

RGB: Convert to Working RGB

CMYK: Preserve Embedded Profiles

Gray: Preserve Embedded Profiles

Profile Mismatches: ☑ Ask When Opening ☑ Ask When Pasting

Missing Profiles: ☑ Ask When Opening

Go to *Color Settings* and make sure that the highlighted fields are as shown here. Adobe RGB (1998) is in any case the working space of choice for photographs. Under Color Management Policy, for RGB choose *Convert to Working RGB*; this ensures that images always appear in this standard color space. The two options at the bottom of the window give you the opportunity to discard unwanted profiles and to assign the one of your choice.

Evaluating a color chart

If getting accurate color is paramount, photograph a test that includes a color chart (such as the GretagMacbeth ColorChecker below). Ideally, do it once for any given lighting situation. For easy reference, crop into the chart and save this image as a check file. Its appearance in Photoshop should be as follows; if not, use the Raw editor so that it does—and note the settings.

1 The white square should be 250-245 and no higher in all channels.

2 The black square (darkest neutral) should be 5 and no lower in all channels.

3 You can distinguish all the neutrals from each other.

4 No RGB values in any square are lower than 5 or higher than 250.

5 The RGB values in the neutral squares are within 5 points of each other (e.g. 126, 130, 127, not 124, 132, 121).

Shooting Raw

Apart from the fact that it requires additional post-production work that will take a little more time, shooting in the Raw format provides many benefits.

The simple reason for this is that the data and settings are stored separately on capture, meaning that you have complete access to the original, "raw" data in your image-editing program. Moreover, this image information remains at the maximum bit-depth of which the sensor is capable (typically, 12-bit, 14-bit, or 16-bit). If you have any need to optimize or alter the image, Raw is the obvious choice.

However, there are some decisions you need to make about fitting Raw adjustments into your workflow. The first is which software to use? One possibility is the image editor offered by the camera manufacturer, with the advantage that this should be thoroughly integrated with the camera's sensor and processor. Alternatively, Photoshop (and Photoshop Elements) has a Camera Raw plug-in. As you are probably going to be working in Photoshop anyway, you might as well start here, especially as it has more sophisticated controls than most camera manufacturer software, odd though this may seem. Ideally, test the two side-by-side with different images and then decide for yourself which one you prefer to use to work on your Raw files.

CAMERA RAW

Photoshop's Camera Raw converter enables extensive changes to be made to the image. These dialog tabs, in combination with the Adjust tab, illustrate the choices available. It is sensible to use these tabs according to the Order of adjustments.

EXPOSURE ADJUSTMENT
This image is originally slightly overexposed, but taken using the Raw format. When opened in Photoshop, the Raw converter allows changes to be made to the exposure, white balance, and numerous other settings. The final shot (left) has had its exposure reduced by 1/5 stop, and changes made to the settings including a custom white balance to enhance shadows.

Raw adjustments

Another decision is which adjustments to make when you are converting the Raw file, and which ones to make later with the normal Photoshop editing tools. The *Exposure* and *White Balance* adjustments are clear winners in Raw, because they can restore original data, while some others, such as *Sharpness*, are usually best left until later, as they use essentially the same algorithms.

More difficult to decide is the contest between Raw adjustment and camera profiling. If you use profiling software to create a specific camera profile, this is only good for images that have not been adjusted during opening. Basically, you can't have both.

One alternative is to restrict the Raw adjustments to tonal range (that is, Exposure, Shadows, and Brightness in Photoshop's Camera Raw plug-in) and then assign the profile. Another option is to use the Calibrate dialog to make the same profile adjustments. If you are having problems with the way in which the plug-in reads non-neutral colors, this may be sufficient reason for using the camera manufacturer's Raw adjustment software instead.

Photoshop CS automatically opens a Raw file and displays an adjustment window that offers all the original camera settings and possibly more, depending on the camera, although the menu structure is different. This is where to begin, and in many cases, this set of dialogs can take care of all that you need to do to an image—one-stop optimization.

Potential Raw workflow

Camera Calibration window
1 Compensate for errors in reading the camera's profile, ideally by loading a pre-prepared profile.

Basic window
2 Set *White Balance*, adjusting with *Temperature* and *Tint* sliders.

3 (optional) Choose *Auto adjustment* to see what the software recommends, but don't necessarily use it.

4 Adjust *Exposure* for the overall brightness, favoring the high values and paying attention to highlight clipping (set the clipping warning on).

5 Adjust *Recovery*, if necessary, to recover clipped highlights by reconstructing from remaining one or two channels.

6 Adjust *Fill Light* if necessary to open up shadows, being careful not to overdo this.

7 Adjust *Blacks* if necessary, effectively to set the black point.

8 Adjust *Brightness* if necessary, to alter overall tonal range (this compresses or expands shadows and highlights without clipping them, provided that the slider is used moderately).

9 Adjust *Contrast* to fine-tune midtone contrast.

10 Adjust *Vibrance* and/or *Saturation* to achieve the desired color saturation. Favor the *Vibrance* control, which has built-in protection against clipping when particular hues approach full saturation.

Tone Curve window (optional)
11 If necessary, make fine adjustments to the tonal distribution after working in the Basic window.

HSL/Grayscale window
12 Tweak individual colors if necessary.

Detail window
13 Adjust *Sharpness* only if aiming directly for a specific output.

14 Reduce noise in a high-ISO image by adjusting *Luminance Smoothing* to control luminance (grayscale) noise and *Color Noise Reduction* to control chrominance noise. Otherwise, perform this with a specialist noise-reduction program.

Lens Corrections window
15 Correct color fringing due to lens defects with the *Chromatic Aberration R/C* (red/cyan) and *B/Y* (blue/yellow) sliders.

16 Correct cornershading if necessary (typically with a wide-angle lens), using the *Vignetting Amount* and *Midpoint* sliders.

17 For greater control and to correct or introduce vignetting to crop selections use the *Post Crop Vignetting* sliders.

Working with Photoshop and Raw

Adobe has worked hard to make sure that editing Raw files in Photoshop is as intuitive and seamless as possible.

The *Workflow Options* are accessed from a clickable line at the bottom—these are color space, bit-depth, and size and resolution. The *Raw Adjust* controls, from top to bottom in the order in which you would normally use them, are *White Balance* (presets plus color temperature and tint sliders), *Exposure, Recovery, Fill Light, Blacks, Brightness, Contrast,* and two color saturation controls: *Vibrance* and *Saturation*.

The image as opened in the Raw Adjust window (left) and the final image, after adjustment (below).

Setting white balance

This is why it doesn't matter which white balance setting you choose when shooting Raw—simply set it here. There are three ways of doing this, offering much greater control than in-camera. The simplest is the dropdown menu that replicates the choice in the camera menu, and the default is *As Shot*.

Alternatively, you can use the color temperature slider, which operates on the Kelvin scale. Once you have got close to the white balance setting, fine-tune it with the *Tint* slider—this adds magenta when slid to the right (+) or green when moved left (–).

Finally, you can also use the White Balance dropper tool at the top left of the main window to select a tone in the image that you know or want to be neutral gray. The sliders can then be used to make any further adjustments.

Midtone adjustments

Following the all-important exposure adjustments, use the *Brightness* slider to alter mid-tones within the set black and white points. Follow this with *Contrast*, which also works principally on the mid-tones. *Fill Light* performs similar work to the *Shadow/Highlight* control in opening up shadow detail, and runs the same risk of false appearance if used too aggressively. The *Saturation* control has a new slider, called *Vibrance*, which minimizes clipping as full saturation in any one hue is approached, so this is generally a safer alternative for photography than the *Saturation* slider.

Adjusting exposure

This feature alone makes Raw editing worth it: the ability to re-visit the shot and select an exposure setting up to 2 *f*-stops brighter or darker—a total of 5 stops real range. Ideally, work from the top down through the adjustment sliders. Watch the highlights as you drag the *Exposure* slider first. Also consider holding down the Option/Alt key as you move the slider. This reveals any highlight clipping as colored areas out of a black base, and so is an ideal way of setting the white point—in the same way as you

would do it in *Levels*, but better, as here it is on more of the image data. Typically, for a normal image, show just the beginnings of clipping. As the colored areas show individual channels, only pure white (the combination of all three) indicates complete (255,255,255) clipping. As long as only one or two channels are clipped in the highlights, the *Recovery* slider can restore pixels by reconstructing from the remaining channel(s). Follow with the *Blacks* slider, where holding down Option/Alt shows shadow clipping out of a white base.

WHITE POINT

BLACK POINT

Advanced Raw Adjustment

With shooting Raw proving to provide the best option for creating optimum image quality, software manufacturers are working hard to produce Raw converters that allow you to undertake more and more post-production tasks.

Raw converters now go beyond exposure, brightness, and color adjustments, with some now offering sharpening, lens aberration adjustments, noise reduction, rotation, and even black-and-white conversion. The number and type of extra features varies with the program. A sign of the direction being taken toward comprehensive post-production within the Raw converter dialog is the arrival of retouching tools, which work at much more localized levels. Expect more features and more sophistication to be added.

Retaining Raw adjustments

Once you've made adjustments to a Raw image, you have to save it into a different format—with TIFF being the usual choice. In other words, you cannot overwrite the original, which is a good thing. An open-source Raw format, DNG, promoted by Adobe, is a saveable format, but there are differences of opinion as to its usefulness. It can be seen as a step away from the original Raw, but in a different direction from TIFF and JPEG. As for the adjustments you make during opening, these can be saved, and in such a way that they can be re-applied to other images if you like. There is a choice of two places in which to save them. The default is the Camera Raw database. In Windows this is usually located in the user's Application Data folder as *Document and Settings/user name / Application Data/Adobe/Camera Raw* (Windows), and in Mac OS in the user's Preferences folder as *Users/user name/Library/Preferences* (Mac OS). The advantage of saving here is that the images are indexed by file content, so the settings stick to the image even if you rename or move it. The alternative is in a sidecar ".xmp" file, which uses the same name and is stored in the same folder. If you want to archive the Raw image files with their settings, this is the better choice. With sidecar files stored on a CD or DVD, make sure that you copy them to your hard drive along with the images before opening.

Choosing a Raw converter

Although Photoshop is probably the best-known Raw converter, camera manufacturers provide their own converter software bundled with their cameras. This may have the advantage that it is designed to work with their specific Raw files.
This is offset by weaker software engineering relative to, say, Adobe. The market for Raw conversion has expanded and become more competitive recently, and there are now many choices, not least among the new class of workflow software, including Lightroom, Aperture, DxO Optics and Capture One. Ideally, download demo versions of different Raw converter software and compare the results for your camera. Because Raw format allows alterations to be made to the original exposure data received by the sensor, use it before image-editing tools.

Fixing lens issues

Chromatic aberration, resulting in color fringing as the lens focuses different wavelengths of light at slightly different distances, and vignetting, in which corners appear darker as the light transmission falls off radially toward the edges of the frame, are two common issues with lenses. The chromatic aberration correction here is very useful if the problem exists, while the vignetting correction is one of several alternatives. Actually, chromatic aberration manifests itself in a number of ways depending on the specific lens, and the Camera Raw adjustment deals with one of them, called complementary fringing. In this, the fringe colors are strongest alongside high-contrast edges in the image, and close to the corners of the frame. They differ in color between the side closest to and the side farthest from the center. The *R/C* slider controls red/cyan fringing, the *B/Y* slider blue/yellow. The *Vignetting Amount* slider lightens the corners when moved to the right (+), or darkens when moved left (–). The *Midpoint* slider alters the spread of the lightening; moving right (+) restricts the effect toward the corners, while moving left (–) broadens it toward the center.

Before

After

Tone with Histograms and Levels

A histogram is a visual representation, in the form of a graph, of all the tones present in a digital image.

In digital photography, a standard 8-bit scale of 0–255 shows 256 columns from pure black at left (0) to pure white at right (255), and normally, in camera displays and Photoshop, they are packed together so that they join and there are no gaps. Pixel brightness is plotted across the bottom on the X axis while the number of pixels that contain a particular tone is plotted up the vertical Y axis.

At all stages of the photography workflow, this is the single most useful representation of the tonal qualities of an image. In Photoshop it appears as a palette (*Windows > Histogram*), and as an image-adjustment dialog (*Image > Adjustments > Levels*). A reasonably exposed (that is, problem-free) photograph has a nice, smooth distribution to the shape of the histogram, peaking somewhere near the middle and tailing off toward the left and right; these tails almost reach, but do not crush up against the edges.

Typically, the first time a digital photograph is opened on-screen you would go immediately to *Levels* to check the distribution of tones. Indeed, for any non-Raw image this is the first port of call for optimization. Unless you are looking for a special tonal effect, such as a flat effect with limited tones (for example a delicate landscape on a foggy day) or a graphic high-key treatment (for example, a fashion shot that deliberately washes out skin tones to emphasize lips and eyes), then the key procedure in *Levels* is to set the black and white points. This stretches or compresses the tonal range so that the darkest shadows are located close to black, and the brightest

Using Levels

From this original, follow the route to image correction using the *Levels* dialog. You can reach the dialog using *Image > Adjustments > Levels…* or by adding an adjustment layer to your image. Two alternative methods are shown on the following pages.

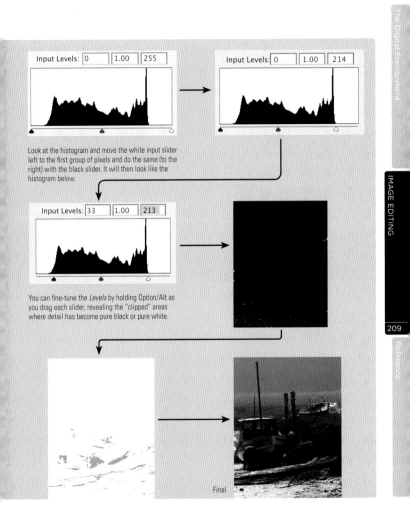

Input Levels: 0 | 1.00 | 255

Input Levels: 0 | 1.00 | 214

Look at the histogram and move the white input slider left to the first group of pixels and do the same (to the right) with the black slider. It will then look like the histogram below.

Input Levels: 33 | 1.00 | 213

You can fine-tune the *Levels* by holding Option/Alt as you drag each slider, revealing the "clipped" areas where detail has become pure black or pure white.

Final

highlights (excluding light sources and specular reflections) close to white. I say "close to" because it's customary to set these limits to slightly less than full black and white.

After this operation, which aims to fill the scale with the range of tonal values, you can use the *Midpoint* (gray) slider to do two things. One is to remove any color cast. To do this, click on the gray point dropper to activate it, then click on a point in the image that you know should be neutral or that you would like to be neutral. The second action is to adjust "brightness." In fact, what it adjusts is gamma, by re-locating the midtone (128) to a darker or brighter position; all the other tones are dragged in proportion automatically, but the end-points stay the same. As a rough guide, move the *Midpoint* slider toward the center of the bulk of the histogram. However, there is more flexibility if you do this in *Curves*, and it may be worth moving to that dialog for the next step in optimization, where you can also use the gray point dropper to remove a color cast. Note that if you have opened and adjusted a Raw image in the Camera Raw plug-in, there should be no need to make any adjustments in *Levels*—and possibly not in *Curves* either.

Input Levels: 0 1.00 255

Click Auto in the Levels dialog, or skip this dialog altogether by clicking *Image > Adjustments > Auto Levels*.

Final

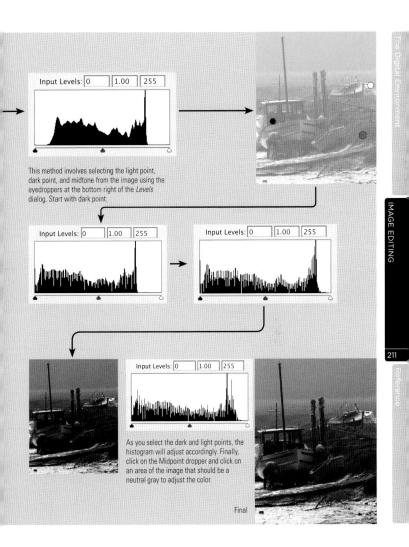

Input Levels: 0 1.00 255

This method involves selecting the light point, dark point, and midtone from the image using the eyedroppers at the bottom right of the *Levels* dialog. Start with dark point.

Input Levels: 0 1.00 255

Input Levels: 0 1.00 255

Input Levels: 0 1.00 255

As you select the dark and light points, the histogram will adjust accordingly. Finally, click on the Midpoint dropper and click on an area of the image that should be a neutral gray to adjust the color.

Final

Tone Adjustments with Curves

For more precise and more localized tonal adjustment turn to the *Curves* command in your image-editing suite.

The characteristic curve plots exposure against density on a graph, and the shape of the curve reveals such things as how contrasty the response is. In the *Curves* dialog, this is changed to a graph in which the horizontal is the Input (the original density of pixels) and the vertical axis is the Output (the changes you apply). The curve appears by default as a straight diagonal line. Because you can select any number of points on the curve and then drag them toward darker or lighter, this is a more flexible tool than *Levels*. Open it by going to *Image > Adjustments > Curves*.

Clicking on any part of the image shows on the graph as a small circle, which is a useful way of seeing how the tones are distributed. Command-clicking (Mac) or Ctrl-clicking (Windows) adds these points to the graph, so you can then use them to drag that part of the curve lighter (higher) or darker (lower). Midtones are in the center, shadows are down to the left, and highlights up to the right. Dragging points alters the shape of the curve and, just as with a characteristic curve, an S-shape indicates a more contrasty image, and a reverse S the opposite—a flat image. This is much more easily understood visually than in a description, and the selection of sample curves best explains the possible corrections.

Curves presets

Recent versions of Photoshop have introduced preset Curves. Clicking on the *Curves* dropdown menu provides a choice of basic but potentially useful settings to try. These include Darker, Lighter, three strengths of Contrast, and more artistic settings, such as Cross Process, Negative, and Color Negative.

Curve adjustments with samples

In this example, Cmd/Ctrl-clicking is used to sample the tones in this image that we want to adjust. The three control points are added, and are then dragged to make the highlights brighter and shadows darker—in other words, to increase the contrast.

Original

Three points on the image and their markers on the adjusted curve.

Final image

Typical tonal adjustments with Curves

The Curve graphs shown here are can be used as the starting points for some common corrections. Individual images, however, should always be assessed on their own merits, and these curves may need tweaking. Note that all the variations shown here are within the set black point and white point limits. Although these can be adjusted using the *Curves* tool, by dragging the endpoints, I prefer to use *Levels*.

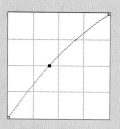

Overall lightening

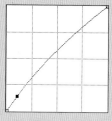

Lightening that favors shadows

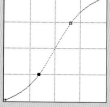

Overall darkening

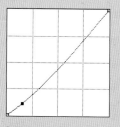

Darkening that favors shadows

Moderate contrast increase

Major contrast increase

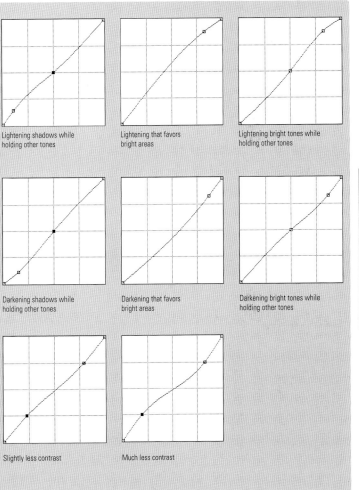

Lightening shadows while holding other tones

Lightening that favors bright areas

Lightening bright tones while holding other tones

Darkening shadows while holding other tones

Darkening that favors bright areas

Darkening bright tones while holding other tones

Slightly less contrast

Much less contrast

Shadows/Highlights Tool

The *Shadows/Highlights* tool was one of the major new features to be released with the first version of Photoshop CS.

The tool uses sliders, and so carries the advantage of being quick and easy to use, although with the possible disadvantage of "hiding" some of the information.

In particular, it works differently from the other optimization tools, such as *Curves* and *Levels*, with algorithms to control effects across specific tonal ranges. Its primary intent as designed by Adobe is to lighten shadows realistically, in particular for backlit images. However, its algorithms for altering the contrast in the midtones alone are possibly more important for many photographers.

What makes this dialog special is that the lightening and darkening that you can apply is based not simply on a range of tones but also on a sample drawn from the surrounding pixels. All adjustments need to be judged visually, rather than by values. To get the most out of this powerful tool, first assess the image and the changes you would like to see made. Then work down through the slider controls from top to bottom, if necessary going back to tweak the effects. Beware of over-correcting, as artifacting is likely— halos around edges and banding, as well as unrealistically light shadows. Open by going to *Image > Adjustments > Shadows/Highlights...*

Shadows/Highlights controls

Amount

This adjusts the strength of the effect, and has to be used in conjunction with the next two sliders.

Tonal Width

This specifies the range of the shadows. 50% takes it up to the mid-point, which will usually be too much. Decide from the image itself which shadows need lightening or highlights darkening. Too high a width will cause artifacting and also look unnatural.

Radius

Until you have experience with this control, it is the least intuitive of the three. It sets the radius around each pixel that is sampled, in order to decide whether it belongs in the shadow group or the highlight group, and is measured in pixels. Moving the slider to the right enlarges the sample area. Adobe recommends a radius approximately equal to the size of the subject of interest.

Adjustments

Color Correction

This affects only the areas that have been changed with the sliders above, so the strength of its effect depends entirely on how strong an adjustment you have made. Move the slider right for more color saturation, left for weaker.

Midtone Contrast

For many of us, this is the most important control, because it achieves an important effect not possible any other way. In most photographs, the middle range of tones contains the important elements. You can easily find many images in which you would like to

increase the contrast in this zone without deepening the shadows or lightening the highlights. There is a limit to how closely you could achieve this with *Curves* (*see pages*). With the *Shadows/Highlights* dialog, however, you can treat the groups of sliders as a way of protecting them—the *Midtone Contrast* slider then works on the remaining parts of the image.

Black Clip and White Clip
Normally you will not want to clip shadows or highlights, as this simply loses image data.

In this image the *Shadows/Highlights* tool has been applied to bring out detail in the shadowy foreground while at the same time introducing a little more warmth to the bright highlight areas in the background.

Sharpening

Perhaps out of all the controls that digital imaging put into the hands of today's photographers, sharpening has been most widely abused.

The reason for this is that sharpening is a subjective impression and not a measurable detail of the photograph. A high-contrast image, for example, tends to look sharper at a glance than a photograph with muted tones. There is also no good measurement of sharpness. Most evaluations are in terms of "too sharp" and "not sharp enough." This isn't to say that these are poor descriptions, just that they don't transfer well from one viewer to another. It reinforces the principle that the photographer should make the judgment.

The factors that give an impression of sharpness are acutance, contrast, resolution, and noise. Acutance is how abruptly one tone changes to another across the image, and the more abrupt the edge between one area of pixels and another, the higher the acutance. Contrast has an effect in that an edge between black and white looks sharper than an edge between two gray tones. Resolution is the degree of detail, and more detail looks sharper than less. Finally, noise breaks up the image and reduces the overall detail, although sometimes it can have the opposite effect and add to the sharpness simply by being itself sharp and definite.

Because sharpness and sharpening are such perceptual issues, we have to consider how the photograph is going to be seen—under what conditions, at what distance, and what size. Because some of the sharpening controls are measured in pixels rather than percentages, the size and resolution of the digital image do matter—a 1-pixel radius has a much greater effect on a screen-sized

Sharpening and third parties

Whenever an image moves out of your direct workflow control, it is absolutely essential that other people know whether or not it has been sharpened. If it has not, you and they should agree on how it will be sharpened. Because of all the variables (see *Factors governing sharpness*, *below*), it is clearly better not to sharpen before delivery, but take no chances that this is understood. In repro, the image may go through several people, including the picture editor, designer, and printer, and there is a risk that the sharpening information gets lost, with the result that the image finally appears soft.

Factors governing sharpness

1 Image size.

2 Quality of image detail.

3 Reproduction size.

4 Printer quality and settings.

5 Viewing distance.

6 Your taste.

640 × 480 image than on a high-resolution 3,000 × 2,000 image. The condition of the original image is also a factor. A detailed, high-quality image, for example, needs a different kind of sharpening technique (finer, more detailed) than does an image that suffers from, say, low resolution, slightly soft focus, or noise.

Varying degrees of sharpness

Sharpening an image should ideally add to its overall impact, not make it appear unnatural or add artifacts to it. Tell-tale signs of over-sharpening are high levels of what appears to be grain, even in areas outside the image's main focused areas, and pixelation around detailed areas.

Original Sharpened Oversharpened

Ultimately, two things stand out. The first is that every photograph needs to be sharpened in a way that is appropriate to it, so judge every photograph—or every set of similar photographs—on its own merits. The other, important point, is that sharpening should be the last action you perform on an image before it is displayed—whether as repro, fine art print, or on the Web. Sharpening can only be judged on its appearance as intended, and never sharpen

an original, only a copy. If you are shooting Raw, then the Raw files are your true originals, but their optimization represents an investment of time and skill, and you may consider saving the finished TIFF in its unsharpened form. Sharpened versions for various purposes can be given a slightly amended file-name (such as adding "sh"). Note that repairing focus blur and motion blur involves sharpening, but should not be confused with the sharpening discussed here.

Basic Sharpening

As discussed, sharpening is concerned more with subjective judgement than a measurable process.

Certainly there are obvious artifacts to look out for, such as the dreaded halos, but ultimately what and how much you sharpen is down to your personal taste. You may, for example, disagree with some of the results here and on the following pages, and that is as it should be. Your taste is the final arbiter.

Although Photoshop has *Sharpen*, *Sharpen Edges*, and *Sharpen More* filters, these are rough and ready, and allow no fine-tuning, so are best ignored. The usual professional sharpening tool is the *Unsharp Mask*. As a way of increasing sharpness, this sounds like an oxymoron, but the apparent illogicality is because the term is a holdover from pre-digital days. In film-based repro, an out-of-focus copy of the image was sandwiched with it as a mask, and the result, as if by magic, was a sharper image. The expression, often shortened to USM, has stuck.

The digital process, however, is quite different, and works by resampling pixels so the contrast between neighbors is increased. At a pixel level, an edge looks like an area of dark pixels against an area of light ones. Increasing the transition between them—making the dark pixels darker, and the light pixels lighter—is the key way of heightening the contrast, or sharpening. Most sharpening techniques, including USM, can be adjusted to suit different images by three variables: amount, radius, and threshold.

In practice, getting these right for a particular image is complicated by a set of factors that include the size and quality of the image, the viewing distance, and your own taste, which is subjective. Proprietary sharpening applications such as Power Retouche Sharpness Editor and Nik Sharpener Pro take a more sophisticated approach than USM, include more variables, and can protect sensitive areas of a photograph such as intricate detail.

Unsharp Mask controls

The three standard settings are *Amount*, *Radius* (also known as *Halo Width*), and *Threshold*, and between them they provide good, though not perfect control over the sharpening. Be aware that there are a number of sharpening algorithms (of which Photoshop's USM is just one), and most aim to heighten local contrast.

Amount
This, expressed as a percentage, is the intensity or strength of the sharpening. Opinions vary, as this setting depends very much on personal taste, but for high-resolution images, values between 150% and 200% are normal.

Radius
This is the distance around each pixel that is used for calculating the sharpening effect. A small radius will sharpen a narrow edge, a larger radius a broader band. It affects the coarseness of the sharpening and is measured in pixels. The wider it is, the wider that edges will appear, and if it is set too wide, a "halo" appears along edges (hence the alternative name Halo Width). For high-resolution images, a radius of between 1 and 2 is normal.

Threshold

This controls the level of difference between adjacent pixels that will be sharpened, and serves as a kind of protection for smooth areas with fine texture and little detail. With the threshold at 0, everything is sharpened. Raising it a little prevents the sharpening being applied to areas in the image where the difference between pixel values is small, such as sky and skin. It concentrates the sharpening more on the distinct edges, which are usually considered more important, and without it, the smooth areas can appear "noisy." It is measured in levels between 0 and 255. Setting the threshold to 4, for example, restricts the filter to areas where the difference between adjacent pixels is greater than 4—for instance, neighbors 128 and 133 would be sharpened, but 128 and 130 would not. For a high-resolution photograph, values between 2 and 20 are typical, reflecting the difference in image content.

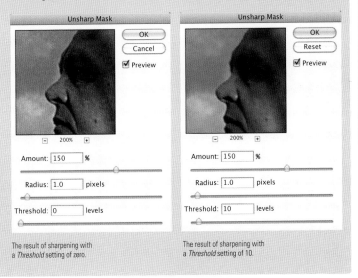

The result of sharpening with a *Threshold* setting of zero.

The result of sharpening with a *Threshold* setting of 10.

When sharpening goes wrong

Oversharpening is responsible for ruining many thousands of photos each year. Undersharpening is also an error of a kind, but difficult to measure because it relies on personal judgment. Common faults are as follows, and can be avoided by readjusting the *Amount*, *Radius*, or *Threshold*, or by using one of the more advanced techniques covered later.

Halo
Also known as negative contour, this is an edge effect in which a too-bright or too-dark band of one or more pixels separates two tonal areas.

Aliasing
Anti-aliasing is the well-known software technique for softening the "staircase steps" that occur on diagonal lines and edges in digital images (due to the square structure of pixels). Sharpening can remove the anti-aliasing.

Color artifacts
Unwanted colors appear at the margins of other colors, particularly in high-contrast and low-quality images.

Local extreme artifacts
Clumps of almost-black or almost-white pixels.

Halo effect

Color artifact

Advanced Sharpening

When it comes to sharpening, not only is every image unique, but different areas within the same image may well require differing levels of sharpening.

Ultimately, what this means is that to achieve successful sharpening—that is the impression of sharpness but without any artifacts—you need to apply selective sharpening. The *Threshold* control shown on the previous pages is the standard means of applying selectivity, but there are others.

Typically, the most sharpening is wanted along edges and in areas of fine detail, and the least (indeed, often none) is wanted in smooth areas and especially in zones that are out of focus. An important caveat is that some areas may have such intensity of detail that they react badly to sharpening—brightly lit foliage is a particular case.

Having identified the areas to select, you can do this in a number of ways. One is manually, by airbrushing in a masking layer

Smart Sharpen

With the introduction of Photoshop CS2 in 2007, an additional *Sharpen* filter was added—*Smart Sharpen*. This filter offers greater flexibility than *Unsharp Mask*. First, *Smart Sharpen* provides a variety of sharpening options, found under the *Remove* menu—*Gaussian Blur*, *Lens Blur*, and *Motion Blur*. *Lens Blur* usually provides the best results for standard sharpening. Additional flexibility comes in the form of the *Fade Amount*, *Tonal Width*, and *Radius* sliders located under the *Shadow* and *Highlight* tabs once *Advanced* is selected. Together these options provide much greater control than the *Unsharp Mask* filter.

to create a selection. Another is to use another filter to find the areas to be sharpened—the example shown opposite uses the *Find Edges* filter. Because the level of detail usually varies between channels, another technique is to apply sharpening to one channel only. An extension of this is to protect colors from sharpening by switching modes from RGB to Lab and applying the sharpening filter to the *Lightness* channel only. Finally, and most conveniently, consider third-party sharpening software that is usually available as plug-ins to Photoshop. Two specialist programs in particular, nik Sharpener Pro and Intellisharpen, use advanced algorithms.

Another advanced approach to sharpening is to apply the filters twice or more at a low level. Multipass sharpening, as it is known, is the best way to apply any sharpener for high-quality results, because it reduces the risk of artifacts. It calls for experiment, but once you are familiar with its effects, it becomes easy to execute. Batch processing makes it more convenient.

Sharpen twice

One way of reducing the risk of sharpening artifacts is to perform two (or more) sharpening passes. Additionally this allows you to aim the sharpening at different parts of the image. For instance, the first pass could be gentle but with no threshold, to subtly improve fine texture, followed by a second pass that is stronger and aimed at the edges, while setting a threshold to protect the smoother areas. This works with whatever sharpening technique you use, but clearly needs experiment and experience. The advantage of doing this is that the second pass multiplies the sharpening effect, while only adding to the artifacting. So, if you sharpen once at 100% and a second time at 125%, the sharpening effect will be $100 + (2 \times 2 \times 125) = 600\%$. The artifact generation, however, will be only $100 + 125 = 225\%$.

Convert to Lab

High levels of sharpening can often lead to color artifacts, particularly along edges. A good solution, worth considering as your default sharpening technique, is to convert the image to Lab and sharpen just the Lightness channel. This, as you can see by looking at the a and b channels, contains almost all the textural detail. The gentleness of the color gradations in the two color channels is preserved. Convert back to RGB when finished (Lab is also used by Photoshop as its conversion color space, and switching between the two loses no quality).

Sharpening with the Find Edges filter

It's the edges of an image that can provide the greatest impression of sharpness, yet the *Unsharp Mask* filter does not pay any particular attention to these. The *Threshold* setting with a high radius will concentrate sharpening, to some extent, on the edges, but there are more focused techniques.

3 Switch back to the *Layers* palette and click on the background layer to make it active again. You should see your newly made selection imposed on top of the original image, rather than the altered channel.

4 With the selection still active, apply the *Filter > Sharpen > Unsharp Mask (USM)* to the image. It will only work on the selected areas.

5 The final image, with extra sharpening applied to the selected areas.

1 Using the *Channels* palette, identify the channel with the most contrast in. In this photograph, the dancers are most clearly distinguished by the red channel. Duplicate the channel you identified by dragging it to the *New Channel* (turning paper) icon at the bottom of the *Channels* palette.

2 Working on the newly copied layer, select the *Filter > Stylize > Find Edges* filter. This will highlight the edges only, and by working on the new channel, it won't affect the image itself. Since we're looking to highlight the edges, not the majority of the image, click *Image > Adjustments > Invert* before clicking the Load Channel as Selection button (dotted circle) at the bottom of the Channels palette.

Increasing Image Size

As sensor resolution has been steadily increasing year on year, the issue of increasing the size of an image—upscaling—has become more and more redundant.

However, even with today's 20+-megapixel sensors, there may still be times when you're not sure if your camera's resolution can fill the size of the print you want.

And so the question still arises, how much is it possible to enlarge a digital image and still have an acceptable level of detail? There is a 300 dpi rule of thumb in repro, but it is no more than that—a safe industry standard. The two principal factors are the line frequency (line screen) of the printer, and the percentage of this that the digital image should be. Newspapers print at 85, most magazines at 133-150, high-quality illustrated books at 200, and a few art books higher still. The percentage is very much a matter of opinion, but generally between 150% and 200%. In other words, even excluding the low quality of newspapers from the calculation, the acceptable resolution for a digital file could be between 200 and 300. And this determines the size.

Interpolation

Going beyond these limits involves interpolation, and there are good arguments for doing this yourself so that you can check and guarantee the result. The important choice is the method, meaning the interpolation algorithm. Within Photoshop, the choice is simple for photographs—*Bicubic*. It gives a smoother tonal gradation than the other two (*Nearest Neighbor* and *Bilinear*) and also better suits the complex structure of a photograph, usually lacking exact straight edges. It's important to realize that there is always a loss of quality in upscaling. How much is acceptable is a matter of opinion. Some users believe that incremental upscaling (say, 10% at a time) gives superior results, as with sharpening, although I have seen no side-by-side comparison that bears this out.

Going beyond Photoshop, there are proprietary applications that promise better results. One approach is a suite of algorithms

Resolution and sharpness

The relationship between resolution and sharpness, while superficially distant, is in fact close and intricate. Resolution in an image is the amount of detail recorded and so is objective, while sharpness is the appearance of definition, and so is perceptual and even a matter of opinion. That would seem to set them apart, but in upscaling they converge. The confusion arises because the whole process of creating a larger image from a smaller version involves guesswork and optical tricks. Digitally, both processes use interpolation, which means re-calculating the values of existing pixels. Sharpening can certainly help in creating the impression of greater detail around edges, but it needs the usual care, and adds to the variables. In practice, upscaling with sharpening can take time and involves multiple choices.

Photoshop's interpolation options

When it comes to rescaling, Photoshop provides three core interpolation algorithms. *Nearest Neighbor* is the simplest, expanding pixels into square blocks of pixels, which can be quite ugly. *Bilinear* and *Bicubic*, on the other hand, soften the edges using data from the surrounding pixels, creating smoother edges similar to anti-aliased text. *Bicubic* is further subdivided into *Bicubic (for smooth gradients)*, *Bicubic Smoother (best for enlargement)*, and *Bicubic Sharper (best for reduction)*, which are all self-explanatory.

Original

Nearest Neighbor Bilinear Bicubic Smoother

that analyze the detail in an image and apply different methods to different areas—maintaining sharp edges, for example. PhotoZoom is one of these.

Another approach is to convert the image to a dimension-free image format so that it can be output at a larger scale. Genuine Fractals is an example of this. Comparisons between these different methods vary depending on the image. There is, however, a difference in quality between interpolation algorithms, and the best do not blindly apply the same techniques to every part of an image,

instead discriminating according to the tonal, color, and textural differences.

Filling in the gaps like this tends to create unsharpness. Upscaling is analogous to stretching, and most methods fail to hold edge sharpness. In enlarging an edge, normal resampling adds an intermediate value between the dark and light pixels, which softens the appearance. After upscaling, a second sharpening operation may be necessary, although proprietary upscaling techniques can complicate matters if they also incorporate edge-sharpening.

Frame composite

With a static subject and time, there is a simple workaround to increase resolution when you're shooting—take a series of overlapping images with a longer focal length, and then stitch these tiled images together.

Overlapping images before trimming.

Resizing Software

A simple 200% scaling

There are fewer examples of dedicated upscaling software on the market than there used to be, with perhaps the need for such programs decreasing.

The most popular two cross-platform programs are Ben Vista's PhotoZoom Pro (a reincarnation of the Dutch software S-Spline), and Genuine Fractals.

Genuine Fractals is not, strictly speaking, dedicated to upscaling, but was developed as a scaleless image file format. Nevertheless this is probably its most valuable use. What both have in common is that the algorithms they use for interpolation are much more complex than that for Bicubic—the Photoshop default for photographic images.

Genuine Fractals

OnOne's Genuine Fractals' Photoshop plug-in is designed to be used either to scale up images, or as an alternative and space-efficient way to save files. In the former case, it is especially good at creating larger files from smaller originals, at up to 600% without serious loss in quality. In the latter case it can create lossless archives of your image files.

PhotoZoom

Formerly marketed as S-Spline, and still using the same S-Spline algorithm, PhotoZoom is designed solely for image enlargement. It uses adaptive interpolation so that the parts of the image that need sharpening the most (with detail) are given more sharpening than featureless areas, and it does this by analyzing the structure of the image. As the designers say, it "works, so to say, more 'aggressively' in areas with high contrast (and this is exactly where details need to be preserved most), while it interpolates more gently in smoother areas."

Digital Color Spaces

The colors available for use in a digital image are determined by color space. A color space is a model for describing color values, and has a "gamut," or range of colors that it is capable of recording or displaying. By convention, the usual way of illustrating this is as shown on the opposite page.

Some spaces are bigger than others, with obvious advantages. A perfect illustration of why color space matters and why it is sometimes less than ideal is the very problem of showing what it looks like on a printed page. The combination of paper and printing inks actually shows fewer colors than in real life, which makes CMYK the smallest color space in normal use. The diagrams here are, of necessity, inaccurate. The area outside the marked spaces contains color subtleties that are impossible to show in print.

Because RGB is standard for digital cameras and computer displays, the most

Color modes

Briefly, color spaces are the theory, color modes are the practice, and can be selected in an image-editing program (*Image > Mode* in Photoshop). Because the four modes normally available—RGB, HSB, Lab and CMYK—separate the qualities of color in different ways, they each have certain advantages for particular photographs:

RGB
The standard mode, by virtue of being used in all digital cameras. Widely accepted. The three colors are highly familiar, so easy to manipulate channel by channel, using *Curves* or *Levels*.

HSB
Separates the colors into the three dimensions of Hue, Saturation, and Brightness—the method most similar to the way in which we see. Therefore, highly intuitive.

Lab
The largest color space available, and useful in that its three channels are divided between Lightness (L), a color axis from red to green (a), and another from blue to yellow (b). The Lightness channel is especially useful for adjustments independent of hue.

CMYK
Used in printing, with a fourth black channel added to make up for the lack of ink density on paper. The smallest color space, and so not particularly good to work in.

Which color space?

Adobe RGB (1998)
A fairly large range, and the most commonly recommended space at the moment for photography. Good for images that will later be converted in prepress to CMYK for printing (as most professional photographs are).

sRGB IEC61966-2.1
This stands for Standard RGB, but it is smaller than Adobe RGB (1998) and so not recommended for professional photography that will be used for prepress. Its advantage is that it matches the average PC monitor, and is standard for low-end printers and scanners.

commonly used color spaces are variants of this. A high-end camera allows you to choose which space to work in, as do image-editing programs. Despite the several possibilities, there is at the moment just one recommended space for professional photography, and that is Adobe RGB (1998). The reasons are that it has the largest range for an RGB space and is widely accepted for prepress work. The other RGB spaces offered are all designed for specific non-prepress uses, principally matching monitor types and printing directly from the camera or memory card.

RGB may be standard, but there is a larger color space available for digital imaging, and it has striking advantages. This is CIE Lab (strictly speaking, L*a*b*), developed in 1976 by the Commission Internationale d'Eclairage, and designed to match human vision as closely as possible—at least in the way we perceive and appreciate color. Thus, it uses three channels, one for brightness and the other two for opposing color scales. L* stands for luminance (that is, brightness), a* for a red-green scale and b* for a blue-yellow scale. Being a large color space, it is also useful for converting colors from one model to another, as nothing is lost. Indeed, Adobe Photoshop uses L*a*b* internally for converting between color modes. With all this going for it, L*a*b*'s only

COLOR SPACE

Two color spaces compared: Adobe RGB (wireframe) and CMYK Press (solid), represented in 3D and viewed from different angles. You can see that in some places, the CMYK space—which is generally smaller—exceeds the RGB, for example in the yellows.

drawback is that RGB just happens to be more widely used. You can use it in image editing, and convert RGB to and from it with impunity—it allows some special procedures, such as noise reduction.

As for CMYK, which is where most professional photographs end up, the advice is straightforward; don't use it to edit or archive images. If you do, the image will just lose color information. As with sharpening, CMYK conversion is best done from RGB at the last step and, incidentally, is best done by prepress professionals.

Adjusting Colors

Although getting colors as you want them is generally part of the optimization process described earlier, it may be that for specific creative reasons, you will want to change specific colors in an image. As usual, there are several methods for achieving this.

There are many tools and dialogs for making color adjustments within Photoshop (from the *Image > Adjustments* menu), and

through third-party plug-ins (such as nik Color Efex Pro) and other software applications. All rely on a basic operation, which is to select a range of pixels and then map these values to a new range of values. To do this in one step—that is, through one tool—there needs to be a method of selecting pixels based on their values: hue, saturation, and brightness.

To make any other kind of selection, such as on the shape of an object in the photograph,

Hue/Saturation

The *Hue/Saturation* dialog is one of the most intuitive ways of making color adjustment. This is because the tool uses the color mode most closely related to the way we judge colors—hue, saturation, and brightness. It helps to keep in mind that the color bar is a straightened-out version of the color wheel, with hues defined by their angle (0°–360°, as on a compass). By default, the entire color range—called *Master*—is selected, but the changes can be restricted to individual colors from a drop-down menu, and even further refined by sampling colors from the image while you are in one of these ranges. The sliders that appear on the color bar can then be adjusted. The two horizontal bars determine the range of colors selected, and the two outer triangle sliders determine the fall-off or fading from this range.

The *Hue/Saturation* dialog presents a number of options. You can adjust the colors in the image using these tools, or apply a color to them by checking the *Colorize* button.

Alternatively, you can opt to affect only a certain range of colors. You can select the range using the droppers, or from one of the pre-defined ranges from the *Edit:* dropdown menu.

you would first need to use one of the selection tools. You may find the *Select > Color Range* facility in Photoshop very useful if you are looking to alter regions of color. Unlike the *Hue/Saturation* tool's color range selection, its *Fuzziness* can be altered.

Photo Filter

Use
- Filter: Warming Filter (85)
- Color:

OK Reset ☑ Preview

Density: 50 %

☑ Preserve Luminosity

PHOTO FILTER

The Photoshop *Image > Adjustments > Photo Filter…* tool allows you to simulate the effect of certain filter colors, or create a color of your choice using the standard color picker. This is a very photographer-friendly approach, since the concept is one long-established in film photography, with the benefit of an undo option.

Memory Colors

Green grass, captured here under the clear, even light of an overcast sky. Grass and plants—and even some animals— are a crucial memory color, especially in temperate climates such as the United States and much of Europe. In the mind, memory colors tend to become slightly more saturated— in other words, the grass is always greener.

Depending on our geographical and cultural upbringing, there are colors that are strongly fixed in our consciousness.

Often referred to as memory colors, such colors are so familiar to us that we are able, with a fair degree of certainty be able to say whether or not they are correctly rendered in a digital image.

They are known as memory colors because they seem to be embedded in our visual memory. Naturally, they play an important role in image-editing because they are an immediate key to assessing the color accuracy of a photograph. For memory colors, we can say whether they are "right"or "wrong," and to what degree, and we can do this intuitively. Measurement is important in optimization, as we saw, but as color is ultimately a matter of perception, never underestimate the importance of subjective judgment. If it looks right, it is right.

The two most important memory colors are those with which we have most familiarity: neutrals and skin tones. Following this, there are green vegetation and sky tones. Your color memory also depends on the environment in which you grow up—if you live in New Mexico or North Africa, you will be more attuned to the colors of sand and rock than if you live in northwest Europe. Adjusting the memory colors in a photograph involves matching them to known samples. At it simplest, this means relying on your memory at the time of correction, but you can refine the process by referring to samples that you already accept as accurate. One way is to open a second image that is already well-adjusted and use it for reference.

In some color areas, our camera is more sensitive to the subtleties of shade than your eye. Areas susceptible to this are often fabrics with organic dyes, and it is not uncommon for greens to appear neutral or on the warm side.

Memory colors are only understood by the mind in the context that we see them in. Place the red from this image somewhere on its own and it is simply a red color, but in this image, the red (and indeed yellow and black) clearly need to appear strong, since they represent commonly understood warning colors.

Fixing Noise

Advances in DSLR sensor technology have seen ISO sensitivity settings reaching previously undreamed of scales (ISO 12,800 is common) and at such high settings, noise will continue to be a problem.

Noise is complex and comes in a variety of forms, which makes it difficult to tackle at the time of capture. In practice, some noise is best dealt with in the camera—notably fixed-pattern noise—but the most useful place for noise reduction is here, in post-production.

To repeat the key characteristic of noise, it is embedded in the image perceptually—that is to say, it can be distinguished from subject detail only by judgment, and that differs from person to person. Not only this, but noise does not even necessarily damage a photographic image. Photographs are not slices of reality; they have their own textural qualities, and one of these that has become accepted is a certain amount of graininess from film. There are many well-known images (to name one example, the sequence of D-Day landing photographs by Robert Capa) that draw some of their power from graininess.

One implication of this perceptual relationship with detail is that noise reduction has side effects on the rest of the image,

Photoshop

Use this technique on a small selected area of an image to see the noise artifacts more clearly.

1 Open the image and choose a smooth, midtone area, where noise will be most apparent.

2 Open the *High Pass* filter (*Filter > Other > High Pass*) and zoom in on the area to 100%. Apply at a radius of 3 pixels.

3 Apply *Auto Levels* (*Image > Adjustments > Auto Levels*) to increase the contrast. This will exaggerate the visibility of the noise.

4 Desaturate the image (*Image > Adjustments > Desaturate*) to show the luminance noise separately from the chrominance noise.

Average vs. Median

Hot Pix Original

Hot Pix Gaussian

Hot Pix Median

Most blurring filters take an average approach, meaning that they sample an area of pixels (the size depends on the radius you set), and find the average value. A median filter may appear to do the same sort of things, but in fact it chooses the most representative pixel. In an extreme case, if an area of 100 pixels is sampled, in which there are 51 black and 49 white, average blurring will return a gray pixel, while a median filter will choose black. The disadvantage of average blurring is that it reduces rather than obliterates completely blown-out hot pixels, while a median filter will replace them. The disadvantage of median filters is that they can introduce large, unnatural, painterly artifacts.

Original

Opinion is divided on this, but the majority view is that if a particular type of noise appears most in one channel, apply the filter to that alone. In an RGB image, the red channel often has the most chrominance noise. Converting to Lab makes it possible to isolate luminance noise by selecting the Luminance channel, or checking to see whether the a or b color channel has the most chrominance noise.

RGB

L * a * b *

usually softening, and the creation of artificial-looking textures. Because of this, most noise-reduction filters incorporate some kind of threshold setting to protect detail below a certain level. The problem is that a hard threshold, which leaves finer detail untouched, works on size rather than visual importance, and this can create an even more unnatural effect, and draw attention to the repair process.

The algorithms used in different software vary. One common procedure is blurring (see Average vs. Median box, opposite). Another is frequency analysis, also known as the Fourier Transformation, in which the image is converted into frequencies; these can then be searched for structures that don't conform to known ones representing lines, edges, and patterns. None of these methods can work alone, however; all need guidance from the user. In other words, when using any noise-reduction filter, the best you can hope for is to adjust the settings and choose the best-looking compromise.

Make a selection

Noise is more apparent in flat, more uniformly colored areas than it is in areas containing lots of detail. This gives us a handy get-out clause, since these are also the areas that the filters have a harder time coping with. To achieve this:

1 Duplicate the layer you wish to apply the filter to.

2 On the higher layer, with a soft-edged brush, erase those areas to which you would like to apply the filter. (It is a good idea to turn off the visibility of the background while doing this.)

3 Apply the noise reduction filter to the lower layer. The effect will only be visible through those areas you erased from the layer above.

Fixing Lens Distortion

Lens technology is improving year on year. However, as the technology improves the desire for producing zooms with a greater range, from wide angle to long telephoto, have resulted in lenses that often display geometric distortion.

Gone are the days when prime lenses were obviously superior in image quality, but it is more difficult to correct distortion in a zoom—on a lens with a large range, it's quite likely that there will be barrel distortion at the wide-angle end, with pincushion at the other, longer-focus end. Wide-angle zooms are understandably popular, but the penalty is distortion. Because distortions can be corrected digitally, there is no excuse for ignoring them, and this becomes yet another addition to the workflow. Lens distortion can be corrected with software, although currently the choice is small. Because lenses have individual distortion characteristics—and more important, with zoom lenses the distortion varies with the focal length—correction software has to be able to interpolate several parameters, including the radial amount of distortion. Of course, lens distortion matters only if it is noticeable, as it is chiefly along long, straight lines close to the edges of the picture. If it doesn't disturb you visually, there may be little point in correcting it.

In principle, both barrel and pincushion distortion are corrected digitally by applying the opposite radial distortion, and to an extent you could use one of the basic tools, such as Photoshop's *Distort* filters. These,

Three common corrections

There are three main kinds of correction that you may need to make to the geometry of an image:

Type	Characteristics	Procedure
1 Lens distortion	Bowing inward or outward around the center (radial).	Lens correction plug-in filter that applies the opposite radial distortion, weighted appropriately between center and edges.
2 Perspective distortion	Convergence of parallels, vertically or horizontally.	*Edit > Transform > Perspective* filter.
3 Rotation	Tilted clockwise or counter-clockwise (around the z axis).	*Edit > Transform > Rotate* filter, or *Image > Rotate Canvas*.

It may not be immediately clear in which order to apply these, and much depends on the specific image. However, in principle, correcting lens distortion first will leave straight lines that are easier to judge for perspective and rotation.

however, do not allow for the variation in the amount between the inner and outer parts of the frame. Lens-distortion correction filters can allow for the different optical characteristics of different makes of lens. The degree of distortion always increases outward from the center, but the way this progresses varies from lens to lens. Without taking this into account, you can end up with corrected straight lines at the edges but under- or over-correction nearer the center.

Using correction software

Correction software is judged by its effect on straight lines and, to a lesser extent, on symmetrical shapes such as circles. A grid overlay is essential for measuring the effect of the filter, either in the filter window or on the applied result in Photoshop—or both. Adjust the spacing of the grid so that the lines are close to those lines in the image that are most important. Image distortion is very demanding of processing ability, and final image quality depends on good interpolation algorithms.

The ideal method is to analyze each lens, map its distortion (and, if a zoom, at every focal length), and then reverse its effect in the program. Essentially this is what DxO Optics Pro does, and it is completely effective. The only drawback is that it is entirely dependent on the time-consuming analysis that the software manufacturer makes, and there is no way of adjusting, tweaking, or creating a user profile for any other lens. An alternative approach is taken by Andromeda's LensDoc, which works by defining points along a line in the image that need to be straightened, then straightening that curve. Andromeda also has a method for users to profile distortions for themselves, though this is very time consuming.

Is distortion apparent?

Certain types of lens distortion are only really apparent if there are long lines that should be straight and parallel to one another. If the scene contains no long, straight lines, there may be no compelling reason to do anything to the image. Natural scenery, for example, usually has no clear geometry. With the exception of fish-eyes, most lenses require a small amount of correction; make a visual assessment first.

Crop last

After correction, the image will need cropping to remove the new curved edges, unless the software offers the option of stretching the image to fit the original frame. For this reason, do not crop an image before applying lens correction. The software assumes symmetrical correction around the center of the image, so cropping beforehand results in a skewed correction.

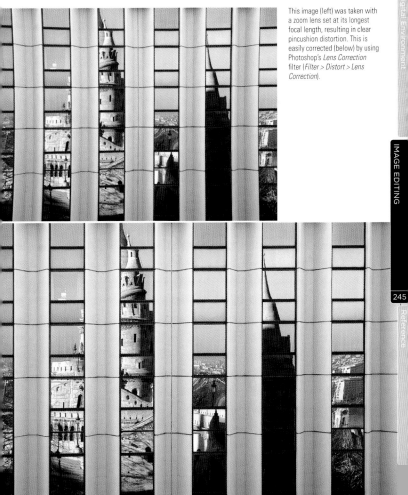

This image (left) was taken with a zoom lens set at its longest focal length, resulting in clear pincushion distortion. This is easily corrected (below) by using Photoshop's *Lens Correction* filter (*Filter > Distort > Lens Correction*).

Glossary

ARCHIVE

The process of organizing and saving digital images (or other files) for ready retrieval and research.

ABERRATION

The flaws in a lens that distort, however slightly, the image.

APERTURE

The opening behind the camera lens through which light passes on its way to the CCD.

ARTIFACT

A flaw in a digital image.

BACKLIGHTING

The result of shooting with a light source, natural or artificial, behind the subject to create a silhouette or rim-lighting effect.

BANDING

An artifact of color graduation in computer imaging, when graduated colors break into larger blocks of a single color, reducing the "smooth" look of a proper graduation.

BIT (BINARY DIGIT)

The smallest data unit of binary computing, being a single 1 or 0. Eight bits make up one byte.

BIT-DEPTH

The number of bits of color data for each pixel in a digital image. A photographic-quality image needs 8 bits for each of the red, green, and blue RGB color channels, making an overall bit-depth of 24.

BRACKETING

A method of ensuring a correctly exposed photograph by taking three shots: one with the supposed correct exposure, one slightly underexposed, and one slightly overexposed.

BRIGHTNESS

The level of light intensity. One of the three dimensions of color in the HSB color system. See also Hue and Saturation.

BUFFER

Temporary storage space in a digital camera where a sequence of shots, taken in rapid succession, can be held before transfer to the memory card.

CALIBRATION

The process of adjusting a device, such as a monitor, so that it works consistently with others, such as a scanner or printer.

CCD (CHARGE-COUPLED DEVICE)

A tiny photocell used to convert light into an electronic signal. Used in densely packed arrays, CCDs are the recording medium in most digital cameras.
Channel Part of an image as stored in the computer; similar to a layer. Commonly, a color image will have a channel allocated to each primary color (e.g. RGB) and sometimes one or more for a mask or other effects.

CLIPPING

The effect of losing detail in the lighter areas of your image because the exposure was long enough for the photosites to fill (and record maximum values).

CLIPPING PATH

The line used by desktop publishing software to cut an image from its background.

CMOS (COMPLEMENTARY METAL-OXIDE SEMICONDUCTOR)

An alternative sensor technology to the CCD, CMOS chips are used in ultra-high resolution cameras from Canon and Kodak.

COLOR TEMPERATURE

A way of describing the color differences in light, measured in Kelvins and using a scale that ranges from dull red (1,900K), through orange, to yellow, white, and blue (10,000K).

COMPRESSION

Technique for reducing the amount of space that a file occupies, by removing redundant data.

CONJUGATE

The distance between the center of the lens and either the subject or the sensor.

CONTRAST

The range of tones across an image from bright highlights to dark shadows.

CROPPING

The process of removing unwanted areas of an image, leaving behind the most significant elements.

DELTA E (ΔE)

A value representing the amount of change or difference between two colors within the CIE LAB color space. Industry research states that a difference of 6 ΔE or less is generally acceptable.

DEPTH OF FIELD

The distance in front of and behind the point of focus in a photograph in which the scene remains in acceptably sharp focus.

DIFFUSION

The scattering of light by a material, resulting in a softening of the light and of any shadows cast. Diffusion occurs in nature through mist and cloud cover, and can also be simulated using diffusion sheets and soft-boxes. See Soft-box.

DYNAMIC RANGE

A measure of image density from the maximum recorded density to the minimum, so an image with a DMax (maximum density) of 3.1 and a DMin (minimum) of 0.2 would have a dynamic range of 2.9. Dynamic range is measured on a logarithmic scale: an intensity of 100:1 is 2.0, 1,000:1 is 3.0. The very best drum scanners can achieve around 4.0.

EDGE LIGHTING

Light that hits the subject from behind and slightly to one side, creating flare or a bright 'rim lighting' effect around the edges of the subject.

EXTENSION RINGS

An adapter that fits into an SLR between the sensor and the lens, allowing focusing on closer objects.

EXTRACTION

In image editing, the process of creating a cut-out selection from one image for placement in another.

FEATHERING

In image editing, the fading of the edge of a digital image or selection.

FILE FORMAT

The method of writing and storing information (such as an image) in digital form. Formats commonly used for photographs include TIFF, BMP, and JPEG.

FILTER

(1) A thin sheet of transparent material placed over a camera lens or light source to modify the quality or color of the light passing through.
(2) A feature in an image-editing application that alters or transforms selected pixels for some kind of visual effect.

FOCAL LENGTH

The distance between the optical center of a lens and its point of focus when the lens is focused on infinity.

FOCAL RANGE

The range over which a camera or lens is able to focus on a subject (for example, 0.5m to Infinity).

FOCUS

The optical state where the light rays converge on the film or CCD to produce the sharpest image.

FRINGE

In image editing, an unwanted border effect to a selection, where the pixels combine some of the colors inside the selection and some from the background.

F-STOP

The calibration of the aperture size of a photographic lens.

GAMMA

A fundamental property of video systems which determines the intensity of the output signal relative to the input. When calculating gamma, the maximum possible input intensity is assigned a value of one, and the minimum possible intensity (no input) is assigned a value of zero. Output is calculated by raising input to a power that is the inverse of the gamma value (output = input $(1/C)$).

GRADUATION

The smooth blending of one tone or color into another, or from transparent to colored in a tint. A graduated lens filter, for instance, might be dark on one side, fading to clear at the other.

GRAYSCALE

An image made up of a sequential series of 256 gray tones, covering the entire gamut between black and white.

HALO

A bright line tracing the edge of an image. This is usually an anomaly of excessive digital processing to sharpen or compress an image.

HISTOGRAM

A map of the distribution of tones in an image, arranged as a graph. The horizontal axis goes from the darkest tones to the lightest, while the vertical axis shows the number of pixels in that range.

HMI (HYDRARGYRUM MEDIUM-ARC IODIDE)

A recently developed and popular light source for photography.

HOT-SHOE

An accessory fitting found on most digital and film SLR cameras and some high-end compact models, normally used to control an external flash unit.

HSB (HUE, SATURATION, AND BRIGHTNESS)

The three dimensions of color, and the standard color model used to adjust color in many image-editing applications. See also Hue, Saturation, and Brightness.

HUE

The pure color defined by position on the color spectrum; what is generally meant by "color" in lay terms. See also Saturation and Brightness.

INVERTER

A device for converting direct current into alternating current.

ISO

An international standard rating for film speed, with the film getting faster as the rating increases, producing a correct exposure with less light and/or a shorter exposure. However, higher speed film tends to produce more grain in the exposure.

KELVIN (K)

Used to measure the color of light based on a scale created from the color changes that occur when a black object is heated to different temperatures. Normal midday sunlight is considered 5,000K. Lower temperature light (less than 5,000K) is more red or yellow, while higher temperature light is more blue.

LASSO

In image editing, a tool used to draw an outline around an area of an image for the purposes of selection.

LAYER

In image editing, one level of an image file to which elements from the image can be transferred to allow them to be manipulated separately.

LOCAL CONTRAST

The contrast range found in smaller areas of a scene or an image.

LUMINOSITY

The brightness of a color, independent of the hue or saturation.

MACRO

A mode offered by some lenses and cameras that enables the lens or camera to focus in extreme close-up.

MASK

In image editing, a grayscale template that hides part of an image. One of the most important tools in editing an image, it is used to limit changes to a particular area or protect part of an image from alteration.

MEGAPIXEL

A rating of resolution for a digital camera, related to the number of pixels output by the CMOS or CCD sensor. The higher the megapixel rating, the higher the resolution of images created by the camera. Midtone The parts of an image that are approximately average in tone, falling midway between the highlights and shadows.

MODELING LAMP

Small lamp in some flashguns that gives a lighting pattern similar to the flash.

MONOBLOC

An all-in-one flash unit with the controls and power supply built in. Monoblocs can be synchronized to create more elaborate lighting setups.

NOISE

Random patterns of small spots on a digital image that are generally unwanted, caused by non-image-forming electrical signals.

PENTAPRISM

Abbreviation for pentagonal roof prism. This prism has a pentagonal cross-section, and is an optical component used in SLR cameras. Light is fully reflected three times, so that the image displayed in the viewfinder is oriented correctly.

PHOTOMICROGRAPHY

Taking photographs of microscopic objects, typically with a microscope and attachment.

PIXEL (PICTURE ELEMENT)

The smallest unit of a digital image—the square screen dots that make up a bitmapped picture. Each pixel carries a specific tone and color.

PLUG-IN

In image editing, software produced by a third party and intended to supplement the features of a program.

PPI (PIXELS-PER-INCH)

A measure of resolution for a bitmapped image.

PRIME LENS

One with a fixed focal length. See also Zoom lens.

RECTIFIER

A device for converting alternating current into direct current.

REFLECTOR

An object or material used to bounce available light or studio lighting onto the subject, often softening and dispersing the light for a more

attractive end result. Resampling
Changing the resolution of an image
either by removing pixels (lowering
resolution) or adding them by
interpolation (increasing resolution).

RESOLUTION

The level of detail in a digital image,
measured in pixels (e.g. 1,024 by 768
pixels), lines-per-inch (on a monitor), or
dots-per-inch (in a half-tone image,
e.g. 1,200 dpi).

RGB (RED, GREEN, BLUE)

The primary colors of the additive
model, used in monitors and
image-editing programs.

SATURATION

The purity of a color, going from the
lightest tint to the deepest, most
saturated tone. See also Hue and
Brightness.

SELECTION

In image editing, a part of an
on-screen image that is chosen and
defined by a border in preparation for
manipulation or movement.

SENSITOMETER

An instrument for measuring the light
sensitivity of film over a range of
exposures.

SHUTTER

The device inside a conventional
camera that controls the length of time
during which the film is exposed to
light. Many digital cameras don't have
a shutter, but the term is still used as
shorthand to describe the electronic
mechanism that controls the length of
exposure for the CCD.

SHUTTER SPEED

The time the shutter (or electronic
switch) leaves the CCD or film open to
light during an exposure.

SLR (SINGLE LENS REFLEX)

A camera that transmits the same
image via a mirror to the film and
viewfinder, ensuring that you get
exactly what you see in terms of focus
and composition.

SNOOT

A tapered barrel attached to a lamp in
order to concentrate the light emitted
into a spotlight.

S/N RATIO

The ratio between the amplitude of the
signal (S) to be received and the
amplitude of the unwanted noise (N) at
a given point in a receiving system.
Soft-box A studio lighting accessory
consisting of a flexible box that
attaches to a light source at one end
and has a diffusion screen at the other,
softening the light and any shadows
cast by the subject.

SPOT METER

A specialized light meter, or function of
the camera light meter, that takes an
exposure reading for a precise area of
a scene.

TONAL RANGE

The range of tonal values in an image.
The histogram feature in an
image-editing application displays
tonal range. When an image has full
tonal range, pixels will be represented
across the whole of the histogram.
Analyzing variation and deficiencies in
the distribution represented in the
histogram is the basis for making tonal
corrections.

TELEPHOTO

A photographic lens with a long focal
length that enables distant objects to
be enlarged. The drawbacks include
both a limited depth of field and angle
of view.

TRANSFORMER

A device that converts variations of
current in a primary circuit into
variations of voltage and current in a
secondary circuit.

TTL (THROUGH THE LENS)

Describes metering systems that use
the light passing through the lens to
evaluate exposure details.

VALUE

A particular color tint. Also a numerical
value assigned to a variable,
parameter, or symbol that changes
according to application and
circumstances.

WHITE BALANCE

A digital camera control used to
balance exposure and color settings
for artificial lighting types.

ZOOM LENS

A camera lens with an adjustable focal
length giving, in effect, a range of
lenses in one. Drawbacks compared to
a prime lens include a smaller
maximum aperture and increased
distortion. See also Prime lens.

Index